Acrylic
school

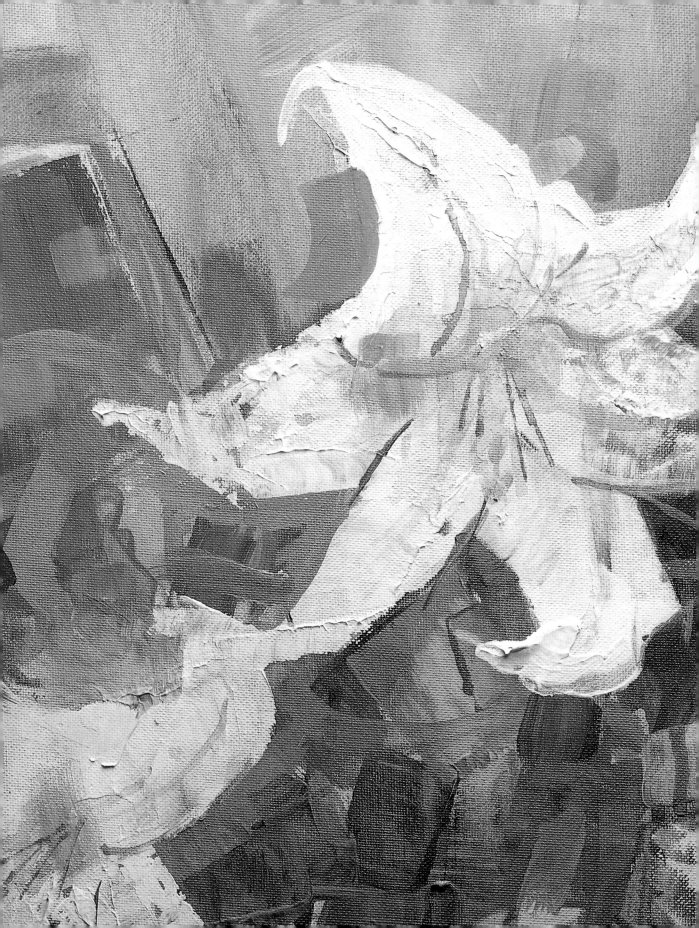

READER'S DIGEST
Learn-As-You-Go-Guide

Acrylic school

HAZEL HARRISON

Reader's Digest

THE READER'S DIGEST ASSOCIATON, INC.
Pleasantville, New York / Montreal

Contents

A READER'S DIGEST BOOK

Designed and edited by
Quarto Publishing plc

Senior Editor *Kate Kirby*
Text Editor *Mary Senechal*
Designer *Anne Fisher*
Picture Researcher *Miriam Hyman*
Picture Manager
Giulia Hetherington
Photographers *Colin Bowling,*
Paul Forrester, Laura Wickenden
Editorial Director *Mark Dartford*
Art Directors *Moira Clinch,*
Penny Cobb

The credits that appear on
page 176 are hereby made a part
of this copyright page.

Copyright © 1997 Quarto Inc

Library of Congress Cataloging in
Publication Data

Harrison, Hazel.
 Acrylic school: a practical guide
 to painting with acrylic/
 Hazel Harrison.
 p. cm. — (Reader's digest learn-
 as-you-go-guide)
 Includes index.
 ISBN 0-89577-929-3
 1. Acrylic painting—Technique.
 I. Title. II. Series.
 ND1535.H36 1997
 751.4'28—dc20 98-45939

Reader's Digest and the Pegasus
logo are registered trademarks of
The Reader's Digest Association,
Inc.

Printed in Singapore

Introduction

For those who are new to acrylic painting there could be no better medium. You can do virtually anything with acrylics, which is why they are favored by artists who like to experiment.

Acrylics are water-based and odor-free, which is a bonus when you work at home. Some people are discouraged from using oil paints because of the pervasive and lingering smell, and a few are allergic to oil-paint solvents such as turpentine and mineral spirits. Acrylics also dry fast, so you will not encounter the oil painter's difficulty of carrying wet pictures home from an outdoor session.

Paintings in acrylic do not crack, fade, or discolor with age or exposure to sunlight. Used on paper, acrylics are less prone to damage than other paints, because once dry they form a tough skin. But their capacity for diversity is the main reason for the popularity of acrylics. You can change their thick creamy tube consistency by adding water, or thicken it for oil-painterly effects with one of the special mediums (see pp.26–27). You can combine different paint consistencies in the same painting, using thin, transparent glazes (see p.70) over thick or medium-thick applications, and vice versa. You can use different paint surfaces (see pp.18–21) or different grounds (p.60).

Acrylic is especially suitable for textured effects (see p.68), which can be produced by painting over a pretextured ground or by mixing paint with substances, such as sand, or one of the mediums made for this purpose.

The finished paintings on these pages show some of these methods, which are fully explained and illustrated with step-by-step demonstrations in Chapter 4 of the book.

Continued on page 8 ▷

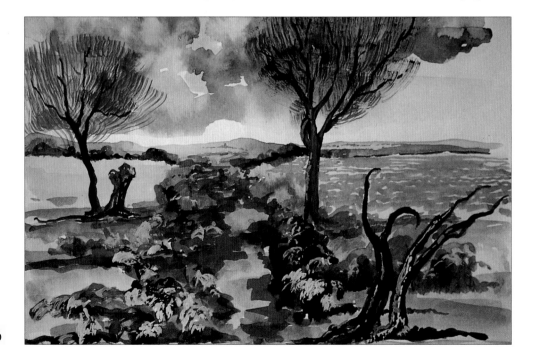

WATERCOLOR EFFECT
This work on paper could be mistaken for a watercolor were it not for the dark tones and colors in the foreground and on the trees. With watercolor, these would need to be built up gradually with overlaid washes. With acrylic, considerable depth of color can be achieved with just one application. (Late Autumn, near Cliffe, Kent — Roy Sparkes)

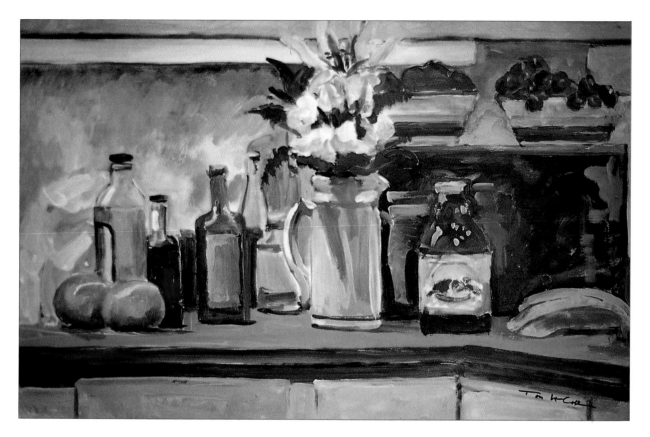

ACRYLIC ON BOARD

In contrast to the painting opposite, this resembles a work in oils (above). The artist worked on board, primed with acrylic gesso (see p.19) to reduce the absorbency, and applied the paint thickly with the traditional oil painters' bristle brushes. Rather than using an acrylic medium (see p.26) to thicken the paint, he gave it extra body by mixing it with the gesso used for the priming. (Groceries — Thomas McCobb)

ACRYLIC ON CANVAS

For this nature study done direct from the subject, the paint was used at tube consistency, applied with bristle brushes on fine-grain canvas. As she worked, the artist made continual adjustments and rearrangements, and built up the stronger tones and colors gradually. (Early Spring on the Porter Trail — Marcia Burtt)

FINDING YOUR OWN WAY

Because of their versatility, acrylics have gained a reputation as an imitative medium. It is true that a painting in acrylics can look very much like one in oils. Oil painters sometimes use acrylics as a substitute when working outdoors because their short drying time makes them more convenient. Acrylics can also mimic the effects of watercolor or gouache (opaque watercolor). But there is little point in trying to make one medium behave like another unless you do so for a specific reason. Acrylics have their own characteristics, and you will enjoy using them more if you learn to understand and exploit these in your individual way. Sympathy with the chosen medium is one of the factors that marks a successful painting, and this book aims to help you achieve it.

If you are not sure what methods to adopt for your first attempts, begin by looking at the pictures shown throughout the book. If you respond more to some than others, take them as a starting point for developing your own approach. To a large extent, painting is learned by example, and the work of other painters can give you more ideas than weeks spent struggling on your own.

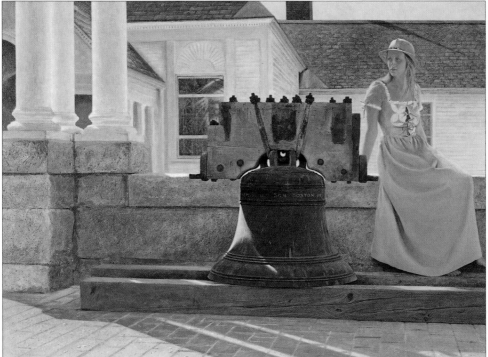

Textures achieved by crosshatching and weaving layers of colors over one another, using soft sable brushes.

ADAPTING OLD TECHNIQUES

Before the introduction of oil paints, tempera (pigment mixed with egg yolk) was the standard painting medium. Tempera paintings are characterized by luminosity of color, fine detail, and a smooth surface, with almost no visible brushmarks — effects that acrylic can imitate successfully. To give his work an authentic tempera quality, the artist worked on a smooth-surfaced primed panel, and mixed his acrylics with egg yolk to increase the translucency and impart a subtle sheen to the surface. (Jennifer and the Bell — Neil Drevitson)

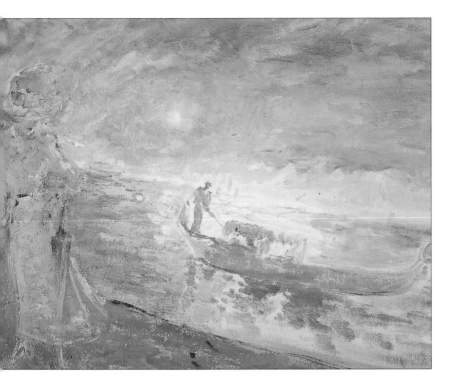

TRANSLUCENCY

One of the properties of acrylic is that unless it is used thickly it remains transparent, and will not completely cover a color beneath. Artists who like a somber or quiet color scheme often paint on a precolored ground (see p.60) of brown or gray, which mutes and darkens the applied colors. Here the artist chose a white canvas board to enhance the vivid colors and overall pale tones. (Interlude in Venice — John Rosser)

Patches of the white ground were left unpainted. Elsewhere the white reflects back through the pale colors to give the work a shimmering, translucent quality.

HOW ACRYLICS ARE MADE

Acrylics were originally a by-product of the plastics industry, developed hand in hand with the latex paints that we use on our walls. Like all paints, they consist of coloring matter, known as pigment, and a binder, which in the case of acrylics is a synthetic resin. This is water-soluble when wet, but forms an impermeable skin when dry. The pigments in acrylics are mostly the same as those used for other paints. The majority are chemically synthesized to give stability and permanence of color.

Acrylic resin, a binding agent, is added to the pigment base.

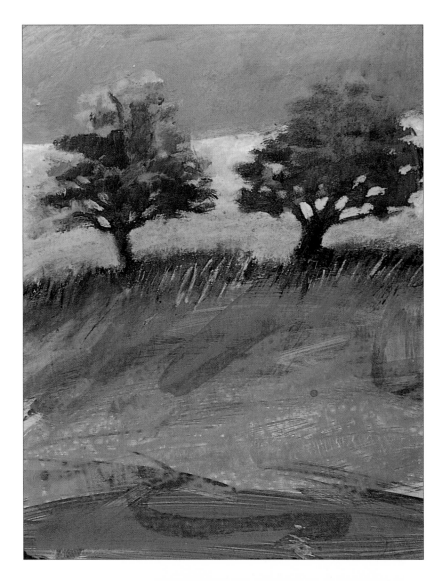

DIFFERENT CONSISTENCIES

*While some paintings in acrylic look similar to oils or watercolors, the medium used for this painting would be identifiable by anyone familiar with acrylics. The artist exploited the full range and versatility of the medium, combining different consistencies of paint with bold and inventive brushwork. The treatment of the foreground, where colors were layered over one another so that each shows through the next, is especially effective. (*Two Trees — Paul Powis*)*

Broad brushstrokes of paint mixed with acrylic medium to make it transparent were laid over earlier applications of both transparent and opaque color.

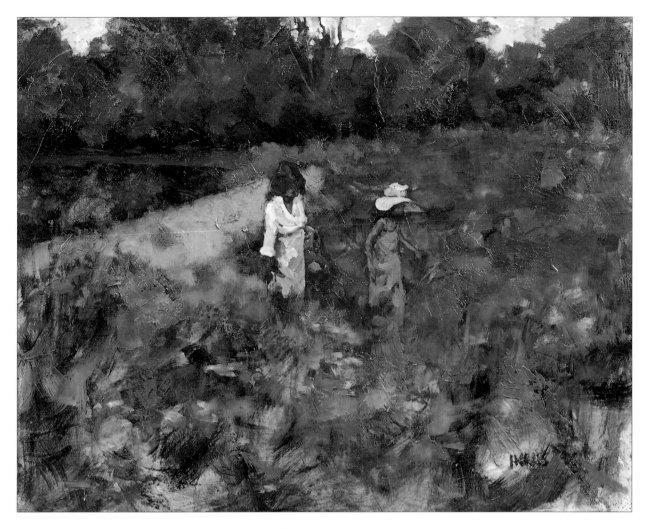

TEXTURE

This painting on canvas bears a superficial resemblance to an oil painting, but closer examination reveals effects that are special to acrylics. As in the painting opposite, the artist achieved a lively surface through varied brushwork and contrasting paint consistencies. Also, an extra dimension of texture was created by working over a textured ground (see p.68) made from a combination of acrylic modeling paste and sand applied with a knife. To increase the surface contrast, the texture was restricted to certain areas. (Two Figures, Still Pond — *W. Joe Innis*)

Single horizontal brushstroke of thinned paint laid over darker colors.

Transparent and semi-opaque paint in several colors laid over thick texture of ground.

WORKING OVER A GROUND

This painting is one of a series of flower studies, for which the artist evolved her own method of working. Working on watercolor paper, she began with the background, using broad bristle brushes and laying wet, sloppy paint all over the surface so that the colors blended into one another wet into wet (see p.74). The flowers were painted over this ground, with a thicker paint applied with a Chinese brush to give crisp, clearly defined edges. (Lilies — Ros Cuthbert)

In places, the ground colors show through the paler hues of the petals to give a soft effect. Unthinned white paint was used for the edges of the petals, covering the ground colors.

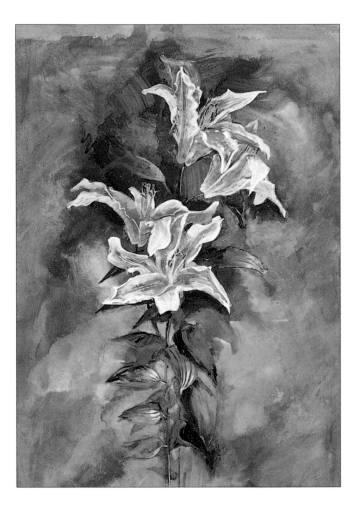

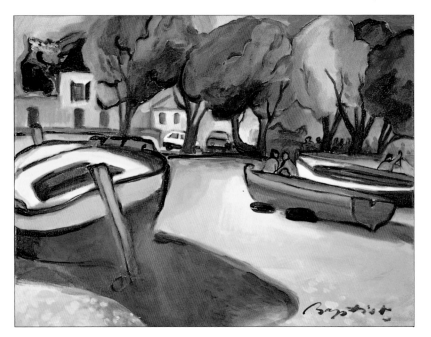

SURFACE MIXING

The brilliance of colors seen in this painting derives from the fact that very little pre-mixing was done on the palette, and a minimum of white was used. (On the Beach — Gerry Baptist)

Blue, magenta, and orange laid over one another to build up a scintillating area of color.

Although acrylics can achieve similar effects to oils and watercolors, they do not behave in the same way. Certain *techniques associated with other media are unsuitable for acrylics, or call for the addition of an acrylic medium.*

ACRYLIC

In watercolor work, depth of color is built up in successive layers. The same method can be used for acrylic. Because the paint is nonsoluble when dry, there is no danger of new layers lifting or muddying those below, which is a danger in watercolor work.

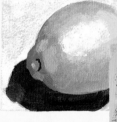

Scumbling (see p.62) is a technique originally used in oil painting. It is a slow process because each layer of color must dry before another is added. With acrylics you need wait no more than a few minutes.

Glazing (see p.70) is another technique originally used by oil painters. It, too, is slow to use because each layer must dry before another is added. The fast drying time of acrylic makes it quick and easy.

OTHER MEDIA

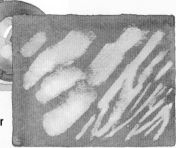

Watercolor remains water-soluble even after drying, allowing colors to be lifted off the surface with a damp brush or sponge. You cannot do this with acrylics, which are immovable when dry.

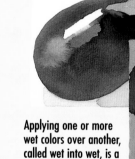
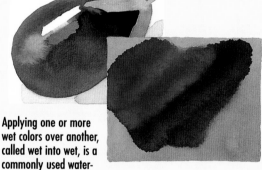

Applying one or more wet colors over another, called wet into wet, is a commonly used water-color technique. You can do this in acrylics, too, provided you work quickly and dampen the paper before painting (see p.74).

Oil paint takes time to dry, so it is easy to blend colors wet-into-wet. With acrylics you will need to add retarding medium to the paint to slow the drying process and paint thickly (see p.27).

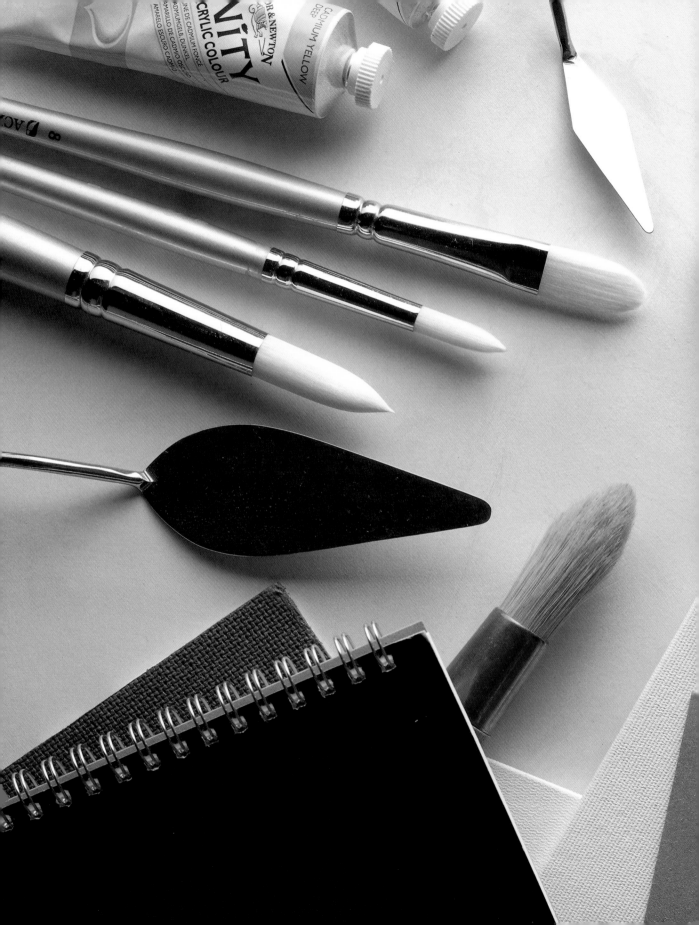

1

What You Will Need

Making Choices

The ever-increasing popularity of acrylics has multiplied the variety of paints on the market, and the same manufacturers sometimes produce several lines. This can be confusing for the beginner. What do the terms "artist's quality" and "flow-formula" signify, and how do you tell which you need?

PAINT QUALITY

The only difference between "artist's" and "student's" quality paints is that the latter are made from less expensive pigments. In most cases, however, they are vivid and durable. They also cost considerably less than artist's quality paints, so they are a good choice for first attempts. They are seldom denoted as student's quality on the tubes, but the more expensive paints are always marked artist's quality or artist's acrylics. If in doubt, ask for the manufacturer's information sheet.

PAINT CONSISTENCY

Some acrylics are relatively thick and buttery, described as full-bodied, while others are runnier, known as flow-formula. Again these characteristics are not always indicated on the tube, but some brands contain the word "flow" in their name. Artist's quality acrylics are made in both consistencies, but most of the student's quality paints are the flow type.

STUDENT'S PAINTS
A beginner's line (top), produced by a well-established manufacturer specializing in acrylics. A line from another well-known company (right) aimed at the amateur market. The range of colors is smaller than in artist's paints, but the quality is excellent.

FLOW-FORMULA PAINTS
Flow-formula artist's paints, produced by this manufacturer in uniform-sized tubes and a wide range of colors.

TUBE SIZES

Some paint manufacturers produce two sizes of tubed color, usually 0.67 fl. oz. and 2.5 fl. oz. You can economize by buying the smaller tubes of any colors you use infrequently. White, which is used up fast if you are painting thickly, can sometimes be obtained in especially large tubes (4.2 fl. oz).

FULL-BODIED PAINTS

A range of high-quality full-bodied artist's paints, suitable for both thick and thin applications, and made in a wide range of colors. The same manufacturer produces flow-formula paints.

PAINT IN POTS

Several manufacturers produce the same paints in both tubes and plastic pots of various sizes. These are useful for large-scale and indoor work, but they are less portable than tubes for outdoor sketching. Choose pots or jars that have a nozzle under the cap, as shown in the photograph. This allows you to squeeze the paint out. If you have to dip your brush into the paint, and the brush is not perfectly clean, you will pollute the color.

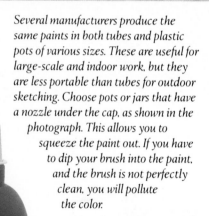

Paper and Cardboard

CHOOSING PAPER
A *wide range of papers and boards are available. They all have different characteristics, so experiment with several, as shown on pages 42–43.*

White matt board

Off-white matt board

Deep cream matt board

Smooth (hot-pressed) watercolor paper

Medium (cold-pressed) watercolor paper

Rough watercolor paper

Mi-Teintes pastel paper, beige

Mi-Teintes pastel paper, gray

WHAT YOU WILL NEED

Y ou can apply acrylic to virtually any paper or cardboard provided it is not greasy; any oil content will repel the water-based color. This means that you cannot use a surface that has been prepared for oil painting, such as oil sketching paper. Watercolor paper is the most popular choice. Three different types are available: rough, medium-rough (cold-pressed), and smooth (hot-pressed). Rough is not easy to work on, because you need a lot of paint to cover the pronounced texture. Cold-pressed, which has enough texture, or tooth, to hold the paint in place, is a good choice, but hot-pressed paper, or smooth matt board, can also produce interesting effects. The paint slides around more on a smooth surface, so that you can exploit the effect of brushmarks.

You can also use pastel papers, made in two textures and a wide variety of colors. These will need to be stretched to prevent them from buckling, as will lightweight watercolor papers. Instructions on how to do this are on the opposite page.

Good-quality watercolor and pastel paper are acid-free, which prevents the fragile watercolor and pastel pigment from possible spotting or discoloration over time. But the tough skin formed by acrylic paint seals and protects the paper, so your work will not be harmed by a slight acid content. This means you can use less expensive surfaces.

ACRYLIC SKETCHING PAPER

Pads of acrylic sketching paper contain sheets of specially primed paper with a canvas-like texture. They are useful for outdoor work, because their cardboard backing removes the necessity for a drawing board. They come in several sizes.

STRETCHING PAPER

1 *You will need a sponge and a tray to hold water, brown gummed paper tape at least 1½ in. (3.8 cm) wide, a drawing board (see p.103), and the paper you intend to stretch.*

2 *Either soak the paper briefly in a bathtub or place it on the board and sponge over it. Wet one side first, then turn it over and wet the other.*

3 *Dampen each piece of gummed paper tape by sliding it over the wet sponge. Stick it along the edges of the paper, starting with the longer sides.*

4 *Sponge lightly over the tape to smooth it out. Then fold the edge over to adhere to the back of the board. It is not essential to fold the edge over if the board is 2 in. (5 cm) larger than the paper; then the gummed tape can be confined to the flat surface.*

PRIMING PAPERS

Paper and cardboard are slightly porous, and the first applications of paint will sink into the surface. To reduce absorbency, prepare, or prime, the surface with a coat of acrylic gesso, which is sold especially for the purpose. This will make it easier to spread the color. The choice of surface will ultimately depend upon your preferred method of working, so experiment with primed and unprimed paper and cardboard as well as rough and smooth textures.

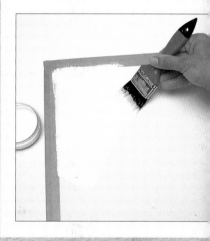

ECONOMY SURFACES

A good rule to follow when you begin painting in acrylics is never to throw things away. Keep packaging materials, such as brown wrapping paper and cardboard, as these make attractive painting surfaces. Use the matte side of wrapping paper, and treat brown cardboard with acrylic gesso. Paint on inexpensive plain wallpaper sold for walls, and try out your brushwork and color mixes on old newspapers.

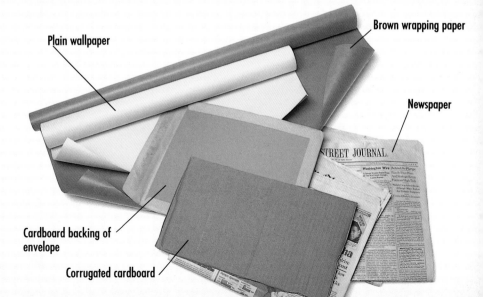

Plain wallpaper

Brown wrapping paper

Newspaper

Cardboard backing of envelope

Corrugated cardboard

Canvas and Board

Many acrylic painters like to work on canvases, which are made by stretching fabric over wooden stretchers. You can buy canvases already stretched and primed. Alternatively, you can prepare your own, as shown opposite. Most of the larger art stores and mail-order suppliers carry a selection of various cotton or linen fabrics, ranging from fine-weave to coarse.

BOARDS

There are a number of different painting boards on the market. The most expensive boards — still a more cost-effective choice than ready-made canvases — are surfaced with fabric, while the others have a simulated canvas grain. Both types are primed during production, usually with acrylic so that they are suitable for both oil and acrylic painting. If you are not sure how the surface was primed, ask the supplier; remember you cannot use acrylic on oil-primed board.

Another board often used for acrylic work is masonite, available from building supply centers. This has two major advantages: it is inexpensive, and you can cut it to whatever size or shape you like, whereas painting boards are made in standard formats. Masonite has a shiny surface, but you can counteract this by sanding it lightly before priming with acrylic gesso.

PAINTING SURFACES

A selection of ready-prepared canvases and canvas boards is available, or you can make your own (see opposite page). Try out different surfaces, as shown on pages 42–43, to discover which you like. If you find that a non-textured surface suits you, the smooth side of masonite is a good choice.

Stretched and primed linen canvas, coarse grain.

Stretched and primed human-made fiber canvas, fine grain.

Stretched and primed cotton canvas, medium grain.

Canvas board, primed for acrylic work.

Masonite, smooth side. Can be sanded down before priming to remove the sheen.

Masonite, rough side. This is only suitable for thickly applied paint and rugged effects.

STRETCHING CANVAS

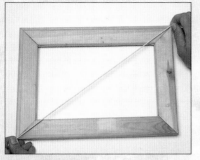

1 *Assemble the stretchers. Check whether the corners are true 90° angles by stretching a piece of string across diagonally. Adjust if necessary.*

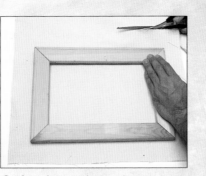

2 *Place the stretcher on the canvas and cut the canvas to size, allowing sufficient fabric around the edges to fold over onto the back of the stretchers.*

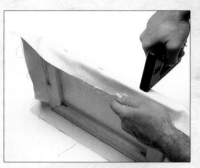

3 *Staple or tack one long side of the canvas to the edge of the stretcher. Then turn it over, pull the canvas with your fingers, and staple the other side. Repeat for the short sides.*

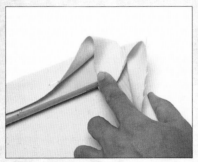

4 *Staple or tack the canvas onto the back of the stretchers, leaving at least 2 in. (5 cm) free at the corners. Miter the corners in two stages. First turn down the point of canvas so that it forms a pleat on either side.*

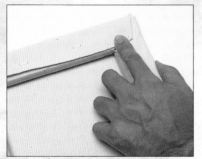

5 *Fold down the pleats, and staple or tack through all the thicknesses. If you are using a staple gun, place the staple diagonally, with one end in each stretcher (see right). If tacking, use two tacks.*

6 *Prime the canvas with acrylic gesso, using a household brush. If you prefer to keep the natural color of the canvas, prime it with acrylic matte or gloss medium (see p.27) instead.*

MAKE YOUR OWN CANVAS BOARD

Stretched canvas has a slight give that some painters dislike. If you prefer a firm surface, glue fabric onto masonite, using acrylic gloss medium. This is a good way to recycle old sheets rather than buying canvas by the yard, but avoid synthetics, such as nylon, which could be too slippery to hold the paint.

1 *Cut a piece of masonite to the desired size, and spread it evenly with a layer of acrylic gloss medium.*

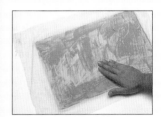

2 *Cut the fabric with enough surplus to take around onto the back of the board. Place it on the glued surface and smooth it with your hand.*

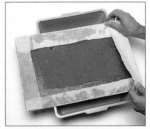

3 *Turn the board over, and raise it off the table so that it does not adhere. Glue around the edges and stick the fabric down, folding it in at the corners.*

Brushes

BRUSH SHAPES

The shapes of these brushes are, from left to right: a round, a short flat (square-ended), and a filbert. Some manufacturers offer two versions of the flat — a long and a short (see opposite) — while others exclude the filbert shape.

WHAT YOU WILL NEED

To some extent, your choice of brushes will be dictated by the size of your work, and whether you like to apply the paint thickly or thinly. The bristle brushes used by oil painters and the soft brushes made for watercolors are suitable for acrylics, but avoid expensive sable brushes, which could be spoiled by constant immersion in water.

The major manufacturers produce synthetic brushes designed especially for acrylic painting. These are tougher and springier than the synthetics made for watercolors. They are an ideal choice for beginners, because they are durable, keep their shape well, and are suitable for both thin and thick methods.

There are three basic brush shapes: square-ended, round, and filbert. Two different sizes of the first two, and one middle-sized filbert will make an adequate starter kit. You can then extend your range later according to your own needs. You may, for example, find a large soft mop brush useful for glazing large areas (see p.70), and one or two bristle brushes for oil-paint effects and exploiting brushmarks (see p.40).

SYNTHETIC BRUSHES

Several manufacturers produce synthetic brushes for acrylic work. The best are tough, hard-wearing, and springy, suitable for both thin and thick paint applications.

PAINTING KNIVES

Thick paint can be applied with knives designed for the purpose; the method is shown on page 66. Painting knives, available in a variety of shapes and sizes, are highly sensitive implements, made from flexible steel and with an offset handle for ease of use. They are expensive, and not recommended as part of a starter kit, but you might want to try them when you become more experienced.

Narrow pear shape

Short diamond shape

Small pear shape

22

BRISTLE BRUSHES

These brushes, which are usually made from hog's hair, are good for oil-painterly effects. Shown here from left to right: filbert, round, short flat (square-ended), and long flat (a variant on the standard shape but with longer hairs).

MOP BRUSH

A soft-haired mop brush is useful for glazes (see p.70) and watercolor-type applications over large areas. This one is made of goat hair; others are manufactured from squirrel hair.

HOUSEHOLD BRUSHES

Household brushes are handy for covering large areas quickly, and good for laying colored grounds (see p.61).

CARE OF BRUSHES

The most important thing to remember about acrylic paint is that it dries rapidly, and it can ruin brushes unless you keep them wet throughout the working process. Do not leave them to stand for long periods in water, because this can bend and splay the bristles. Rinse them well after each application of paint so that they remain damp, or place them flat in a shallow dish. The reservoir palette shown on the following pages has a compartment designed for this purpose.

Brushes quickly become clogged with paint, from the tip to the ferrule.

Before immersing in water, remove the excess paint with a palette knife.

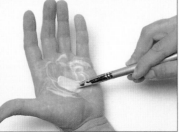
Rinse in warm water. Then clean by rubbing brush in the palm of a well-soaped hand.

Often the hairs will become splayed. To reshape, dampen the brush and stroke it between finger and thumb.

Palettes

This reservoir palette is especially designed for acrylic work. Replace the plastic lid after a working session, and the paint will remain damp for at least a week, avoiding wastage. The side compartment can be half-filled with water to keep brushes moist, or used as a subsidiary mixing surface.

WHAT YOU WILL NEED

Acrylic will not adhere permanently to a non-porous surface, so this is the main requirement for a palette. Do not use the wooden palettes sold for oil painting; you will not be able to remove the paint after use. Some art suppliers carry white plastic palettes for acrylic painting, but you can easily improvise your own mixing surface.

For acrylic used relatively thickly, a sheet of glass is ideal, though only for indoor work. An alternative would be a piece of laminated particle board, such as formica, or you can use old ceramic or enamel plates. These are easy to clean and will not stain, whereas laminated board will retain some of the paint dyes.

Acrylics will dry out quickly on any of these homemade palettes, so use a plant spray or other atomizer to spray the colors with water from time to time — before they begin to acquire the skin that indicates drying. To keep the paints workable while you take a break, cover the palette with plastic wrap.

OTHER POSSIBILITIES

For thick or medium-thick applications you can mix the paints on a flat surface, such as a piece of glass or a plate. But if you like thin paint you may find a palette with separate compartments more satisfactory. These prevent mixed colors from flowing into one anothe or slopping over the edge.

Kidney-shaped plastic palette with thumbhole, easy to hold when standing.

RESERVOIR PALETTES

One useful ready-made palette is a reservoir palette. This is a deep tray with a clear plastic lid that holds water to keep the paint moist. The paints are laid out and mixed on a sheet of special paper, with a piece of dampened absorbent paper underneath. Sufficient water seeps up to keep the paint moist while you work, after which you put on the lid to trap the moisture. The palette incorporates a compartment for laying brushes in water.

A sheet of laminated plastic is ideal for indoor work

Plastic palette with compartments for mixing.

Edges of glass should be bound with adhesive tape to prevent damage to fingers.

Glass or ceramic plates make suitable palettes.

Disposable paper plates, useful for indoor and outdoor work.

A plant spray will enable you to keep the paint moist.

How you go about the process of mixing your colors depends upon the way you work. For thin or medium applications, a brush is the usual mixing implement, but for thick impasto or large-scale work, a palette knife is sometimes used. In either case, make sure the colors are thoroughly mixed or you will have streaks when the paint is applied.

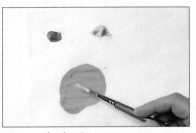

Mixing with a brush.

Mixing with a knife.

At present, reservoir palettes are produced by only one or two manufacturers, so if you have difficulty obtaining one, try making your own. You will need a metal or plastic tray, sheets of blotting paper or capillary matting (sold for gardening purposes), and several pieces of wax paper or thin tracing paper, both cut to the same size as the tray.

Thin tracing paper

Blotting paper

Plastic tray

Acrylic Mediums

The word "medium" has two meanings for the artist. The broader sense of the word refers to the material used for the painting; for example, this book is devoted to the "medium of acrylic." In its narrower meaning, the word describes substances added to the paint, either during its manufacture or when mixing color on the palette, and that is the kind of medium we consider here.

Because acrylic is water-based, you can thin it by adding more water. This is the only medium you need for early experiments. But there are several mediums made especially for acrylic work that you may find useful later on. They change the nature of the paint in various ways, making it slower to dry, more transparent, or thicker. Based on the polymer emulsion used in the manufacture of the paint, the mediums are white when applied but become transparent when dry.

DIFFERENT BRANDS

All the major paint manufacturers produce the basic acrylic mediums. The packaging varies from tubes to tubs and bottles, but the brands are much the same. However, only one or two manufacturers make mediums for special textures (top right), so you may need to seek these out.

You can achieve watercolor-like effects, or lay transparent glazes, simply by thinning the paint with water, but the special glazing mediums (acrylic, matte and gloss medium, and gel medium) make the paint more lustrous as well as more transparent. They will even impart a translucent quality to thick or medium-consistency opaque paint — which water will not do — and they give the paint more body, so that it stays in place rather than running down the surface.

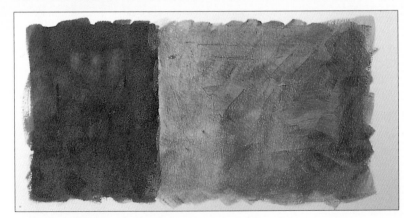

The paint on the right was mixed with gloss medium, and that on the left with water alone.

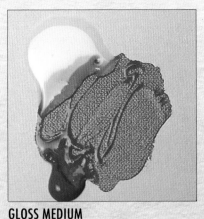

GLOSS MEDIUM

This is mainly used for glazing methods (see p.70). It makes tube colors thinner and more transparent, so that they can be built up in successive layers.

MATTE MEDIUM

Similar to gloss medium, but thicker, because it contains a waxy substance to reduce shine. Use it for glazing if you want a matte surface.

GEL MEDIUM

A jelly-like form of gloss medium, which thickens the paint for impasto effects (see p.64). It does not affect the translucency of the colors.

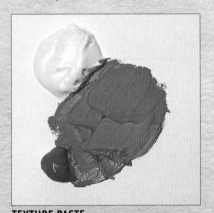

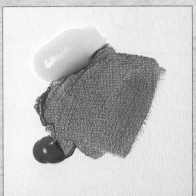

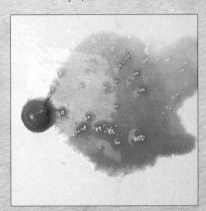

TEXTURE PASTE

Also known as modeling paste. A very thick medium for heavy impastos, and special texture effects (see p.68).

RETARDING MEDIUM

Used by artists who like to achieve oil-painting effects, this slows the drying time, so that colors can be blended.

FLOW IMPROVER

Also known as flow enhancer, this is a solution of wetting agents that helps to break down the gel structure of acrylics.

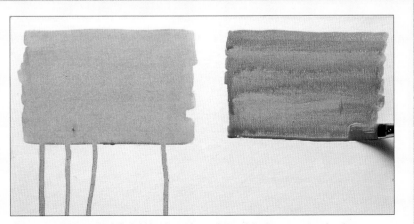

The watery paint on the left dribbles down the surface, while the paint mixed with matte medium remains in place.

VARNISH

Acrylic varnishes are made in matte and gloss versions. Their main function is to protect work from discoloration caused by dust and other pollutants. It is wise to varnish a painting that is to be hung and framed without glass.

Choosing Colors

Some paint manufacturers sell starter sets, usually consisting of six to eight tubes of color. Some of these sets lack essential colors, while including colors you can easily mix yourself, so it can be preferable to make your own selection. Alternatively, begin with an introductory set and add to it as you discover what you need.

A starter palette must contain two of each of the primary colors: red, yellow, and blue. As you can see from the color swatches opposite, there are different versions of each color, and you need both in order to make successful secondary colors: greens, oranges, and purples. There is more information about mixing these colors on page 46.

Secondary colors are a mixture of two primaries, so you could manage with the six basic colors alone, plus white, but this would mean spending as much time mixing colors as painting. Also, some of the ready-made secondary colors, notably the purples, are brighter and purer than those you can mix, so a small selection of these is recommended.

A good range of browns, known as tertiary colors, can be mixed from primary and secondary colors, but again, it saves time to have one or two on hand. Tertiaries and secondaries are useful both on their own and for modifying other colors. For example, a little purple added to a sky blue will deepen it, and a touch of brown mixed into an over-bright green or red will reduce its intensity. The gray recommended in the starter palette was formulated especially for toning down colors without making them appear muddy.

Unlike watercolor, which becomes paler as it dries on the paper, acrylic becomes darker. This is because of the medium used in the manufacture of the paint, which is invisible when dry but white when wet. With experience, you will learn to allow for this by mixing colors just a little lighter than you need. If you want to match a color exactly, perhaps to correct an error, paint a swatch on a piece of paper, hold it up against the color to be matched, and adjust it as necessary.

Paint has a sheen while still wet.

It dries matte, and the color darkens.

ORGANIZING YOUR PALETTE

Do not set out your colors in a random way, squeezing out whichever one comes to hand. Decide on a sequence of colors, and repeat the same order every time you paint. This makes it simpler to find and identify a color, especially the dark colors, which look similar in undiluted blobs and can easily become jumbled. The order you choose is up to you; different artists have different ways of setting out their colors. On this palette, the two browns are placed first; then yellow ocher, which is more brown than yellow; the two greens; the yellows; the reds; the blues; Davy's gray; and finally black. The white is kept separate to avoid contamination with the colors.

This suggested palette contains 13 colors, plus white, black, and gray, which is more than adequate for most subjects. The range of mixtures you can achieve with these colors is shown on page 52. If you want to reduce the initial expenditure, omit gray, cerulean blue, and cobalt green.

Cadmium lemon

Cadmium yellow deep

Yellow ocher

Cadmium red medium

Permanent alizarin crimson

Dioxazine purple

Ultramarine blue

Phthalo blue green shade

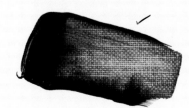

Cerulean blue

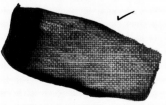

Cobalt green light

Chromium oxide green

Raw umber

Burnt umber

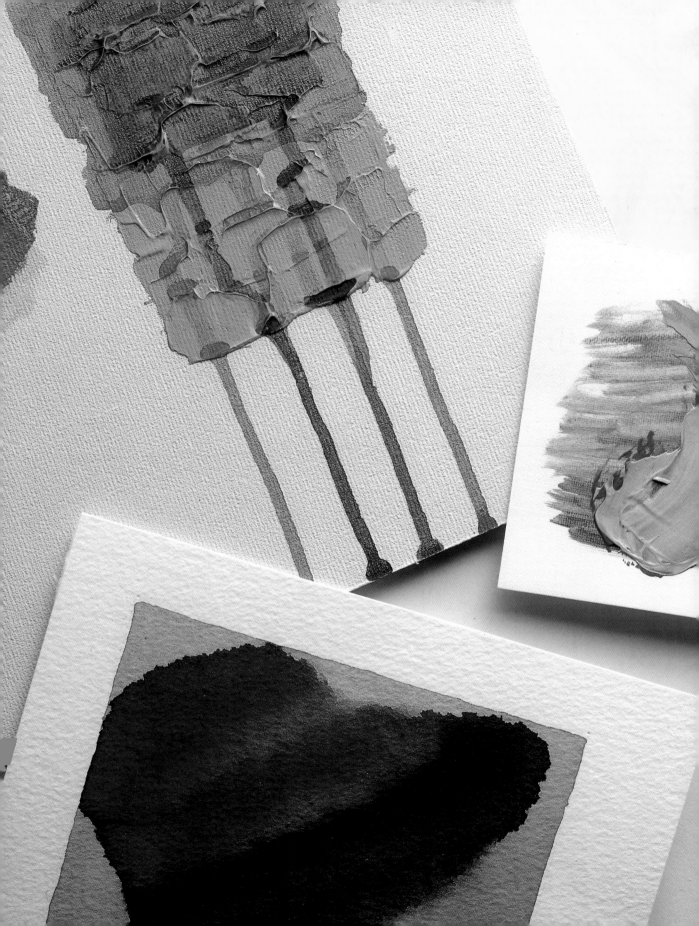

2
Getting to Know the Paints

Thin Paint

I f you are new to acrylics, it is a good idea to become familiar with them by experimenting on some inexpensive water-color paper before you embark on a painting. Start by exploring the different consistencies of paint. Dilute it with water, so that it resembles watercolor, and then progress to thicker applications, as shown on the following pages. This will help you discover the qualities of the paints and begin to find out how you might prefer to work.

By starting with water-thinned paint and no additional white, you will learn a lot about the colors themselves and how they differ. Set out all the starter palette colors, mixing each one with water in roughly half-and-half proportions. You will see that some colors are naturally much darker than others, and some have a slightly chalky consistency.

Next, explore ways of applying the paint. Make a flat wash by taking color over the paper with a broad brush. Then grade the wash from dark to light by adding more water for each stroke. Try the effect of sweeping diagonal strokes, and of dabbing color onto the paper with the tip of a round brush. Lay one color over another to create mixtures, or dampen the paper so that the colors mingle.

Each of the starter palette colors (see p.29) mixed with water in half-and-half proportions. The darker colors need more water added to create a paler shade.

A flat wash made by taking a broad brush from one side to the other, then recharging it for the next and each subsequent stroke.

A wash graded from dark to light by adding more water for each stroke.

Sweeping strokes, with each brushmark pulled out toward the end.

Crisp edges are created by laying one color over another after the first has dried.

A new color dropped into one that is still wet, with the paper first dampened.

Color blends created by dabbing one color over another, using the point of the brush.

ADDING WATER

It takes a little practice to learn how much water to add to a color to lighten it, so when you are painting, it is wise to test mixtures on a spare piece of paper. Some colors are so dark that to produce a pale shade you will need more water than paint. These examples show phthalo blue, a very strong color, and yellow ocher, a relatively weak one, mixed with varying quantities of water. The color at the top in each case is the pure tube color applied with a lightly moistened brush.

Pure tube color

25 per cent water

50 per cent water

75 per cent water

Medium-thick Paint

Used straight from the tube, the paint remains transparent.

It becomes opaque when white is added.

GETTING TO KNOW THE PAINTS

The tube consistency of acrylic paint is similar to that of heavy cream, so it can be used without the addition of water. However, a little water is helpful when mixing colors, because it encourages them to blend together, and it also makes the paint easier to spread when you are covering large areas.

For this exercise, utilize a minimum of water, dipping the tip of your brush into your water jar and then into the paint. For the transparent applications on the previous pages, colors were made lighter by adding extra water, but when transparency is not required they are lightened with white, which causes them to become more opaque.

As before, work on watercolor paper, and experiment with different ways of laying on the paint, from flat applications over large areas to more complex effects achieved by using one color over another. Try the colors straight from the tube, and then mixed with varying amounts of white.

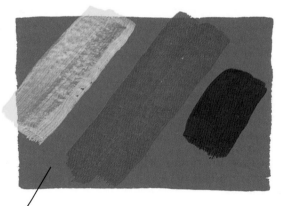

Brushstrokes of straight tube color over flatly applied opaque color.

Three similar blues blended by using short, dabbing strokes.

Two colors worked together while still wet.

Ultramarine dabbed on with a small square brush. Crimson laid on top in the same way.

MEDIUM-THICK PAINT

COVERING POWER

Although acrylic is technically an opaque paint, the colors will retain much of their transparency unless mixed with white, so a pure red or blue will not completely cover an earlier color. This is one of the medium's most attractive features, since it allows you to build up effects in layers, with each color showing through the next. But it can be a disadvantage. When you start on real paintings, remember not to make any initial brush or pencil drawing too dark, or you may be unable to paint it out.

Paint used with a minimum amount of water and no added white. Colors running downward applied first.

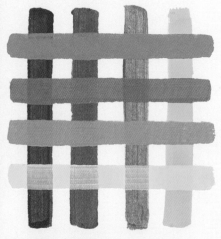

Pure colors running downward, overlaid with the same colors mixed with white. Covering power is much greater.

Thick Paint

By now you will have discovered how rapidly acrylic paint dries. Even at medium consistency it will harden within about 15 minutes, and less if you are working on an absorbent surface, such as watercolor paper. But really thick paint takes much longer to dry (approximate drying times are given in the examples here). This allows you to blend and mix colors on the surface by laying them next to, or over, one another while still wet, a method used by many oil painters. You can also build up rich impastos (see p.64), exploit brushwork to the fullest, and apply paint with a painting knife (see pp.22 and 66).

For these experiments, it is best to use a primed canvas board, which is nonabsorbent and keeps the paints wet for longer. Try one of the mediums made for bulking out the paint (see p.26) to avoid using up too much color. The medium also causes the paint to become more transparent. You can create unusual effects by laying this thick but transparent paint over other colors.

Paint straight from tube. Green, yellow, and blue blended together while still wet. Drying time 1 hour.

Paint mixed with impasto medium becomes thicker but retains its transparency. Drying time 2 hours.

Tube consistency yellow, overpainted with green mixed with impasto medium. Some of the yellow shows through. Drying time 2 hours.

36

Paint mixed with impasto medium and applied with a knife. Drying time 3–4 hours.

Tube-consistency paint incompletely mixed, so that brushstrokes contain several colors. Drying time 1 hour.

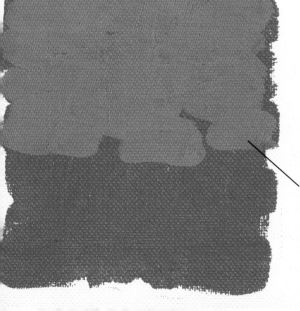

Building up thickness by laying one coat of tube-consistency paint over another. Drying time between each application ½ hour.

COVERING POWER

Unless applied heavily with a knife, even thick paint does not always obscure an underlying color, especially if the earlier color is dark or vivid. But you can obliterate a color by painting over it with thick white and allowing it to dry before applying the new color. This is useful when a bright color seems to be losing its clarity because a dark hue is showing through.

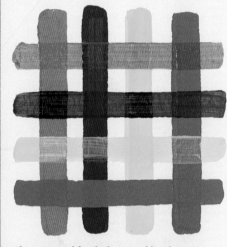

The paint used for the horizontal bands is thick, but a little color from the vertical bands shows through. Only the chrome oxide green covers them completely, because this is a more opaque pigment than the others.

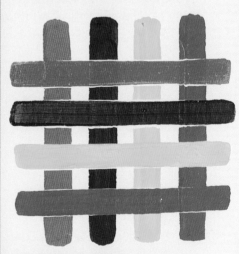

Each of the horizontal bands was given an undercoat of thick white. None of the first colors can be seen through the new ones.

Combining Thick and Thin Paint

This is where you will find out why acrylic is such a special medium. There is only one other paint that allows you to combine different consistencies in the same painting, and that is oil paint. But thin oil paint over thick can cause cracking, so is not advisable. There is no such danger with acrylics, where you can paint heavy impastos over watery washes, and vice versa.

But there is one caution. When you are painting over a very thick application, such as one applied with a knife, make sure that the paint is thoroughly dry or you could scuff the surface. You can judge this easily: the paint is dry when it has lost its gloss. Drying times vary from around one to three hours, depending on the thickness. The captions opposite give approximate times as a guide.

Thin, transparent washes laid over other colors are known as glazes (see p.70), and there are mediums sold especially for this kind of work (see p.26). Glazing can be done simply by thinning the paint with water, but it is worth trying the mediums, since they give extra body to the glaze, hold the marks of the brush, and prevent the thin paint from running down the paper. If you apply a water glaze with the working surface held vertically, it will dribble down, which can be effective — but is not always the effect you want.

Knife-applied paint over swept brushstrokes of thin, transparent purple. Drying time of thick paint 2–3 hours.

Watercolor-type wash overlaid with medium-consistency opaque blue and then thicker knife-applied blue. Drying time of knife work 2–3 hours.

Brushstrokes of pink mixed with acrylic matte medium, laid over green straight from the tube. Drying time 5 minutes.

Although transparent glazes will not cover a color beneath — this is not their purpose — they can significantly affect the color. A glaze of yellow, for example, gives a greenish tinge to blue. Colors can also be lightened by glazing; here the black at bottom right has become gray.

For the horizontal bands, color was mixed with acrylic matte medium.

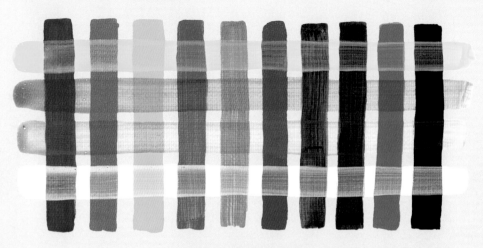

A glaze of yellow mixed with gloss medium, laid over thick, opaque color. Drying time ½ hour.

Thickened paint applied with a knife, glazed over with water-thinned crimson and then blue. Surface held upright, so that the runny paint settles above the ridges. Drying time for knife work 3 hours.

Brushwork

Large square and medium square brushes. These brushes make brick-like marks.

Some artists like to apply colors flatly or very smoothly, with no visible brushmarks. But in most paintings, the marks of the brush and the way the paint is applied contribute as much as color and composition to the overall effect. Beginners often ignore this aspect of painting. Instead, their first concern is the accurate representation of the subject. But brushwork is very important, as a painting can be spoiled easily by sloppy brushwork.

Your brushes are your working tools, and the task of visual description becomes easier and more satisfying when you choose the right one for the job. Size is one consideration. There is also a variety of different shapes (see p.22), and you need to become familiar with their possibilities.

Working on a smooth surface, such as acrylic sketching paper or primed board, try out all your brushes to see the kinds of marks they produce. Practice different ways of holding them, making sweeping strokes with the brush held near the end, and smaller, tighter ones holding it near the ferrule — this gives you maximum control, and is the grip to use for details, where accuracy is important. If you have both nylon and bristle brushes, you will find nylon best for laying flat color, while bristles give a more rugged texture.

A filbert brush produces a more rounded stroke, which can be graded to a point by reducing pressure at the end of the stroke. The brush can also be used on its side.

A round-ended brush makes small dabs and dots, or lines that can be varied from thick to thin by increasing or decreasing the pressure.

Sweeping strokes made with a bristle filbert held loosely near the end.

A medium round brush held at the end vertically, with the surface horizontal.

A small, pointed nylon brush held loosely in the middle.

The smallest pointed nylon brush held tightly at the ferrule.

Paint laid on flat with a large square nylon brush recharged after each stroke.

Medium-size flat bristle brush used with dabbing motion and held near ferrule.

SPONGING

A small natural sponge forms part of the equipment of many watercolor painters, and it can also be useful for acrylic work. Thin or medium-consistency paint can be laid on flatly with a sponge — a quick way of coloring a large area. You can also dab on paint to create textured effects, working one color over another. Wash the sponge immediately after use, since the paint will rapidly harden on it.

Medium-consistency paint laid on flatly with a sponge.

Medium-consistency paint dabbed on with a sponge.

Testing Surfaces

The kind of surface you work on makes a great difference to the handling of the paint and to the appearance of the finished work. The paint will glide over a smooth surface, such as primed matt board or masonite, while the rougher, porous texture of canvas or watercolor paper breaks up the brushmarks, because the paint catches on the raised grain. It takes longer to cover a textured surface than a smooth one, because you have to push the paint into it. But these surfaces are ideal for broken-color techniques (see p.62), because they enable you to apply a color that only partially covers one beneath.

The other main difference between the various surfaces is their degree of absorbency. Any surface that is not primed (see pp.19 and 21) will absorb the water content of the paints, so that it dries fast. Priming reduces the absorbency by forming a barrier between the paper surface and the applied color. Primings vary also, and some of the factory-primed canvases and boards have a slippery surface, which some people like and others find difficult to paint on. What these surfaces have in common is that they are porous. Non porous surfaces — glass, plastic — will not take acrylic paint.

The choice of surface depends upon your method of working, so the only way to discover what suits you is by trial and error. If you painted in oils before, and want to use the same techniques, canvas or canvas board are obvious choices. If you previously used watercolors, continue with watercolor paper for the time being. But if you are new to painting, with no prior experience to guide you, try out as many surfaces as possible, starting with the inexpensive ones, such as masonite, matt board, and paper.

UNPRIMED WATERCOLOR PAPER
Thinned paint spreads easily, but thicker paint needs to be worked into the surface.

PRIMED WATERCOLOR PAPER
The priming makes it easier to spread medium-thick paint, but thin paint does not go on so evenly.

PASTEL PAPER
The slight texture makes it a good choice for gouache-type effects. Should be stretched before use, or may buckle.

ACRYLIC SKETCHING PAPER
Nonabsorbent, slightly slippery. Difficult to apply flat paint, but shows brushmarks well.

PRIMED MASONITE, ROUGH SIDE
Not a common choice, but worth trying for thick applications. Heavy texture can be reduced by sanding.

PRIMED MATT BOARD
Easy to spread paint, ideal for smooth paint applications and glazing methods.

PRIMED CANVAS
Traditional surface for oil-painterly effects, but also takes transparent color well.

PRIMED MASONITE
Nonabsorbent. Easy to spread paint, but thinned paint forms streaks.

CANVAS BOARD
Primed during manufacture. Cheaper than ready-made canvas.

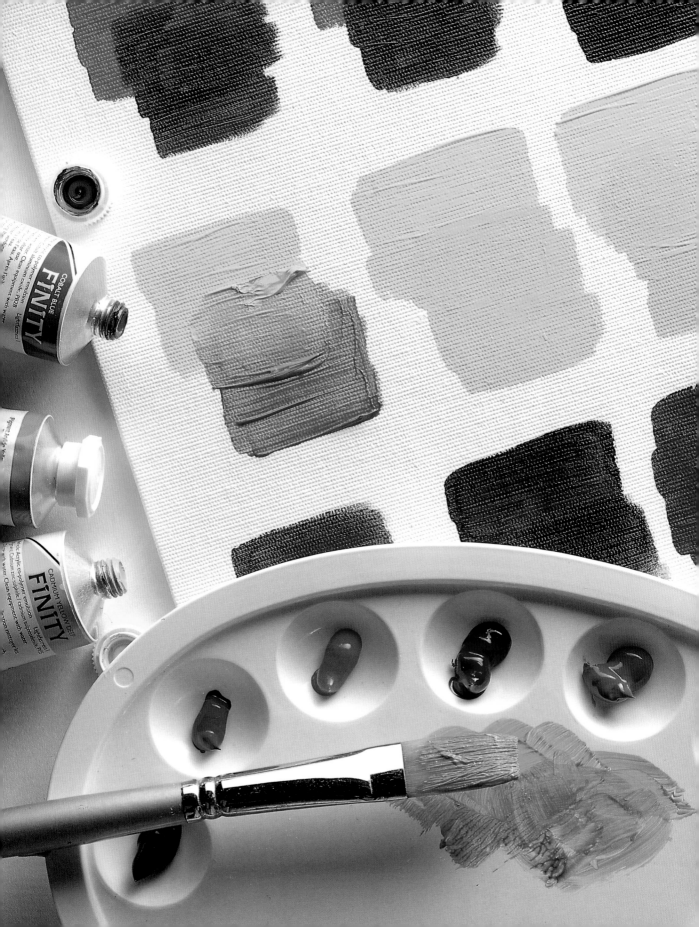

3

Color

Primary and Secondary Colors

One of the most important skills is mixing paint colors to match those you see in the subject. To some extent this will come with practice; when you have been painting for a while you will begin to evaluate colors in terms of the pigment or mixture that most closely resembles them. Instead of seeing a sky as simply blue, you will view it more specifically — perhaps as a mixture of cerulean blue and ultramarine. The first stage in successful color mixing is to become familiar with your paints.

THE COLOR WHEEL

Red, blue, and yellow are known as primary, because they cannot be produced from mixtures of other colors, and are completely unlike one another. On the color wheel, which is the standard device for showing color relationships, they are placed at equal distances from one another. Between them lie the secondary colors — orange, green, and purple — which are made from mixtures of two primaries.

The first version of the wheel, at top right, has only three primary colors, because these are all the printing process requires to produce a huge range of mixtures. But the painted wheel has variations of each primary, because in artist's pigment there is no such thing as a pure red, yellow, or blue. That is why the recommended starter palette (see p.29) contains more than one of each. So to mix a secondary color, you must first decide which version of each primary to use for the shade you want. For example, red and blue make purple, but cadmium red mixed with any of the blues will lend it brownish hues; cadmium red and cadmium yellow will make a vivid orange; but lemon yellow and crimson will produce an orangey brown.

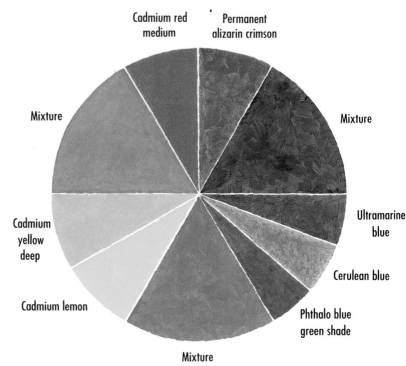

PRINTER'S COLOR WHEEL

This six-color wheel, made with printing inks, shows the three primary colors and three secondary colors, which are mixtures of the primary on either side of them. The wheel could be extended to 12 or even 24 colors showing a wider range of secondary color mixtures, but there would still be only three primaries.

PIGMENT WHEEL

This painted wheel, made with the selection of primary colors given for the starter palette (p.29) shows that they do not all correspond with the pure primary values of the printed wheel. The secondaries are mixtures of the primaries on either side, but of course, a much larger selection could be achieved by varying the primary components. Some possible mixtures are shown opposite.

MIXING SECONDARY COLORS

The painted wheel opposite shows that the reds, yellows, and blues all have a slight bias toward one of the secondary colors. Ultramarine, for example, veers toward red, and phthalo blue toward green. The most vivid secondary colors are made by mixing the pair of primaries with a bias toward each other, while more muted hues are produced by pairing those with an opposite bias. In each of these charts — except the one for the green mixtures, which contains two pairs of "like" primaries — the top row shows two "like" primary colors with the secondary mixture, and below are mixtures of "unlike" primaries. The latter can provide some useful ideas for greens and browns, where you often want subtle rather than vivid colors. The range can be extended by varying the proportions of the colors.

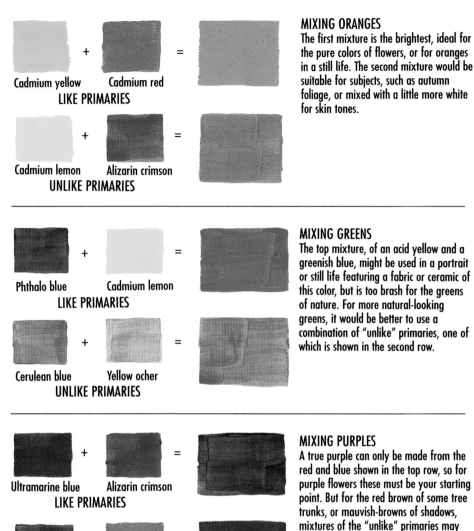

Cadmium yellow + Cadmium red =
LIKE PRIMARIES

Cadmium lemon + Alizarin crimson =
UNLIKE PRIMARIES

Phthalo blue + Cadmium lemon =
LIKE PRIMARIES

Cerulean blue + Yellow ocher =
UNLIKE PRIMARIES

Ultramarine blue + Alizarin crimson =
LIKE PRIMARIES

Ultramarine blue + Cadmium red =
UNLIKE PRIMARIES

MIXING ORANGES

The first mixture is the brightest, ideal for the pure colors of flowers, or for oranges in a still life. The second mixture would be suitable for subjects, such as autumn foliage, or mixed with a little more white for skin tones.

MIXING GREENS

The top mixture, of an acid yellow and a greenish blue, might be used in a portrait or still life featuring a fabric or ceramic of this color, but is too brash for the greens of nature. For more natural-looking greens, it would be better to use a combination of "unlike" primaries, one of which is shown in the second row.

MIXING PURPLES

A true purple can only be made from the red and blue shown in the top row, so for purple flowers these must be your starting point. But for the red brown of some tree trunks, or mauvish-browns of shadows, mixtures of the "unlike" primaries may be more satisfactory.

DIFFICULT COLORS

Although you can mix most of the secondary colors you need from two primaries, some ready-made secondary colors are stronger and brighter than those you can mix. It is almost impossible to mix a purple to equal the intensity of the various tube purples, and the tube version of cadmium orange is more vivid than a yellow-red mixture. The starter palette includes one purple, but you may find in time that you need another, along with an orange, especially for floral subjects.

Mixture of crimson and ultramarine

Tube color: Dioxazine purple

Mixture of cadmium red and cadmium yellow

Tube color: Cadmium orange

Neutral Colors

COLOR

The range of unobtrusive browns, grays, and beiges classed as neutral are important in painting, because they set off the other colors and make them appear brighter by contrast. They can be more difficult to mix than secondaries for three reasons. First, they often involve mixing more than two colors; neutrals are also known as "tertiary," because they typically have three color components. Second, they are often hard to identify in terms of paint colors, and sometimes even to name. The third reason is that they are affected by surrounding colors. A bluish or purplish gray that seems right on the palette may look too bright when placed next to an even more neutral color.

This is because none of these colors conforms to the dictionary definition of neutral, i.e., without bias. The only true neutrals would be black and white, which are not classed as colors, and gray that is a mixture of the two. In painting and in nature the so-called neutrals all have a color bias. Gray will rarely be a straight mix of black and white; it may have a blue, mauve, or brown tinge. Browns may veer toward red, green, or blue; and beiges toward pink or yellow.

MIXTURES

You can make neutrals by adding small quantities of color to black or brown, but this can give dull results. Neutrals with more character can be achieved by mixing the three primary colors — or one primary color and one secondary, which is in effect the same thing, a combination of three colors. Some of these mixtures are shown opposite, but there are many other possibilities. Artists develop their own recipes for making neutrals, so make a note of any successful mixtures.

THREE-COLOR MIXTURES

Because the primary colors are unlike one another, a mixture of all three in equal proportions produces a neutral. If you want a neutral with a more positive color bias, increase the quantity of one of the colors. To lighten the shade, add white, or water if you are using transparent paint.

EXAMPLE ONE

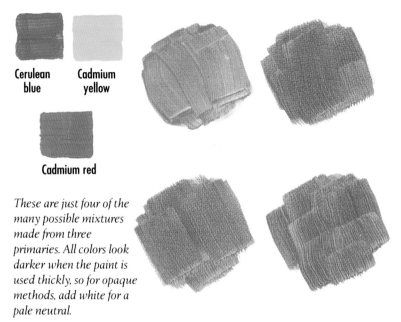

Cerulean blue

Cadmium yellow

Cadmium red

These are just four of the many possible mixtures made from three primaries. All colors look darker when the paint is used thickly, so for opaque methods, add white for a pale neutral.

EXAMPLE TWO

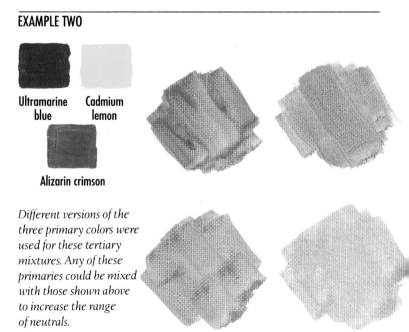

Ultramarine blue

Cadmium lemon

Alizarin crimson

Different versions of the three primary colors were used for these tertiary mixtures. Any of these primaries could be mixed with those shown above to increase the range of neutrals.

48

NEUTRALIZING WITH GRAY

Davy's gray is a color specially formulated for the purpose of toning down, or neutralizing, colors. This is useful if you want to reduce intensity but do not want a true neutral. Davy's gray is one of the more transparent pigments, so if you are using opaque paint rather than the transparent color shown here, you may need to add a little white also.

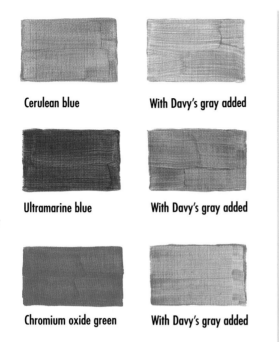

Cerulean blue — **With Davy's gray added**

Ultramarine blue — **With Davy's gray added**

Chromium oxide green — **With Davy's gray added**

RELATIVE VALUES

These examples show how colors are affected by neighboring hues. The neutral colors look less neutral when seen against a gray made by mixing black and white than when juxtaposed with vivid colors. When you paint, apply some of the brighter colors before mixing the neutrals, so that you have something to judge them against.

A brownish neutral against orange — **The same neutral against gray**

A green-gray neutral against blue — **The same neutral against gray**

The colors that are opposite one another on the color wheel (see p.46) are known as complementary colors. There are three pairs of these: red and green, blue and orange, yellow and violet, each comprising one primary color and one secondary. Juxtaposing these colors in a painting creates vibrant, sometimes startling effects, but when mixed together they cancel each other out, and are therefore a quick way of mixing neutral browns and grays. By varying the proportion of complementary colors, an extensive range of tertiary mixtures can be produced.

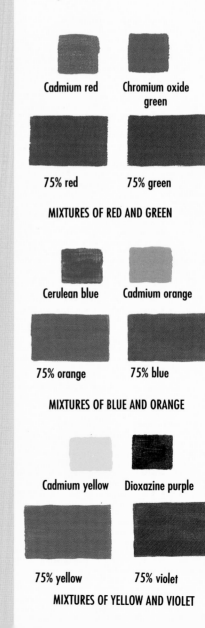

Cadmium red — **Chromium oxide green**

75% red — **75% green**

MIXTURES OF RED AND GREEN

Cerulean blue — **Cadmium orange**

75% orange — **75% blue**

MIXTURES OF BLUE AND ORANGE

Cadmium yellow — **Dioxazine purple**

75% yellow — **75% violet**

MIXTURES OF YELLOW AND VIOLET

Light and Dark

The word "tone" describes the lightness or darkness of a color, regardless of its hue. All pure colors have an intrinsic tone. Reds are much darker than yellows, and the blues and purples (with the exception of cerulean blue) are darker still. You will often need to lighten these darker colors. Applying undiluted ultramarine blue for a sky, for example, would not create a realistic effect.

When you use the paint opaquely, you can lighten colors by adding white. For transparent watercolor effects, water performs the same function; the more diluted the paint, the paler the color. But some colors cannot be lightened without changing their character. Red becomes pink when mixed with white, so to create highlights on a red object it is sometimes better to add yellow.

Using black to darken colors can also change them. It does not affect the nature of blues and purples, and works well for the neutral colors, such as browns and grays, but it can have unexpected effects, changing yellow into green, and red into brown.

As you can see from these swatches, you cannot successfully darken red or yellow with black, but you can achieve some useful mixtures. Yellow and black produces a rich range of greens.

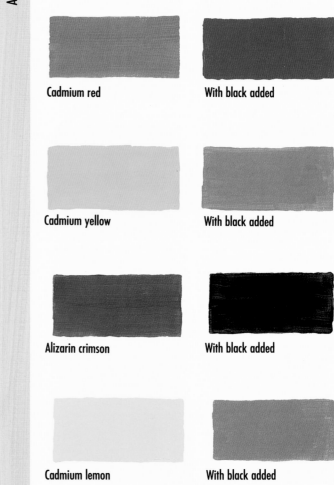

Cadmium red With black added

Cadmium yellow With black added

Alizarin crimson With black added

Cadmium lemon With black added

When you want to mix a very light color, such as pale pink or blue, always start with white, adding small amounts of color until the tone is right. The pure colors are much stronger than white, and if you work the other way around you may have to use a large quantity of white to counteract their effect.

Pick up a small amount of the darker color with the tip of the brush. Mix it in well, adding more paint if needed.

50

MAKING COLORS LIGHTER

These swatches (right) show each of the starter palette colors mixed with varying amounts of white. As you will see, adding white to lighten colors has some interesting effects. Red loses its redness, and the intensity of yellows and greens is reduced. The same applies when you add water for transparent applications. But purple and ultramarine blue become more intense when a little white is added. This is because they are naturally dark-toned, looking almost black if thickly applied, and a slight lightening makes the colors emerge more clearly.

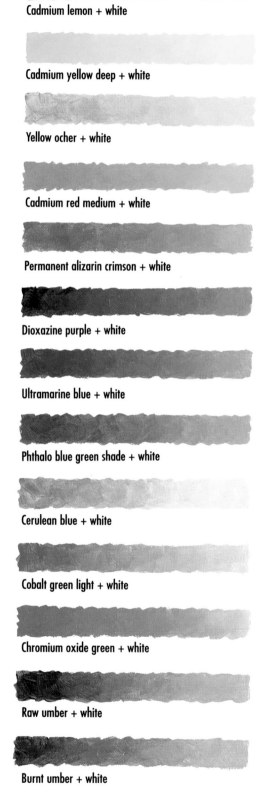

Cadmium lemon + white

Cadmium yellow deep + white

Yellow ocher + white

Cadmium red medium + white

Permanent alizarin crimson + white

Dioxazine purple + white

Ultramarine blue + white

Phthalo blue green shade + white

Cerulean blue + white

Cobalt green light + white

Chromium oxide green + white

Raw umber + white

Burnt umber + white

DARKENING WITH OTHER COLORS

For the colors that cannot be mixed with black, achieve deeper tones by mixing in a darker related color.

Add dioxazine purple to alizarin crimson

Add yellow ocher to lemon yellow

Add burnt umber to cadmium red

LIGHTENING WITH OTHER COLORS

If you do not want to use white, lift the tone by mixing in a related but lighter-toned color.

Add cerulean blue to ultramarine blue

Add lemon yellow to yellow ocher

Add yellow ocher to raw umber

Two-color Mixtures

COLOR

When colors are mixed, they become reduced in intensity, that is, less brilliant. A mixed secondary or tertiary color is seldom as bright as any of its components. That is why most art teachers recommend mixing no more than three colors. When beginning artists fail to achieve the color they want, they sometimes panic and mix four or five different colors, which usually results in muddy-looking colors.

Unless you are mixing neutral colors (see p.48), it is wise to restrict yourself initially to two-color mixtures plus white. You will be surprised at how many hues, or gradations in color, you can achieve with the starter palette colors. A selection of possible mixtures is shown here, but you can extend the range considerably by varying the proportions of the colors and adding different amounts of white. If a color does not look right when you apply it, remember that you can alter it later with transparent glazes or washes of water-diluted paint (see pp.54 and 70). The method of mixing colors on the working surface is shown on the following pages.

STARTER PALETTE MIXTURES
The chart shows a range of two-color mixtures you can achieve with the colors in the starter palette. The 13 starter palette colors are shown on the first row, first from the tube and then as a 50:50 mix with white. The rest of the chart shows each of the colors mixed with the other starter palette colors, and also the same mixtures with white added. You can create more colors by varying the proportions of the mixtures and by adding varying amounts of white.

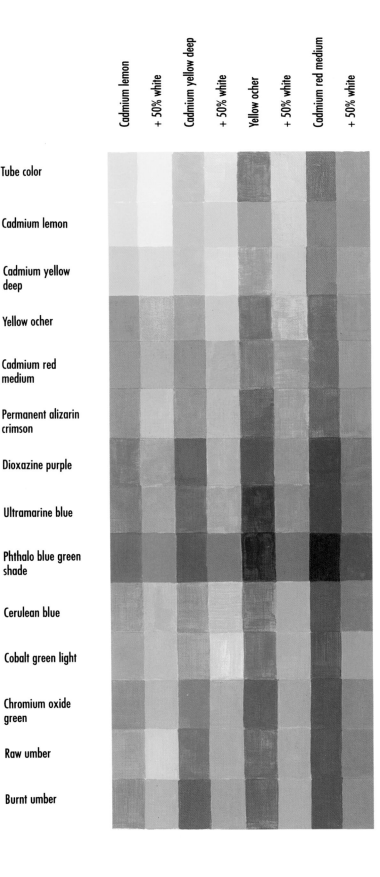

Column headers: Cadmium lemon | + 50% white | Cadmium yellow deep | + 50% white | Yellow ocher | + 50% white | Cadmium red medium | + 50% white

Row labels:
Tube color
Cadmium lemon
Cadmium yellow deep
Yellow ocher
Cadmium red medium
Permanent alizarin crimson
Dioxazine purple
Ultramarine blue
Phthalo blue green shade
Cerulean blue
Cobalt green light
Chromium oxide green
Raw umber
Burnt umber

Permanent alizarin crimson

+ 50% white

Dioxazine purple

+ 50% white

Ultramarine blue

+ 50% white

Phthalo blue green shade

+ 50% white

Cerulean blue

+ 50% white

Cobalt green light

+ 50% white

Chromium oxide green

+ 50% white

Raw umber

+ 50% white

Burnt umber

+ 50% white

Surface Mixing

In watercolor painting the stronger tones and colors are built up gradually, by applying successive transparent layers of color over one another. The same applies to acrylic, when used in watercolor mode (see pp.76-77). You are, in effect, mixing colors on the working surface.

This does not eliminate the need for premixing on the palette, since there are limitations to surface mixing. You can make colors darker, richer, or more muted, but you cannot make them lighter, because you are dealing with transparent paint. Although you can mix secondary colors on the surface — laying blue over yellow to make green, for example — it would be laborious to rely on this method for an entire painting. It can be effective in small areas: for example, you could paint a tree by laying a yellow wash and working over it with different strengths of blue. Make sure that you select the correct primary colors for this (see pp.46-47). It is a good idea to try out the effect first.

AMENDING COLORS

Transparent color overlays are not restricted to watercolor-mode painting. They are also useful when you need to alter color balances in an opaque painting. Instead of overpainting with additional opaque color, you can apply a watery wash. Use this to add a hint of blue to a shadow or increase the depth of color in a sky. You can change colors most by laying dark colors over light, but you can also make a noticeable difference by working light over dark. A yellow wash over a green tree or field will produce a distinct color variation.

SECONDARY COLOR MIXES

Although you would be unlikely to use the surface mixing method for every secondary color in a painting, you might consider it for certain areas, because it creates interesting effects. Mixing a green from blue and yellow in the palette will achieve a smooth blend, but as you can see here, when you overlay colors the brush deposits the color unevenly, producing a hue that varies in intensity within each brushstroke.

Phthalo blue laid over cadmium lemon

Ultramarine blue laid over alizarin crimson

Cadmium red laid over cadmium yellow

BUILDING UP TONES

When you use transparent paint you can darken colors and tones, but you cannot make them substantially lighter. So for watercolor effects (p.76) you must build up the deeper tones by means of successive overlays, as shown here.

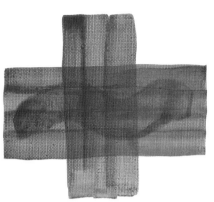

Three separate applications of ultramarine

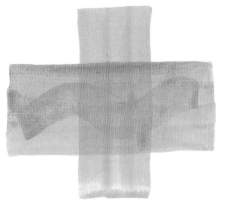

Three separate applications of cadmium red

CHANGING THE HUE

The nature of a color can be altered either radically or subtly by means of color overlays. You can also lift the tones to some extent. The cadmium lemon applied over the green in the first example lightened and intensified it.

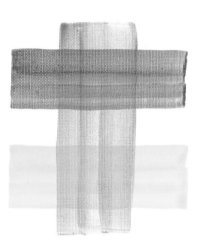

Blue and yellow laid over green

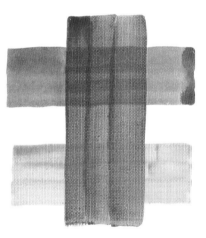

Purple and green laid over blue

TRANSPARENT OVER OPAQUE

Do not reject the possibilities of transparent color overlays even if you are working mainly with opaque techniques. If a color looks dull, try laying a vivid hue over it, covering the entire area or selected parts.

Phthalo blue over an opaque, heavy gray

Cadmium lemon over an opaque, muddy green

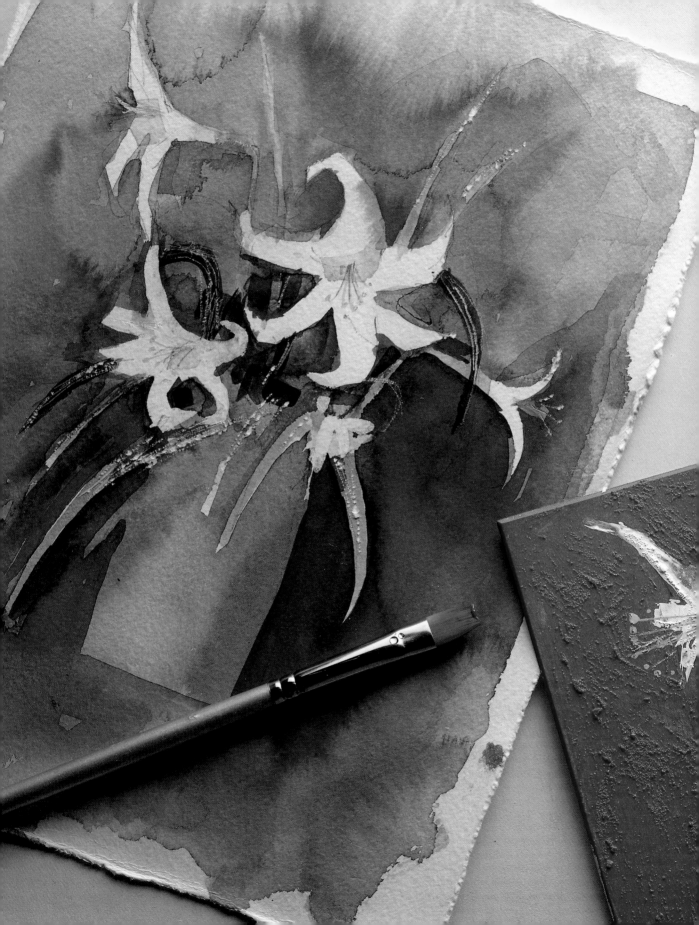

4
Ways of Painting

Opaque Techniques

Acrylic paint is often used as an opaque paint, which means that a layer of color will cover the one beneath it. Anyone who has tried oil or gouache paints, both of which are opaque, will probably find this a natural way of working, since it allows you to correct errors and make changes as you go along.

Acrylic applied to paper at medium consistency — straight from the tube or thinned with just a little water — superficially resembles gouache, but is much easier to use. Gouache paint remains water-soluble even when dry, so there is a risk of muddying the colors by layering one over another. There is no such problem with acrylic; you can overpaint as much as you like, because once dry, the paint forms an impermeable "skin."

There are many ways of working in oils, but typically, oil paintings are done on canvas and characterized by thick paint and visible brushwork. One of the basic rules of oil painting is to build up paint gradually. This is because thin paint applied over thick may cause cracking, and although this will not happen with acrylic, it is a useful rule to follow, at least initially. You may want to make corrections by overpainting, and the texture created by brushstrokes of thick paint can be difficult or impossible to obliterate.

GOUACHE EFFECTS

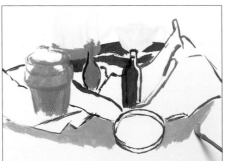

1 Work on watercolor paper, and mix the paint with a little water to help it spread easily. Apply separate areas of color initially; amend them by overpainting later if necessary.

2 When you have completed the blue bottle and background, paint the cloth with slightly thinned purple, and use the same purple mixed with white, for the highlights. In opaque techniques you can paint light over dark.

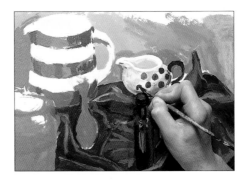

3 After completing the bottle and striped pitcher, you can judge the strength of the blue needed for the spotted pitcher. Use similar blues for this, but vary the tones so that the spots are darker on the right, where the rounded form turns from the light.

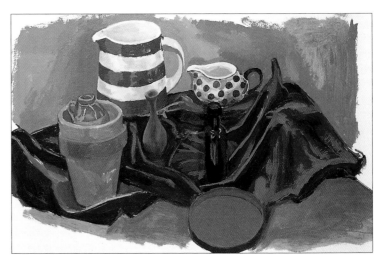

FURTHER IDEAS

For gouache effects, you can use the paint at the same consistency throughout, or build up some areas more thickly, either to give additional emphasis, or to provide a contrast of paint textures. The background of a still life or portrait is often painted thinly, as this helps to create the impression of receding space.

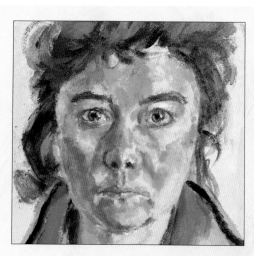

Transparent washes are used for the background and parts of the face; the hair and highlights are more thickly applied.

OIL PAINT EFFECTS

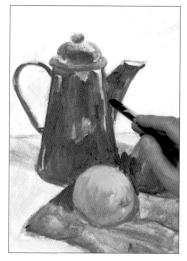

1 *Work on canvas, and begin with thinned paint. Block in the main shapes only at this stage; the pattern on the pitcher can be painted over the basic blue, and details, such as highlights on the fruit, are best left until last.*

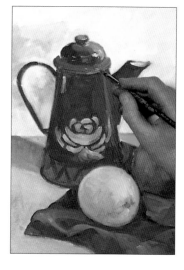

3 *Still using the paint thickly, add touches of crisp definition to the lid of the pitcher, taking the red carefully around the ellipse. A small filbert brush is a good choice for this detailed work. An alternative would be a pointed round brush.*

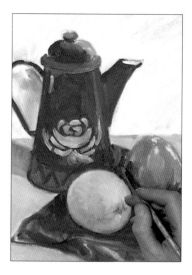

2 *Paint the pattern next, using the paint unthinned so that the light pink and green cover the blue beneath. Continue to build up the colors. Take dark blue paint around the side of the apple to sharpen up the edge.*

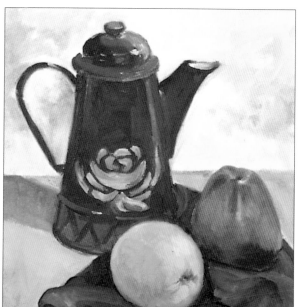

Painting on a Colored Ground

WAYS OF PAINTING

Artists often color their canvas or paper before starting a painting, and there are two good reasons for this. The first is purely practical; white can be difficult to work on. In nature you seldom see any pure white, because white, more than any other color, is altered and modified by the effects of light. Thus by providing an artificial comparison, a white surface makes it difficult to assess the first colors you lay down.

You will quickly find this out if your subject includes a number of pale tones. The blue of a wintry sky, although substantially paler than shadows or tree branches, is still much darker than pure white, so even a correctly mixed pale blue will look too dark initially. If you work on a middle tone, such as gray or light brown, it is easier to work up to the lights and down to the darks.

LETTING THE GROUND COLOR SHOW

The second reason for coloring the ground is that it will influence the overall color scheme of your picture and can set up exciting contrasts. Artists often choose a color for the ground that is the opposite of the dominant color in the painting. For example, a dark yellow will set off the blues in a flower painting, or a red underpainting may contrast well in a green summer landscape. If you use the paint thin or at medium consistency, the ground will show through, creating vibrant passages of color.

If you prefer to work thickly, in oil-painting mode, you can leave small patches of the ground color showing between and around brushmarks, which achieves a lively broken-color effect (see pp. 62–63).

COLORING THE GROUND

Laying a ground color is simplicity itself, all you do is paint a color over the entire surface using a broad brush. If you prefer to use the paint in a series of thin layers, either on paper or canvas, a transparent color might be best, using well-diluted paint. You can also use thick paint, vigorously working it into the surface so that it provides a slightly rough texture.

PAINTING ON A RED GROUND

1 *Apply a cadmium red ground, as shown above, and leave it to dry. Then paint the dark blue-green of the hills, using the color thinly, so that it does not obliterate the red.*

2 *The red ground is a middle tone, which helps you to judge both the dark and light tones. Paint some of the yellowish foreground next, so that the extremes of light and dark are established.*

3 *Still using the paint thinly, suggest the shapes of the trees and strengthen the blue-gray tones of the distant hills, which will contrast with the more vivid light and dark greens of the trees.*

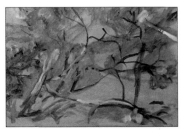

4 *Begin to build up the foliage with a variety of greens, using the paint unthinned. The contrast between the thin and the thick paint creates an impression of space and depth, because the full-bodied paint "advances" to the front of the picture.*

A rag spreads the paint thinly so that a strong color, such as the red used here, becomes paler.

A broad brush, used with medium-consistency paint, makes a series of striated marks that provide added interest to the painting.

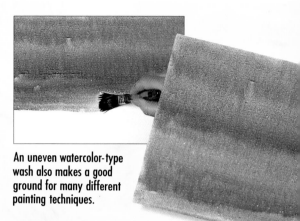

An uneven watercolor-type wash also makes a good ground for many different painting techniques.

5 *The foreground branches need to stand out more strongly than those behind and above, so again use thick paint. Avoid a detailed treatment; use a medium-size round bristle brush and let it "follow" the shapes and direction of the branches.*

6 *Trees are seldom a solid mass of green; there are small gaps where light shows through the foliage. In opaque techniques, you can add these last. Use medium-consistency white paint to make dabs that suggest "sky holes."*

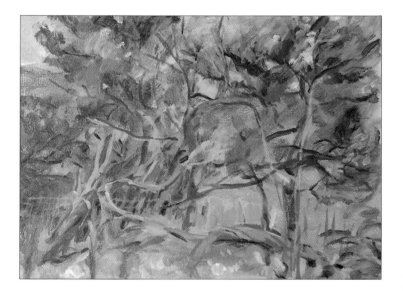

FURTHER IDEAS

Whatever your subject, you can use a colored ground as a starting point. First decide what the overall color scheme is to be, because the ground will influence the applied colors.

A traditional ocher ground helps to warm up the whites, and contrasts well with the blue of the sea.

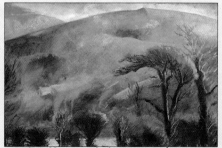

A medium-blue ground, also on watercolor paper, was used for a landscape using harmonies of blue and yellow.

Broken Color

When a color is built up by juxtaposing brush-strokes of different colors, instead of being applied flatly, the result is described as broken color. You might paint a sky, for example, in various blues and mauves, with each patch of color remaining separate, or a tree with a selection of greens, blues, violets, and yellows. When the painting is seen at a distance, the colors will mix in the viewer's eye, an effect known as optical mixing. They read as a single color, but create a more vibrant effect than flatly applied blue or green.

The colors must be close in tone; if you put a dark blue among middle tones in a sky, the colors will fail to cohere and the sky will not be credible as a flat surface.

SCUMBLING

Another way of breaking colors is to layer them in such a way that each new application only partially covers those beneath. Scumbling involves lightly brushing on opaque or semi-opaque paint to create a veil of color through which earlier colors show irregularly. You can scumble light over dark or vice versa, and you can use the technique to build up several layers of color.

A related method is dry-brushing, in which you use a fairly stiff bristle or synthetic brush to apply a small amount of thick paint. You should use light strokes to avoid covering the surface completely.

SEPARATE BRUSHMARKS

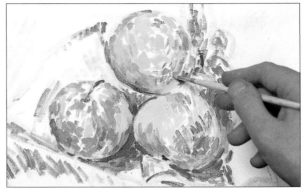

1 *Using a square-ended synthetic brush and paint thinned with a minimum of water, apply small brushstrokes of different colors, curving them slightly to suggest the rounded forms.*

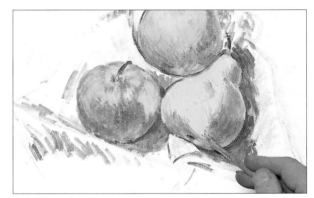

2 *Continue to work in the same way, overlapping the brushstrokes and laying one color over another. Keep the colors in each shadow area close in tone.*

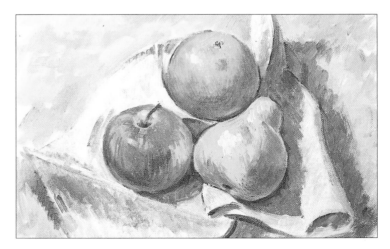

DRY BRUSHING

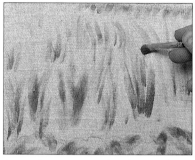 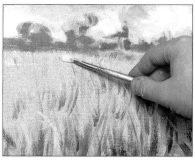 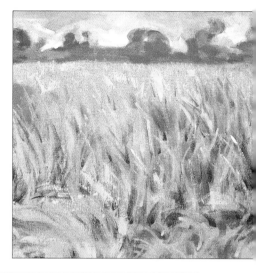

1 *Work on a textured surface, such as canvas or canvas board. Make a thick mixture of paint, pick it up with the tip of the brush, and pull the paint lightly over the surface to suggest the upward growth of the grasses.*

2 *Build up the grasses with a variety of colors. Use horizontal strokes for the far end of the field. In the foreground you can see how the paint catches only on the raised grain of the surface.*

SCUMBLED SKY

 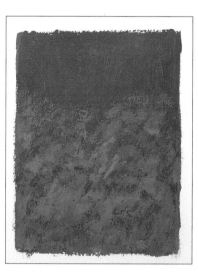

1 *Lay a flat base color and allow it to dry. Using unthinned paint and a bristle or synthetic brush, apply a paler mauve-blue lightly over it. Vary the direction of the brushstrokes and leave patches of the first color visible between them.*

2 *When the first scumbled layer is dry, introduce a third color, such as cerulean blue. Take care not to cover the first colors completely; the effect comes from the way one color shows through another color.*

FURTHER IDEAS

Broken-color techniques can be adapted to any subject. The dry brushing methods can be used selectively, for example, to suggest the texture of old stone. The other method of building up, however, is best applied throughout the painting, otherwise it will lack consistency of style.

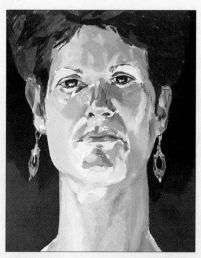

The individual patches of color are varied in shape so that they help to describe the forms of the face.

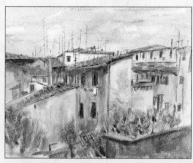

Dry brushing one color over another color gives a good impression of the crumbly wall textures.

Impasto Technique

Another technique borrowed from oil painting is the use of thick paint that stands out from the picture surface. Impasted paint can be applied throughout a picture or in a single area. Thick paint, with highly visible brushmarks, has a stronger presence than thin paint, and will always draw the eye, so artists often restrict impasto to areas they want to emphasize. You see this effect in many oil portraits by Rembrandt, where thickly painted highlights on skin, clothes, and jewelry stand out strongly against the thin paint used for backgrounds and dark areas. Adapt this idea to a landscape or still life, painting the background more thinly than the foreground objects to create the illusion of space.

IMPASTO MEDIUM

Most acrylic paints are runnier than oils, so if you want to use heavy impastos for an entire painting you may need to thicken the paint with acrylic gel medium (see p.27). This is also an economy measure, because without it you might need a whole tube of paint for one area. If you are using white, or a color with a high proportion of white, you are unlikely to need the medium. White is the thickest and most opaque of all of the colors.

Like all acrylic mediums, gel medium dries transparent, but is white when wet, so the palette mixture may look too pale. The best way to be sure that you have the color you want is to mix it before adding the medium.

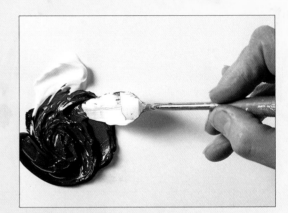

Mix the color you want, then add the medium. Use a painting knife or palette knife for mixing, because they are easier to clean than brushes.

When the paint dries, the medium becomes transparent, leaving the original color.

Using thick paint gives you a chance to exploit brushmarks, but do not use too many different marks in one picture or the image will become muddled and the composition will lack unity. These two paintings show contrasting approaches, but the brushwork is consistent throughout.

The short, square brushmarks create a lively, mosaic-like pattern in the background, and link with the shapes of the pale leaves, each painted with one or two separate brushstrokes.

USING THICK PAINT

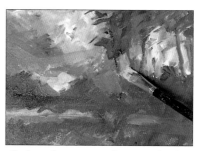

1 *You may find yourself in trouble if you use thick paint from the start, because the colors will mix together. Block in the colors first with thinned paint using a scrubbing motion to push them well into the surface.*

2 *Now begin to build up the sky with a thick, juicy mixture of white and phthalo blue. Try mixing the color only partially on the palette, so that each brushstroke consists of streaks of two or more colors of paint.*

3 *Introduce some yellow into the sky and foreground to contrast with the blues. Do not worry if the color looks too bright. Simply paint over it with another color while it is still wet, and the two will mix (see finished painting).*

4 *The thicker the paint, the longer it takes to dry. If the buildup of paint becomes too heavy for you to add colors without creating muddy mixtures, wipe some of the paint off with a rag before continuing.*

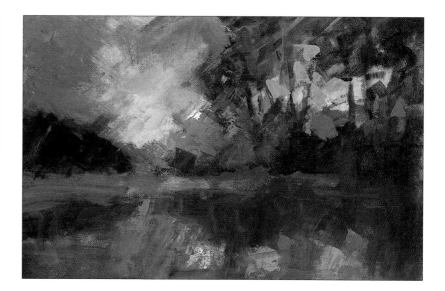

The brushwork is directional, with sweeping strokes following the forms of the scarf, hat, and hair, and shorter ones describing the planes of the face.

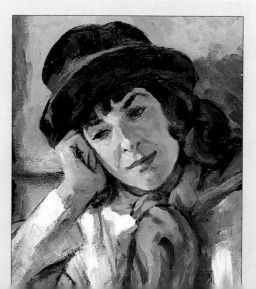

Knife Painting

If you enjoy applying paint thickly, try using a painting knife, a selection of these is shown on page 22. Knife painting is another form of impasto, but the effect is entirely different from that of brush impasto. The flat blade of the painting knife spreads out and squeezes the paint to produce a flat plane with ridges where each stroke ends.

The ridges catch the light and cast tiny lines of shadow that you can utilize to define the edges and shapes in your subject. In a flower painting, for example, make separate, differently shaped knife marks for each petal or leaf and use the side or point of the knife for fine lines such as stalks.

Painting knives are also good for imitating textures. A rough stone wall, for example, could be rendered with a variety of knife strokes, and later glazed over (see pp.70-71) with other colors. Impasto methods are often combined with glazing techniques.

A painting done entirely with painting knives has a lively surface effect and can enhance the drama of the subject; this could be the perfect technique for a rocky land-scape. But as with brush impasto, knife painting can be confined to selected areas, adding emphasis to foreground grasses or tree trunks, for example.

FOLIAGE AND BLOSSOM

1 *Start with a long, straight-blade knife. Lay down some sweeping strokes of yellow-green for the background, then begin to establish the dark areas within the tree, leaving the blossom as white canvas. Use mixtures of green and black, and thicken the paint with gel medium.*

2 *Begin to build up the foliage and lighter leaves. Squeeze cadmium lemon straight from the tube onto the surface, so that very thick paint stands out well from the more flatly applied paint on the background tree.*

3 *For the flurries of blossom on the right of the tree, use a small triangular-blade knife, making short strokes of pure white and yellow that mix slightly on the surface. Then continue to build up the contrasting dark greens with broad strokes of the straight-blade knife.*

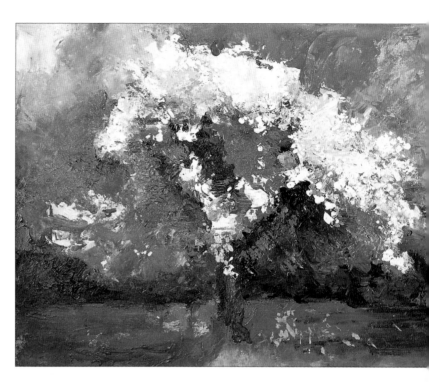

4 *When you have completed the blossom, paint the foreground with horizontal strokes of the straight knife. Use the triangular knife again for the tree trunk. Make a raw umber and white mixture, thickened with medium, and pull the paint downward with the point of the knife.*

FURTHER IDEAS

You can use the knife painting method for any subject that does not contain intricate detail. Try out various techniques, laying flat areas with the blade and making lines and ridges with the tip or edge. These two paintings show different uses of the same technique.

Knife marks were varied in shape and direction to suggest the contours of the landscape. On the trees, the point was utilized to scratch into the paint.

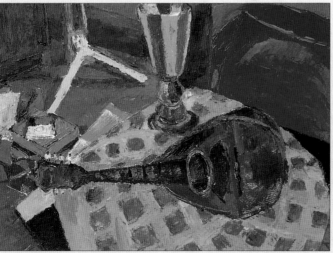

Mainly flat strokes were used for the floor and background drapery. On the instrument, some of the mid-brown paint was scraped off to reveal a yellow ground color.

Texturing

Acrylic paint is ideal for building up surface texture — that is, the texture of the paint itself as distinct from texture seen in the subject. Brush and knife impasto (see pp.64 and 66) are both popular texturing methods, but there are many other possibilities. One method is to mix textured substances, such as sand or fine sawdust, with the paint.

Texture is sometimes used simply to create additional interest, but you can also imitate real textures. Adding plaster to paint, for example, gives it a crumbly appearance similar to that of old whitewashed houses; crushed eggshells could imitate rough stonework; or sand, an actual beach.

TEXTURED GROUND

Another method is to create the texture before putting on the color. To do this you will need texture paste (see p.27). For an overall uneven texture, apply the paste with a palette knife or dab it on with a sponge. Or you can build up a variety of textures by spreading the paste and pressing objects into it before it dries — this method is known as imprinting. Experiment with pieces of crumpled foil, plastic bubble wrap, and heavy fabric, or items such as coins, which will give pattern as well as texture.

When painting over a heavily textured ground, it is best to use thin, transparent glazes (see p.70), which will slide off the raised areas and settle in the declivities to create intriguing effects. Thick, opaque paint over texture tends to look dull.

TEXTURE IN LANDSCAPE

1 *Work on a rigid surface, such as canvas board or masonite, and spread acrylic modeling paste with a painting knife. Make marks in different directions, to create an interesting effect.*

2 *Allow the textured ground to dry thoroughly; this will take at least an hour. Apply the color flatly, using opaque but relatively thin paint that does not obscure the texture.*

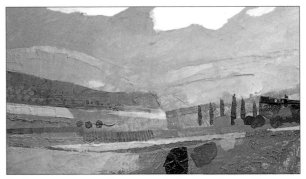

3 *Do not attempt to be over-realistic, since this could mar the impact of the texture. Instead, treat each area as a simple shape. Leave the clouds as white canvas, and paint each of the trees with a brushstroke of one color.*

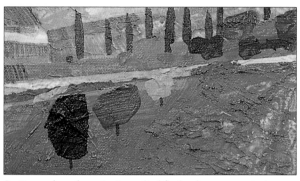

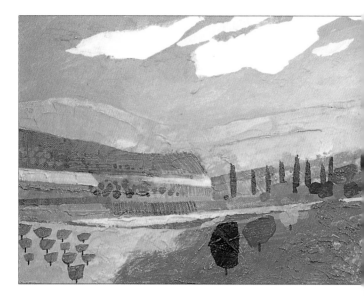

4 *Even when the paint is applied flatly, there are variations of tone and color, because the ridges of the underlying modeling paste catch the light and cast small shadows.*

Experimentation is part of learning to paint, and it is always worth trying different methods of creating texture. Make up a series of samples like the ones shown here. If you cannot immediately see a way of incorporating them into a painting, keep them handy for future inspiration. You may find a subject that seems to demand texture, or one that could be enlivened by such an approach.

Paint mixed with sand. Using a dull red or gray, this grainy texture could imitate old brick or stonework.

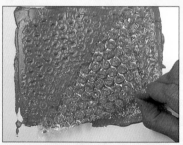

Bubblewrap pressed into paint creates an even texture, which could bring interest into the background of a still life.

Fabric, such as terrycloth pressed into thick paint, gives a less obtrusive texture. Ideal for actual fabric in a portrait.

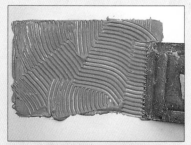

Combing or scratching into paint can create a variety of effects. These could suggest trees or grasses blown in the wind.

Crushed eggshells stuck down with gloss medium and painted over. Use for the foreground of a stony beach.

Coins pressed into acrylic modeling paste and painted with transparent paint. Could contrast with flatter paint in a semi-abstract work.

Glazing

Like many of the techniques in the acrylic painter's repertoire, glazing was originally used by oil painters, who built up their pictures in a series of thin, transparent layers. The slow drying time of oil paints made this a lengthy process, but it is perfectly suited to fast-drying acrylics.

Very rich colors can be achieved with this layering method. Because the paint is transparent (thinned with water or a mixture of medium and water), each color shows through the succeeding one to give a scintillating effect entirely unlike that of opaque color. Glazing is also a means of mixing colors on the surface. If you glaze blue over red, or yellow over blue, you will have purple and green respectively.

COMBINING METHODS

Glazing can be combined with any of the opaque painting methods (see p.58) and used only in certain areas of a picture. Increase the brilliance of a still life object, enrich a blue sky, or bring color into the shadows of a portrait by glazing over a thick or medium-thick paint application. Exciting effects can be created by glazing over a heavy texture produced by impasto, knife painting, or a textured ground (see pp.64, 66, and 68).

Glazing is also useful for toning down colors. When a picture is nearing completion you may decide that one area — say, the background of a portrait, or the distance in a landscape — is too bright. Rectify this by applying a gray or blue-gray glaze; you will see this method in action on page 78.

SELECTIVE GLAZING

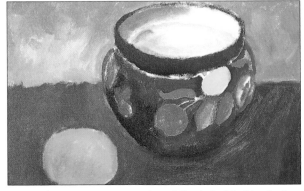

1 *Work on canvas or canvas board. Begin by blocking in the complete image — including the pattern on the vase — with opaque paint of medium consistency. You can then enrich the colors and build up the forms with glazes.*

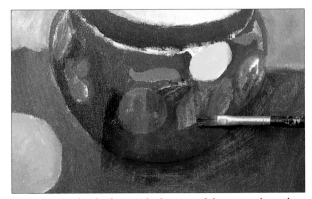

2 *To create the shadow at the bottom of the vase, where the form turns away from the light, use a glaze of dioxazine purple thinned with a half-and-half mixture of water and gloss medium. This darkens the tones slightly.*

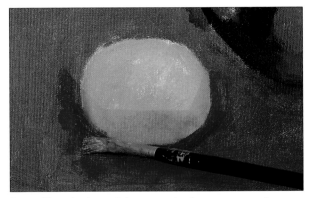

3 *Build up the form of the orange in the same way, using a glaze of alizarin crimson for the shadowed area. To suggest the shadow on the background as well as that on the fruit, take the brush across both in one broad sweep.*

4 *The tone and color gradations on the orange must be refined to make it appear solid. Apply a glaze of cadmium yellow over the entire area to bring out the highlights, then add a touch of transparent green at top right.*

5 *Complete the background wall and the back of the red cloth by darkening them slightly with glazes of diluted burnt umber. This helps the vase to stand out, and avoids too much contrast between the opaque paint and the transparent glazes.*

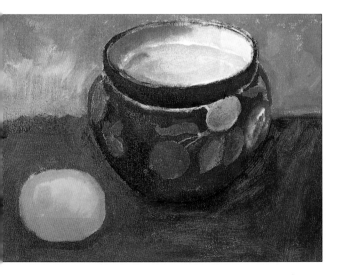

FURTHER IDEAS

Because acrylic colors retain a degree of transparency unless used very thickly, glazing, either selectively or over the whole picture surface, is a natural way of working. The method can be used for any subject, but is especially effective for capturing the shimmer of water or the subtle colors of skin.

Successive layers of transparent paint were used for the face, with final touches of opaque pale pink laid over them on the nose, chin, and brow.

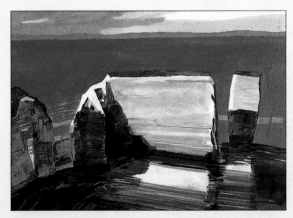

The dark tones and rich colors of the cliffs and the foreground water were built up gradually, with several layers of glazed color.

Tonal Underpainting

Until the 19th century, the standard oil-painting technique was to paint in two separate stages. A full monochrome underpainting was made first, most often in brown, establishing the composition and building up the forms by tonal modeling. When this had dried, color was glazed on top. This traditional method adapts well to fast-drying acrylics, and it can be very helpful. Instead of having to think about tonal values and colors at the same time (see pp.98-99), you can work out the drawing, composition, and tonal structure of the picture first, thus freeing yourself to consider color on its own, much as you would if you were tinting a photograph.

But while a photograph may contain very dark tones, and even blacks, avoid these in your underpainting, since they will deaden the subsequent colors. The darker areas will be intensified as you lay on the colors, so try to make the underpainting a light-toned "ghost" image of your subject, using only middle tones and leaving the palest parts white or near-white.

Warm browns or grays are suitable for underpainting most subjects, but you could try the effect of a contrasting color, leaving parts of it uncovered to set up contrasts. The Renaissance painters favored a green underpainting to counterbalance the warm colors of skin. Like a colored ground (see pp.60-61), an underpainting can influence the overall color scheme of the picture.

COLOR OVER TONE

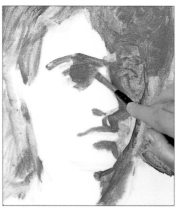

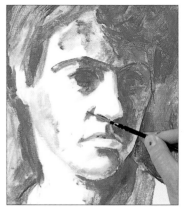

1 *Use cobalt green well diluted with water for the underpainting. Block in the head broadly with a bristle brush, paying particular attention to the shadow areas that define the planes of the face and the features.*

2 *Continue to work on the underpainting until you achieve a full tonal "map" of the head and face. Use a small synthetic brush for details such as the shadow at the side of the nose.*

If you intend to work with thin or transparent paint, give thought to the color you choose for the underpainting, because the darker areas of tone will show through. You can deliberately leave areas of underpainting uncovered, as when working on a colored ground (see pp.60-61).

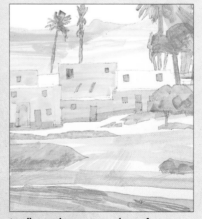

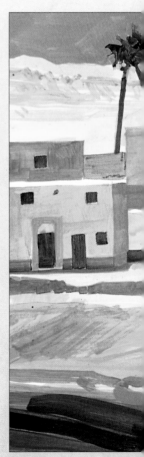

A yellow underpainting is chosen for a picture of yellow and blue.

In parts of the foreground, blues are painted over yellows to give greenish hues.

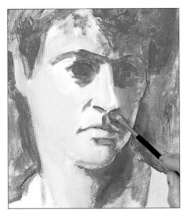

3 *Begin to apply color: a mixture of yellow ocher, white, and a touch of cadmium red for the light side; the same but with less white and more red for the shadowed side.*

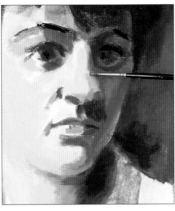

4 *Bring some of the warm reddish skin color into the background. Then continue to build up the features, again using a small brush for details. Leave little patches of the green underpainting showing around the eyes.*

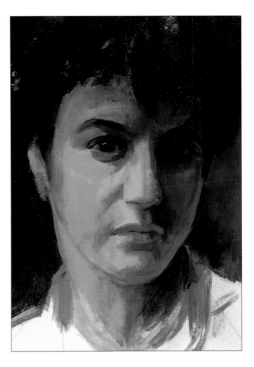

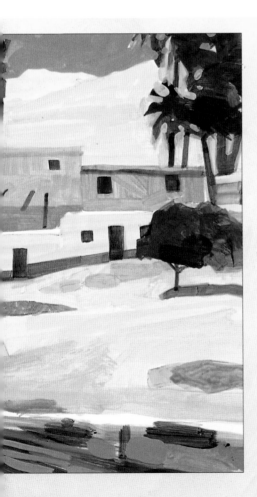

A gray underpainting, made by thinning black paint with varying amounts of water, establishes the tonal structure of the composition.

Again, some areas are left white or pale gray to avoid muddying the translucent, watercolor-like washes. The dark gray used for the background gives strength to the red-brown laid on top.

Wet into Wet

WAYS OF PAINTING

When two or more brush-strokes of wet paint overlap, the colors mix, creating soft blends. This is the technique known as wet into wet. Unlike oil paint, which remains wet for a long time, acrylic does not, so to imitate this oil technique effectively with acrylics you must adopt one of two strategems. The first is to wet the working surface before you begin and periodically thereafter with a spray bottle. The second is to mix the colors with retarding medium (see p.27) before applying them. The medium slows down the drying time for several hours, allowing you to blend colors and move them around on the surface as oil painters do. Do not spray with water if you use retarder, because water affects its performance, and do not dilute the paint for the same reason; use it at tube consistency.

WATERCOLOR EFFECTS

Wet into wet is also a watercolor technique, and this too can be imitated in acrylics. Retarding medium is no use here, since you will be using a lot of water with the paint. All you need to do is to dampen the paper well in advance and keep it damp — again you can use a spray bottle from time to time. The paint will remain wet and workable until the paper dries.

OIL PAINTING METHOD

1 Block in the background with thin mixtures of yellow ocher, burnt umber, and a little cadmium red. For the teapot, use dark red-brown, green-brown, and pinkish mixtures of paint, with touches of pure red and blue. Add retarding medium but no water, and encourage the colors to mix.

2 Use the same method for the fruit, applying a rich deep red over orange. A bristle brush is best for this method, because it pushes the paint on and helps the colors to blend rather than sit on top of one another.

3 For details, such as this highlight, you want a crisp effect, so let the paint beneath dry. Paint mixed with retarding medium remains tacky for half an hour or more, depending on the thickness of the paint, so make sure it is thoroughly dry, or you may scuff it when you add a new color.

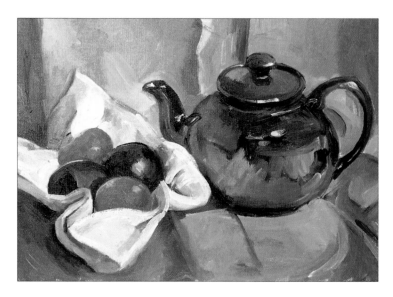

WATERCOLOR METHOD

1 Work on a heavy watercolor paper that will not buckle when wet. Dampen it all over and use a large, soft brush to lay on broad washes of pale blue, mauve, green, and yellow-green.

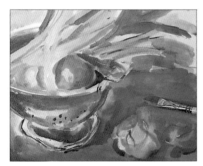

2 While the paper remains damp, the colors will mix slightly without forming hard edges. Continue to build up the image, using well-watered paint, and redampening the paper as needed.

3 A painting done entirely wet into wet can look too vague, so let the paper dry before adding crisper touches of detail. If you lose a highlight, use a little opaque paint in the final stages to retrieve it.

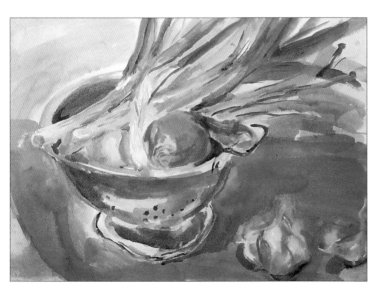

The wet-into-wet method can be applied to any subject, but is especially suitable for landscapes and seascapes, where you will often want to minimize hard edges. You can work in the same way throughout the painting or reserve the soft effects for certain areas.

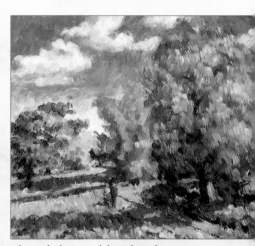

The method was used throughout this picture. The paint was mixed with retarding medium and applied thickly in oil-painting mode.

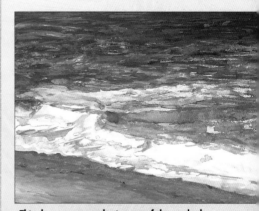

This shows a more selective use of the method. Much of the water was painted wet-into-wet in watercolor mode, contrasting with thicker, drier paint used for the foreground beach.

Watercolor Technique

The delicate, translucent effects associated with watercolors can be achieved with diluted acrylics provided no white, or very little, is used in the mixtures. White is always opaque, and if you mix it in with other colors in large quantities, you will sacrifice their transparency. In watercolor painting, the white is that of the paper, which reflects back through a thin covering of paint. White highlights are reserved — that is, the paper is left unpainted — whereas in opaque techniques they are applied with white paint.

Acrylic used in this way has one major advantage over watercolor. Because acrylics are insoluble when dry, you can apply one color over another without disturbing the paint beneath. In watercolor you must limit the number of overlaid colors because new layers of paint dissolve the earlier ones, and the paint can become muddy-looking.

But the permanent nature of acrylics can be a disadvantage. In watercolor work you can move paint around, soften edges, or lighten colors, even after they have dried, by brushing over them with water. Unless you paint acrylics wet into wet (see pp.74-75), or work very fast, you cannot carry out these amendments, which makes the "watercolor mode" of painting with acrylics more daunting than the opaque techniques. But it is certainly worth trying, because the effect can be beautiful, and if a painting goes wrong, you can turn it into an underpainting for an opaque approach. Artists who use opaque paint at thick or medium consistency often begin with thinned, transparent paint.

USING TRANSPARENT PAINT

1 *Work on watercolor paper. Mix the paint with plain water or with a blend of water and flow improver (see p.27). Suggest the red and yellow flowers, then paint the large leaf with yellow and green paint, leaving the white paper for highlights.*

2 *Paint the flowerpot with mixtures of yellow ocher and crimson, then move on to the right-hand leaves, dropping one color into another before the paint dries, so that they merge creating a wet-in-wet effect (see pp.74-75).*

Watercolor styles and methods vary widely, from soft wet-into-wet blends (see pp.74-75) to crisp effects achieved by laying wet colors over dried washes. The only uniting factor is that the paint is transparent, but it need not be so over the whole picture surface; many watercolor artists use touches of white mixed in with the colors in certain areas of the picture.

Transparent paint was used for the sky and most of the water. Small amounts of white were added to the colors for the boats and background buildings.

3 In the final stages, crisp up some of the flower heads by outlining them with slightly diluted cadmium red. Always leave detail or strong colors until last, because you cannot change them once the paint dries.

Reserving areas of white paper by painting around them can be tricky. The solution is to use a masking fluid known as liquid frisket to protect these particular areas of the picture.

1 *Make a drawing to show the highlights. Paint on frisket over selected areas.*

2 *Allow the frisket to dry. Paint over the image.*

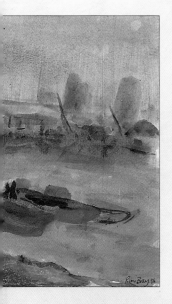

The skin colors were achieved with no addition of white. To build up the darker tones, one color was laid over another, with the paper slightly dampened in order to facilitate blending.

3 *When the paint is dry, rub off the frisket with a plastic eraser.*

Making Changes

One of the great attractions of opaque acrylic is that it allows for drastic alterations at each stage in the working process, and therefore gives you the freedom to try out different compositional ideas and color combinations. If you decide that there are too many objects in a still life, you can paint one or two of them out. If the sky does not work well with the other colors in a landscape, you can paint over it with opaque color or lay a transparent glaze (see pp.70-71) on top to modify the hue. Glazing is a quick and easy way of adjusting color balances within a painting.

When the paint is used at medium consistency, you may find that a new paint application does not completely cover what is beneath. Some colors, such as crimson and ultramarine blue, are relatively transparent unless mixed with white. In such cases, paint over the offending area with unthinned white paint or acrylic gesso (see p.26) and let it dry before applying the new color.

In watercolor mode, you cannot make major changes, such as painting an item out or changing a shape, unless you are prepared to sacrifice the translucent effect by over-painting with opaque paint. However, opaque white can safely be used to redefine or emphasize highlights. Watercolor painters often use touches of white gouache to create similar effects.

ALTERING COLORS BY GLAZING

The photograph below shows this painting divided into four sections, three that have glazes in different transparent colors, using paint diluted with water alone. Try out your glaze first on a piece of spare paper.

The yellow glaze slightly intensifies the original greens and gives a green tinge to the blue stripes of the pitcher.

This area was left unglazed to compare with the yellow-glazed area on the left.

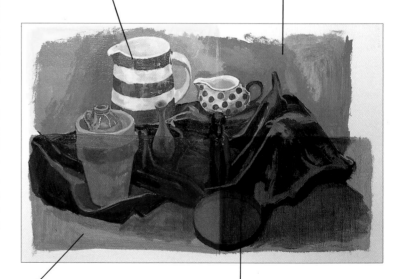

The red glaze has a powerful effect, turning the purple cloth a red-magenta color and the pot a rich red-orange.

The blue glaze also changes the colors radically. The purple cloth is now almost pure blue, and the red pot lid is purplish, and much darker in tone.

COMPOSITIONAL CHANGES

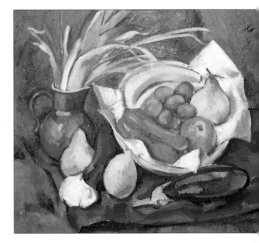

1 One of the leaves of the leek was painted out and another was introduced higher up. A layer of white is painted over with yellow-green.

2 All traces of the original leaf are removed using the same red background color as before, and also using the paint at the same oil-paint consistency.

CORRECTING ERRORS

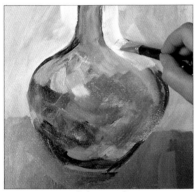

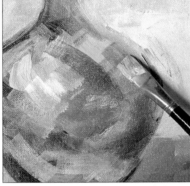

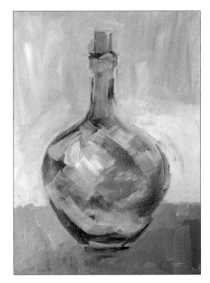

1 Symmetrical shapes often cause problems, and this vase is lopsided. The edge of the vase is redefined by laying the light blue-gray background color firmly around it.

2 The edge was also too hard, failing to give an impression of form, so some light gray is applied to blur the edge and merge it into the background.

TAKING PRECAUTIONS

Some alterations arise from changes of mind about color and composition, but others are a result of poor initial drawing and careless paint application. Shapes that should be symmetrical come out lopsided, and straight edges become crooked. So take precautions to avoid unnecessary corrections. Start with an underdrawing and be sure it is right before you put on the paint. If your subject includes straight edges, paint against the edge of a plastic ruler.

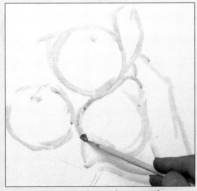

Underdrawings can be made in pencil or charcoal, or you can make a brush drawing, using thinned paint.

Keep lines and edges straight by painting against a ruler or a piece of thick paper.

Comparing Methods

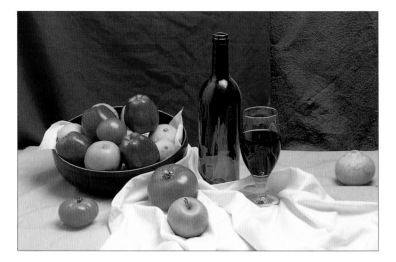

The preceding pages showed you various ways of handling acrylic paints, and these four pages demonstrate the techniques in the context of a finished picture. You will see two artists in action, both painting the same subject with the same range of colors from the starter palette (p.29), but achieving very different results.

The divergence in technique is apparent from a quick glance at the finished paintings opposite. The pictures are revealing in other ways, too. No two artists will approach a subject in an identical way, even when the same basic technique is adopted. There will be stylistic differences, as there are here, with artist one applying sweeping strokes and softer blends of color, and artist two using shorter, separate brushmarks. There will also be compositional variations, with each artist choosing a different viewpoint and arrangement of elements on the surface. A comparison of the photograph with the paintings shows how and why the artists made particular choices. You will learn more about composition later in the book (p.86), but these two paintings provide an early insight into this vital topic as well as illustrating painting methods. On the following pages you will see the artists in action.

CHOICE OF VIEWPOINT

The frontal view seen in this photograph does not provide an ideal composition. The glass and bottle are thrust together in an uneasy way, and the bowl of fruit does not have enough prominence. Artist one moved in to reduce the background, and by taking a position to the right of the group stressed the overlapping forms and the strong diagonal made by the left-hand edge of the tablecloth. Artist two also moved in more closely to give greater emphasis to the fruit, and painted from slightly left. This viewpoint separated the large tomato and the apple, increased the gap between the bottle and the glass, and placed them against the green, not the red, part of the background. Whatever your subject, look at it from different angles to decide on the viewpoint that you feel will make the best picture.

An exciting effect is produced by the broken color and lively brushwork, with separate brushmarks of red, orange, and mauve following different directions.

The use of large, square-ended bristle brushes gives a distinctive style. The yellow band of highlight was dry-brushed over the greens.

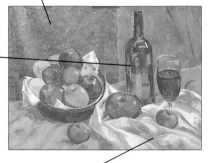

To suggest the texture of the cloth, a dry-brushing method was adopted, with thick white paint dragged over earlier applications of color.

A little of the green ground color can be seen here, only partially covered by later glazes of purple and mauve.

ARTIST ONE

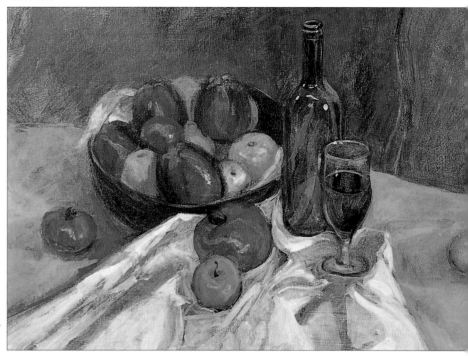

Successive layers of color were glazed over one another, starting with a green ground and a light purple glaze, and working up to vivid reds and greens.

The glazing method gives a smooth effect, with colors gently blending into one another.

ARTIST TWO

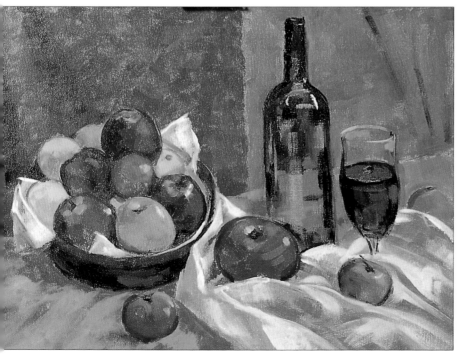

DIFFERENT PAINTING METHODS

The two pictures show very different uses of acrylic. In the painting above, the artist created an oil-painterly effect, applying thick, opaque paint, with areas of broken color and dry brushing (p.63). In contrast, the colors in the painting left were built up gradually, through a series of overlaid transparent glazes (p.70), using paint mixed with acrylic medium. Both paintings are on canvas, and both are rich in color, but the overall tonality is darker in the first painting due to the middle-toned colored ground (p.60). Overleaf you can see how the artists achieved their results.

ARTIST ONE

1 *This artist chose a darker ground color than artist two, of cobalt green mixed with matte medium, achieving a deliberately uneven effect by wiping over the canvas with the palm of her hand. She plans the basic structure of the composition with chromium oxide green and a Chinese brush.*

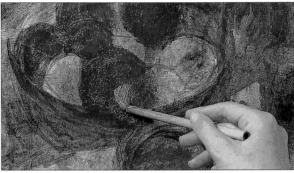

2 *Unlike artist two, she likes to begin with the cool colors — the blues and blue-greens — and work up to the warm reds and yellows. After applying a thin purple glaze over the greens in the central areas, she paints a base color of dark red for the apples, using paint mixed with gloss medium.*

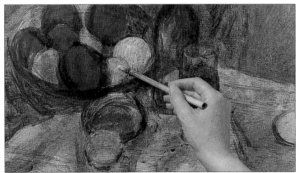

3 *This detail shows the effect of the glazing method, with several layers of color mixed with gloss medium laid over one another to build up a scintillating effect. For the lemons, the artist uses pure cadmium yellow, which is enriched and subtly modified by the earlier green ground and purple glaze.*

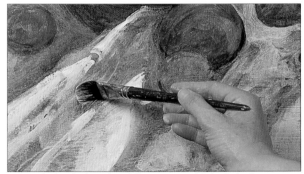

4 *With the dark and middle tones established, she begins to work on the lighter areas. The diagonal lines of the cloth are important, since they draw the eye in toward the bowl of fruit. For these highlights, she follows the direction of the folds, using long, sweeping strokes made with a soft, square-ended brush.*

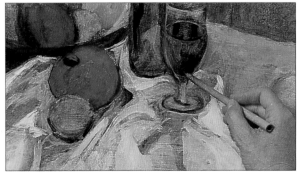

5 *She works on the entire picture at the same time. The forms of the tomatoes were built up more strongly with glazes of cadmium red over the purple base color, and next she turns her attention to the glass of wine, defining the bottom curve with a deep purple applied with the point of a Chinese brush.*

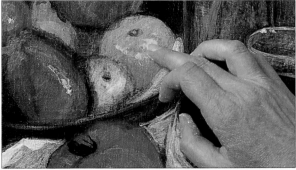

6 *Touches of definition, such as the stalk of the tomato and the highlights on fruit and bottle, were left until last. For this final highlight, opaque, unthinned paint is dabbed on very lightly with a finger — a scumbling method that suggests the texture of the tangerine skin.*

ARTIST TWO

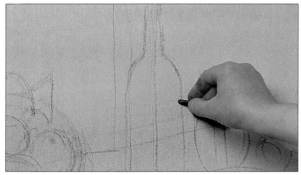

1 *To reduce the glare of the white canvas, a pale wash was laid by brushing on color and then rubbing it down with a cloth to even it out. A line drawing is made in charcoal to place the objects. The lines are kept light to avoid the muddying effect of charcoal dust mixing with the paint.*

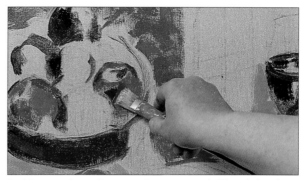

2 *Using unthinned paint and a square-ended bristle brush, the artist builds up the colors and tones of the fruit. The same brush was used for the red background, with the brushmarks applied in different directions to create a lively effect.*

3 *Before painting the green background, the artist established the vivid colors and some of the darkest tones, which makes it easier to judge the strength of color needed in this area. The paint is taken around the edges of the bottle, with the brushmarks again following different directions.*

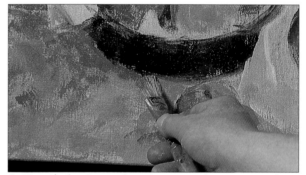

4 *To unify the picture, the artist repeats the same or similar colors from one area to another. The mauve he now uses for the shadow beneath the bowl echoes the brushstrokes of mauve among the reds in the background. He is still using large bristle brushes, because he likes to work broadly until the final stages.*

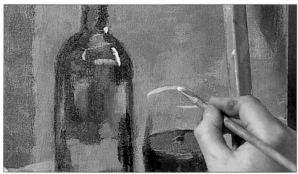

5 *The green background can be seen through the clear glass, so all that is needed to describe its shape is the highlight on the top of the rim. Ellipses require careful treatment, so here the artist uses a smaller brush, with an improvised mahlstick resting on the top of the canvas and supporting his hand.*

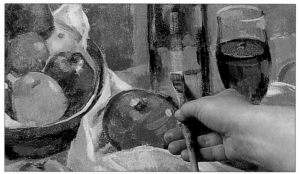

6 *The glass was completed with pink highlights reflected from the cloth, and now the bottle is given final definition, with dry yellow paint dragged lightly over the earlier colors. Again repeated colors were used, with the purple in the wine echoing the purples of the background and the bowl.*

83

5

Picture-making Principles

Composing the Picture

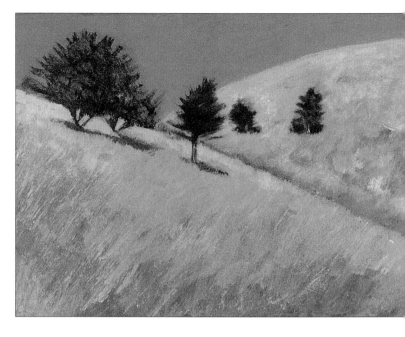

However well you paint, you must also pay attention to the composition of your picture. A good painting is an interpretation of something seen, rather than a faithful copy. Nature provides the ingredients, but you decide how you want to place them on the canvas, and whether you will emphasize some features more than others.

If your subject is a still life (see p.134) you will have chosen the objects and arranged them in a way that pleases you, but for outdoor subjects you make your selection at the painting stage. You do not need to include everything you see, nor do you need to paint everything in equal detail. If a new fence or a utility pole detracts from a landscape scene, leave it out, or play it down by treating it with the minimum of detail.

UNITY AND BALANCE

There are no unbreakable rules about composition, but there are some guidelines. Aim for a good balance of shapes, colors, and tones, so that there is interest in every part of the picture. Try to set up visual links that bind all the elements together into a unified whole. You can do this through color (see p.96), but you can also arrange the shapes so that they establish harmonious visual relationships. A dark clump of trees in the middle distance might be balanced by a shrub nearer the front of the picture, creating a link between the two.

Avoid making your composition too symmetrical. Dividing the picture into equal areas of sky and land, for example, produces a disjointed effect. Nor is it wise to place some dominant feature directly in the center, because this makes a dull and static composition.

SHAPE AND COLOR

This composition also makes use of the interplay of shapes, with the scalloped curves of the water contrasted with horizontals and near-verticals (see below). But what is more immediately noticeable is the restricted color scheme, which unites all areas of the picture. To avoid possible monotony of color, the artist worked on a pinkish ground, allowing patches of this warm color to show through the cool blues and blue-greens and form a link with the skin tones of the figures. (Two on the Wet Sand — W. Joe Innis)

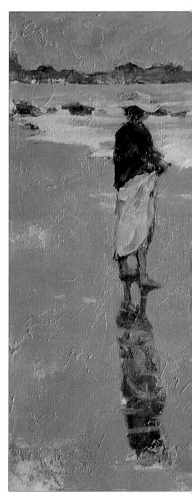

The figures and the shadows make a leaning vertical shape, intersecting the curves and horizontals of the water and thrusting upward to the smaller curves of the cliffs.

REDUCTION TO ESSENTIALS

A composition does not need to be complex to be successful. This painting derives its impact from the way the artist reduced the scene to its bare bones, basing his composition on strong contrasts of tone and on the interplay of simple shapes. The three key shapes are those of the sky and the two hills, cleft by the path. The smaller shapes of the dark trees echo those of the hills and form a link between them and the sky, which was painted flatly so that it reads as a shape in its own right. The only touch of detail is the suggestion of grass texture in the foreground. (North Hill, Trees — Paul Powis)

This shows how the picture is divided into a series of large and smaller shapes, and three basic tones: light, middle, and dark.

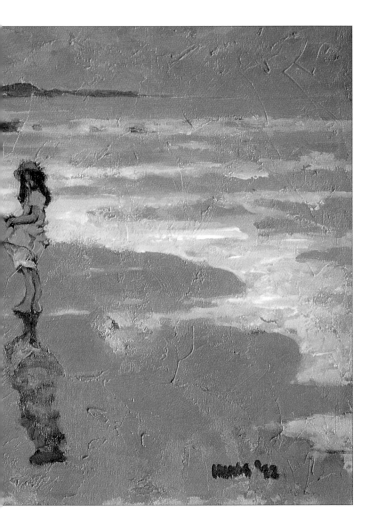

CROPPING

Sometimes a composition is improved by cropping, which means allowing part of the subject to go out of the frame. Tall trees in the foreground of a landscape, for example, could extend from top to bottom of the picture. This would stress the spatial relationships, because cropping foreground elements brings them firmly to the front of the picture plane to act as a frame within the frame for the landscape beyond. Cropping is a useful compositional device for flower paintings, too.

The foreground tree trunks balance the verticals of building and reflections. Cropping them at top and bottom brings them forward in sapce.

The close-up view provides a strong composition based on two intersecting triangles, the pale one of the face and the darker one of the background.

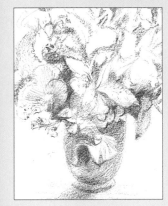

Cropping the tops of the flowers focuses attention on the central blooms, the vase and its shadow.

Choosing a Viewpoint

Painting is a continual process of making decisions, both at the painting stage and before. Your first decisions concern not only what to paint but from what viewpoint. It is surprising how radically a change of viewpoint can alter a subject, even if all you do is to raise or lower your own eye level. A low viewpoint makes the foreground more dominant; in fact, a tall foreground feature can block your view of the distance. In still life, looking down on the subject can provide a better composition than viewing it at eye level. A high viewpoint organizes the elements into a pattern.

The angle of viewing has a direct effect on how you perceive the spatial relationships of objects. Trees in a landscape may overlap and therefore be difficult to read when viewed from one angle, but if you move to the right or left they will separate out. Spend some time exploring viewpoints, using the viewfinder system shown below to frame the subject in different ways. If you are taking photographs to paint from, you will, of course, use the camera's built-in viewfinder.

NEAR AND FAR

A viewfinder will help you to decide which part of the subject to focus on and how much of it to include. For example, do you want to bring a group of trees in the middle distance nearer by reducing the amount of foreground, or push it back with a wide expanse of foreground? How much of the background do you want to include in a portrait or still life? Hold the viewfinder at different distances from your eye; the farther it is from you the nearer the subject will appear. If you have no viewfinder, use your hands, joining thumbs and index fingers to make a rough rectangle.

EMPHASIZING THE FOREGROUND

The artist decided to place the figures at a distance, choosing a viewpoint that allowed him to make the most of the glistening expanse of wet sand in the foreground. He worked from a standing position, with his head at roughly the same level as the figures. (Cornish Summer — Bart O'Farrell)

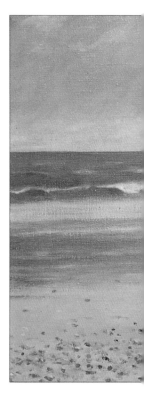

A lower viewpoint would have reduced the amount of sea visible, and the heads of the figures would have jutted into the sky, making the composition less satisfactory.

The verticals of the reflections, created with light downward brushstrokes, counterpoint the dominant horizontals.

EMPHASIZING PATTERN

The high viewpoint chosen for this still life emphasizes the flat-pattern element and the contrast of shapes. Notice how the shadows beneath, beside, and within the objects are treated as shapes in their own right, and stressed by sharp divisions between light and middle tones, so that they contribute to the overall pattern. (A Moment in the Sun — William Roberts)

The shadows and light areas create their own pattern.

An adjustable viewfinder is made by cutting two L shapes of cardboard, which you can slide over one another, turning a horizontal rectangle into an upright one or a square. The cardboard should be black or gray rather than white.

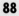

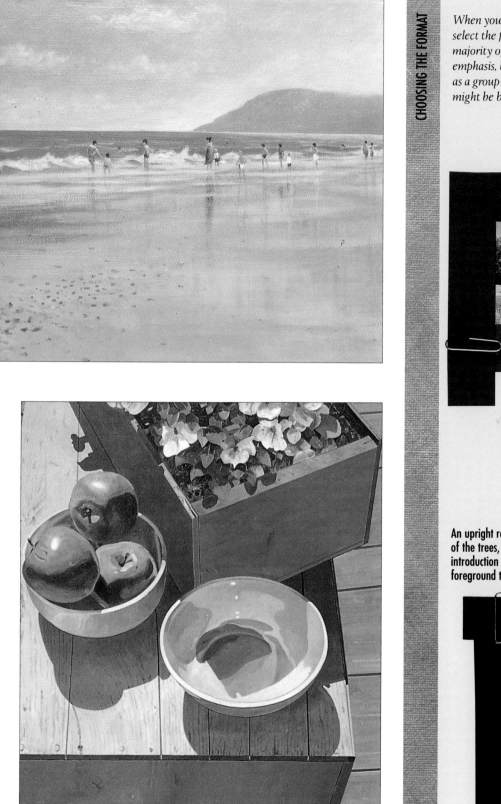

When you have chosen your viewpoint, select the format for your painting. The majority of landscapes have a horizontal emphasis, but for certain subjects, such as a group of tall trees, an upright shape might be better.

A traditional landscape format accommodates the group of middleground trees and the sweep of the path leading in from the foreground.

An upright rectangle shows less of the trees, but allows for the introduction of dark tones in the foreground to balance them.

The Focal Point

It is not essential for paintings to have a center of interest, or focal point, but many do. Often this arises directly from the subject. When you choose a landscape to paint you may do so because you are attracted by some dominant feature, such as a building in the middle distance, and this will automatically become the focal point. In a full-length portrait, the natural focal point is the face, and in a head-and-shoulders portrait it is the eyes. But sometimes you will need to determine the focal point yourself. In a still life, for example, you could emphasize one object through color or tonal contrast.

PLACING THE FOCAL POINT

Where you place the focal point in spatial terms depends upon how much space you are dealing with. In landscape it is traditionally placed in the middle distance, which has the effect of leading the viewer's eye into the scene. A good painting should invite the viewer to participate.

Remember the rule of asymmetry (see p.86) and do not put the focal point in the center of the picture. This would make it too obvious, and the eye would travel straight to it instead of journeying around the picture from one area to another.

LEADING THE EYE

You want to draw attention to the focal point — that is why it is there — but to do so subtly, through a system of visual signposts. Our eyes naturally follow diagonal or curving lines, and these are often used to lead toward a center of interest. In landscape they can take the form of a path or river running in from the foreground. In a still life or flower group, folds of drapery could serve the same function.

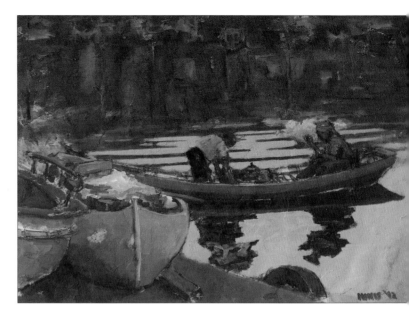

TONES AND SHAPES

The strong tonal contrasts in the center of the picture, emphasized by the dark background, draw our eyes to the figures in the boat. But equally important is the way the shapes are orchestrated. The diagonal in the foreground leads to the curving side of the gray boat, and then to the long, elegant shape of the row boat. This finds an echo in the less obvious curves of the figures and their reflections, and is contrasted with the horizontal lines of the ripples behind. (Dawn at the Boatworks — W. Joe Innis)

At one level the painting can be read as an abstract arrangement of shapes, with the elongated curve setting the key for the composition. Notice how the negative shapes of the pale water in the foreground play as important a part as the positive reflections themselves.

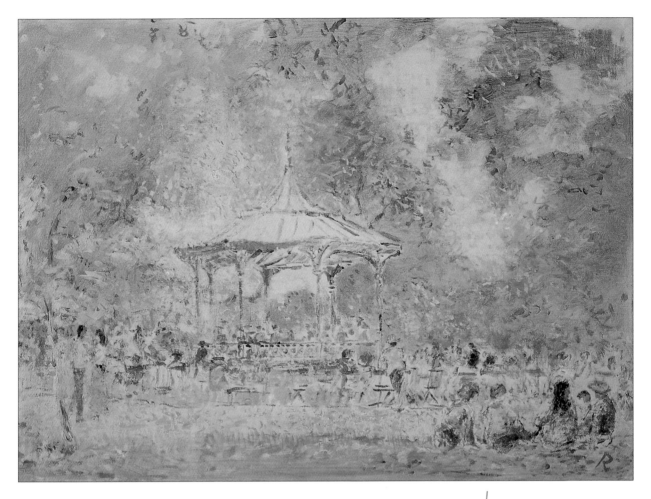

PLAYING IT DOWN

While the focal point was stressed in the painting opposite, here it was played down. In a landscape, human-made features, such as buildings, always stand out against natural ones, and they risk becoming over-prominent. The pretty bandstand is the focal point, both because it is human-made and because it is the theme of the picture. But the artist's main interest was in capturing the carefree atmosphere of a sunny afternoon in the park. He therefore treated the bandstand delicately, so that it blends with the background trees and foreground figures. The use of repeated colors, with yellows and blues appearing throughout the picture, ensures compositional unity. (Bandstand at Greenwich Park — *John Rosser*)

Although the focal point is not emphasized, our eyes are led into and around the picture, from the group of figures on the right to those on the left and thence to the bandstand. The light shape between the trees leads down again from the top of the picture.

Color Relationships

When you begin painting a picture you may find your colors behaving unexpectedly. You mix the apparently perfect color for something, only to discover that it looks too bright or too dull, too dark or too pale when you put other colors next to it. This is because colors are relative, changing in appearance according to their context. A brown that seems almost black on a white surface will look much paler if surrounded by black. A blue may show a greenish bias if juxtaposed with a more purplish blue.

WARM AND COOL COLORS

You can also find that a color pushes itself forward in a way that you did not plan. This is usually because it is too warm. Artists classify colors in terms of temperature. Reds and yellows, and all mixtures containing these colors, are perceived as warm, while blues, blue-greens, and blue-grays are cool. The warm colors tend to advance to the front of the picture, and the cool ones to recede. One of the ways of creating the illusion of space in a landscape (see p.110) is to use warm colors in the foreground and cooler ones for the middle and far distance.

But like hue and tone, color temperature is relative. Blue, although on the cool side of the color wheel, can appear warm next to a cool neutral gray, so it is not just a question of painting the distant hills blue — you must relate the blue to the other colors. There are also temperature variations within the same color groups. Some blues are warmer than others. The same applies to reds, yellows, and greens. Even the so-called neutral colors have a warm or cool bias.

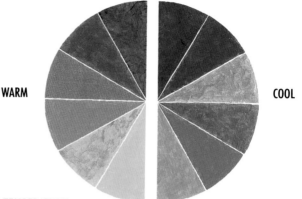

WARM COOL

COLOR TEMPERATURE

The colors on the right-hand side, greens and blues shading into purple, are cooler than those on the left, where yellows shade into oranges, reds, and finally magenta, a red-purple.

WARM AND COOL PRIMARY COLORS

These swatches show two reds, two blues, and two yellows from the starter palette (p.28). In each case, one is warmer than the other. The crimson has a slight blue-purple bias, and is cooler than the cadmium red. The lemon yellow is acid and greenish, cooler than the more orange cadmium yellow. Cerulean blue is cooler than the slightly purple ultramarine.

Permanent alizarin crimson

Cadmium red medium

Cadmium lemon

Cadmium yellow deep

Cerulean blue

Ultramarine blue

RELATIVE TONES

Neither colors nor tones can be judged in isolation. This brown looks darker on white than it does on black. In the third swatch, the brown is so close in tone to the surrounding gray that it is barely distinguishable; half-close your eyes and it disappears.

Brown on white

Brown on black

Brown on gray

TEMPERATURE AND HUE

The first four squares show how the warm red and yellow stand forward from the cooler blue and blue-green in the center. But when these colors, which would normally be considered recessive, are seen against a neutral gray, as in the squares at far right, they in their turn advance. The most vivid color will always stand out even if it is technically "cool."

Blue on orange

Blue on yellow

Blue on gray

Blue-green on orange

Blue-green on yellow

Blue-green on gray

PAINT TEXTURE

The relative warmth or coolness of a color is not the only thing that makes it advance or recede. Thick paint has a stronger presence than thin, and will thrust itself forward regardless of the color. The Old Masters, notably Rembrandt, created powerful three-dimensional effects by using thin paint for the backgrounds of portraits, with thick impastos (see p.65) for the highlights on faces, or details of clothing.

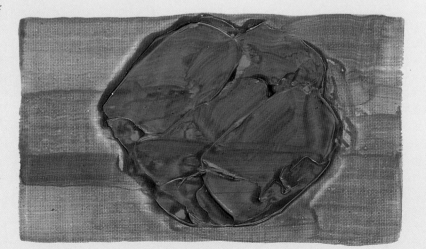

Color and Mood

In addition to describing subjects we see in the world, color can be used expressively, to create a particular mood or atmosphere. Vivid colors and strong primary or complementary contrasts that call out tend to evoke a happy response. Dark heavy colors, such as browns, deep blues, and purples can be powerful in a different way, giving an impression of stability and thoughtfulness. A portrait painter might express something about the character of the sitter through color, choosing light, bright colors for a youthful subject and somber ones for a graver figure.

COLOR PERCEPTIONS

Colors have different associations for each of us, and these can vary. Red, for example, is the traditional color for warning signs. In some contexts it can be aggressive, but it can also be cheering. Blues, greens, grays, and pastel colors, the most usual choices for interior decor, are unassertive. A painting dominated by red is likely to draw attention more immediately than one utilizing blue-green harmonies or light-toned neutrals.

HARMONIOUS COLORS

You can create a gentle atmosphere by avoiding contrasts and using harmonious colors, which are those close to one another on the color wheel. A landscape painting is likely to have this restful quality because the colors of nature are harmonious: greens from yellow-green through blue-green; skies comprising shades of blue and mauve. Flower painters often set up groups of harmonizing colors, such as mauves and pinks, or shades of yellow and orange, with perhaps one or two white blooms to provide tonal contrast.

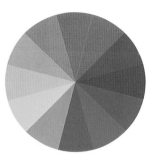

HARMONY AND CONTRAST
Colors opposite one another on the color wheel set up dramatic contrasts. Adjacent colors are harmonious. In any section of the wheel, these form a related sequence.

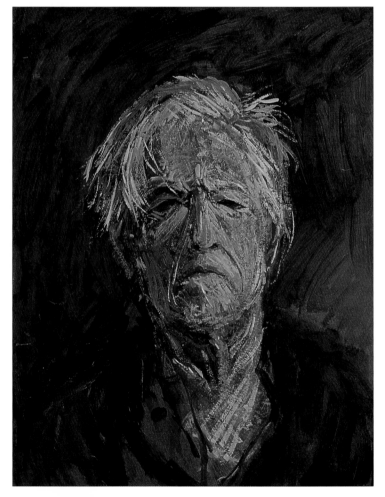

USING DARK COLORS
The somber palette chosen for this portrait, together with the strong tonal contrasts and expressive brushwork, give the painting both atmosphere and drama. The colors are mainly darkened or lightened versions of the color wheel segment shown on the left. (Portrait of the Artist's Father — Gerald Cains)

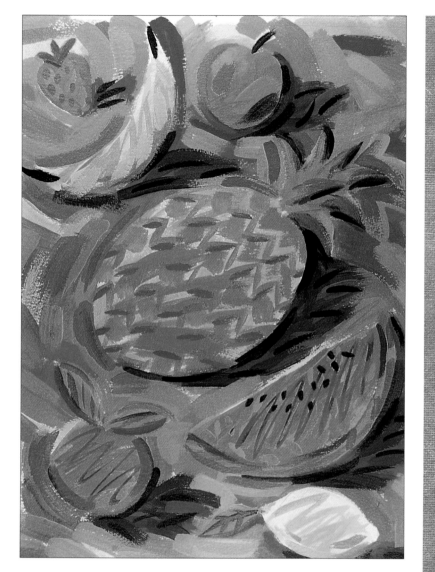

USING BRIGHT COLORS

In contrast to the painting opposite, this still life conveys a joyous mood through the use of the primary colors shown on the left, and equally vivid secondary color mixtures — the green and the orange. The artist did not attempt a realistic depiction of this subject; the theme of the painting is color and pattern. (Summer Fruits — Sara Hayward)

COMPLEMENTARY COLOR CONTRASTS

As you saw on page 49, mixing the pairs of colors that are directly opposite each other on the color wheel produces neutrals. But when these colors are not mixed but juxtaposed, they strengthen each other, and the effect is vibrant. Artists often exploit complementary color contrasts, using violet for the shadows on yellow objects, placing small areas of red in green landscapes, or mixing blue and orange blooms in a flower painting. The colors need not be utilized at their full intensity; muted versions, as shown in the second of each pair of colors below, produce subtle but effective complementary contrasts.

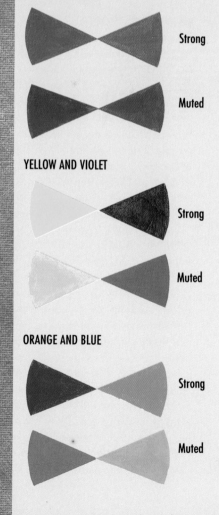

RED AND GREEN

Strong

Muted

YELLOW AND VIOLET

Strong

Muted

ORANGE AND BLUE

Strong

Muted

Color Unity

In a good painting all of the colors work together to create a unified image. A common mistake is to view each object or area separately. A painting that lacks an overall color strategy can appear disjointed or even create a discord like a wrong note in music. Choose which kind of colors you want — warm or cool, bright or muted — and then work at the entire picture all of the time rather than bringing one part to a higher stage of completion than others.

HEIGHTENING COLORS

This can often happen when you depart from strictly realistic color. Deliberately heightening colors is an exciting possibility, but if you do it, remember that no color exists in isolation. Intensifying the purple of a shadow, for example, will not work unless you establish the same intensity all over the picture. The purple shadow will look out of place among muted colors, so you would need to bring in other strong color notes to provide a balance; for example, vivid yellows in trees or fields, and mauves and purples in the sky.

REPEATING COLORS

Whether you brighten the colors in this way or stick to naturalistic ones, you can link the various parts of the picture by using color echoes, that is, by repeating the same or similar colors from one area to another. Some landscape paintings are less than successful because the sky does not seem to relate to the land. Create color relationships by using touches of sky color among the greens of trees. If there are browns in the landscape, bring in browns on the undersides of clouds. In a still life, use muted versions of the foreground colors for the background, thereby linking the two planes of the picture.

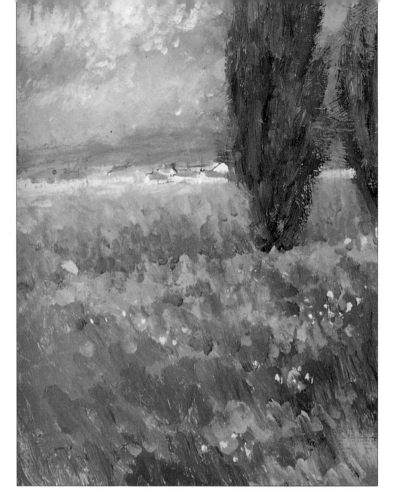

MUTING THE COLORS

The artist chose a scheme of cool, muted colors, which express the gentle feeling of this landscape. He carried them through the entire painting, repeating the blues and blue-grays of the trees in the foreground and in the sky. He rejected any vivid color accents; the foreground flowers, for example, were intentionally subdued. Although the contrasts of color and tone are not marked, this painting is lively and full of interest, with each part of the composition containing a number of different, but closely related colors. (Poplar Blues — James Harvey Taylor)

The creamy yellow of the sunlit clouds links with the yellow on the sides of the houses and the small flowers in the foreground.

The mauve-grays in the immediate foreground are repeated in the sky, and the muted reds suggesting flowers echo the distant rooftops.

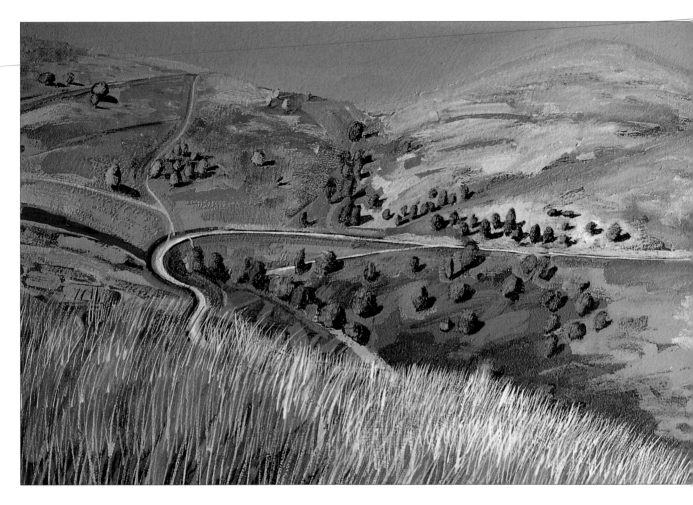

BRIGHTENING THE COLORS

This painting also has perfect unity of color. In this case the colors were heightened to give an impression of intense light and heat. Here, warm colors predominate, with reds, yellows, oranges, and mauve-blues offset by the cooler but equally vivid turquoise in the central area. As in the painting opposite, the artist brought the composition together with color echoes, repeating the yellows and reds from foreground to hills. (Towards North Hill — Paul Powis)

Any of the colors used in this area might look too bright if set against a neutral, but they work perfectly together.

This squiggling brushstroke of brilliant red does not describe any specific landscape feature; its purpose is to contrast with the turquoise and to echo the reds in the foreground and hills.

97

Color and Tone

Color plays a central role in identifying objects. You could paint a lemon in a flat overall yellow and everyone would recognize it through color and shape. But it would not be realistic, because it would lack solidity. This is where tone comes in. It is the light and dark variations of color, caused by the fall of light, that make objects appear three-dimensional.

TONE AND LOCAL COLOR

The actual color of the object, the one we describe it by, is called its local color. To give an accurate account of what you see, you must evaluate both the local color and the different tones that you will observe on the object. It is surprisingly difficult to judge tone, because we do not naturally see in terms of light and dark; our eyes are more receptive to color. Half-closing your eyes, which reduces the impact of the color and blurs detail, makes it easier to identify the tones.

Reproducing tones is not always a simple matter of making a color darker or lighter. Both the shadowed side of the object and the light-struck areas may depart from the local color. Yellow is always light in tone, and ceases to be yellow if darkened, so the shadowed side of a yellow fruit may be greenish or brownish. A tree seen in bright sunlight may be almost yellow in places, with deep blue-green or even purple shadows, and the local color may only be visible in small areas. If you overstate the variations you may lose the local color altogether. A useful method of judging both tones and colors is to mix some paint and hold your brush, with the paint on it, in front of the subject. You will be able to see immediately whether the paint is too light or dark, or too warm or cool, and you can amend the mixture accordingly.

COMPARING TONES

To paint successfully you must make a continuous series of comparisons and judgments. Instead of looking at an object or area in isolation, assess its tone against those of neighboring objects to decide whether it is lighter or darker overall, or lighter in some places and darker in others. Often you will find that objects with different local colors, such as yellow and purple, appear to have areas of common tone because the light produces strong variations.

LEMON
The lemon looks almost like a cut-out shape, because the overall tonality is so much lighter than the background.

The black and white photograph reveals a dark shadow on the underside that is only slightly lighter.

APPLE
The local color of the apple is darker than that of the lemon, but lighter than the maroon background.

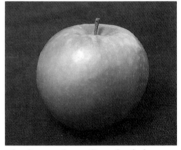

The shiny surface reflects the dark maroon, causing dense shadows equal in tone to the red above the apple.

EGGPLANT
The eggplant is darker than the background, but the shiny surface creates highlights that are much lighter.

The soft highlight running along the top is equal in tone to the left side of the apple and middle of the lemon.

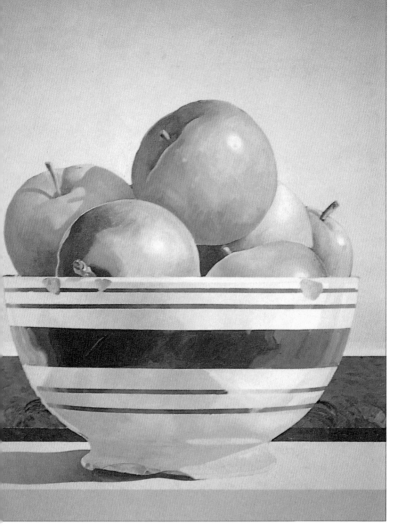

USING A GRAY SCALE

A gray scale is a useful aid to judging tone. It will help you to learn the intrinsic tone of each of the colors in your palette and to assess the variations caused by light and shade. A common mistake is to overstate the darks. If you hold the scale up against a dark area in your painting you may find that it is nowhere near the black end of the scale. Here you can see how the tube colors fit into a tonal scale, with yellow near the top, and blue and purple near the bottom.

Cadmium lemon

Yellow ocher

Cadmium red

Phthalo blue

Dioxazine purple

SHADOW COLORS

Most of the local color on a rounded object, such as these apples, is seen in the center. Shadow and highlight colors will depend upon the light that illuminates the objects, and whether they are reflecting any color from nearby items. Here, the blue shadow cast by the apples is due, not to reflected colors, but to the strong, cold light.
(Cracked Bowl — William Roberts)

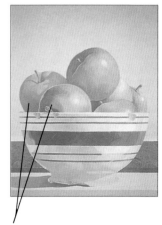

The artist exaggerated the blueness of the shadows to maintain his cool color scheme.

Tonal Structure

Just as the colors in a painting must work together, so must the tones. A painting needs an overall tonal structure, in which the lights and darks balance and counterpoint one another, forming a pattern that is independent of the colors used. Look at some black and white reproductions of pictures by professional artists to see how this aspect of painting works at its best.

HIGH AND LOW CONTRAST

You do not need heavily marked light-dark contrasts to achieve a tonal pattern, but there must be some contrast, or the picture will look flat and dull. The amount of contrast will depend upon your subject and the lighting conditions. Portraits are sometimes lit to provide dramatic contrasts of tone, but the majority of subjects seen under natural light are in the mid-toned range. This means that neither the lightest nor the darkest tones will approach the black or white end of the gray scale shown on page 99. A landscape seen under strong sunlight will have more tonal contrast than on an overcast day, but it will still contain no pure whites.

RELATIVE VALUES

Like colors, tones must be judged one against the other rather than being viewed in isolation; something looks dark only because a neighboring thing is lighter. It helps to work on a mid-toned colored ground (see p.60), which gives you a basis against which to assess the darker and lighter tones. If you are using a white surface, do not begin with the lightest tones, because this may cause you to pitch the entire painting too high. Instead, block in the dark and middle tones first and work up to the lights. Make comparisons throughout the painting process.

USING LIGHT TONES

A high tonal key was used here, which means that there are no really dark tones, yet there is enough contrast to make an interesting composition, and the subtle modulations of tones within each area — for example, the clumps of trees — describe the form clearly. The picture conveys an impression of shimmering heat, with the sun bleaching out the colors and reducing contrast. In landscape painting it is important to judge tones as well as colors accurately, because it is through both of these that you express the quality of light that is inherent to any outdoor scene. (Castle Morton — Paul Powis)

The darkest tones, in the foreground hedge, tree, and shadow, are nowhere near the black end of the gray scale.

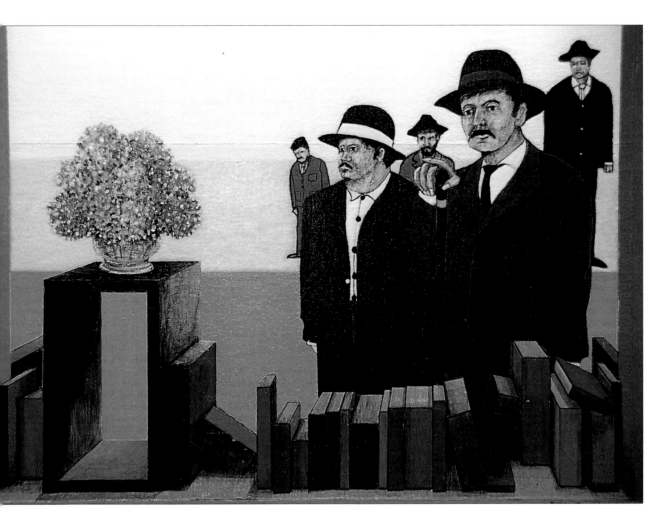

HIGH CONTRAST

This degree of tonal contrast would never be found in the real world because the prevailing light would modify the blacks of the garments, creating areas of middle to light gray. But this is not a realistic painting, and the artist used high contrast and hard-edged shapes to emphasize the strange immobility of the figures, giving them a carved quality similar to that of the foreground objects. Apart from the careful modeling of the faces, the painting is an exercise in two-dimensional pattern-making. (After Jean de Florette — Barrington Magee)

The dark upright shapes of the figures and vertical box are counterpointed by the middle- and light-toned horizontal bands in the background.

TONAL SKETCHES

Some artists like to plan the tonal structure before painting by making monochrome sketches. This is a useful exercise, and helps to concentrate the mind. Use a soft pencil (4B to 5B), or a brush and diluted drawing ink. Do not try to include every tone you can see, or the drawing will become muddled. Look only for the main areas of light and dark and two or three middle tones.

Working from Life

Many art teachers encourage students to work direct from the subject, rather than constructing paintings from photographs. There are good reasons for this. The first is that a photograph has usurped one of the primary functions of a painting — that of depicting the three-dimensional world on a flat surface. The second is that a photograph limits your choices by presenting one fixed viewpoint. If you are painting a real scene, you can walk around and explore different options for viewpoint and composition.

This does not mean that there is no value in photographs (we show how you can use them to advantage on the next two pages), but you should try to work from life at least some of the time. You may discover that your painting conveys more of your feelings about the scene simply because you are experiencing it first hand.

CHANGING LIGHT

There are difficulties to overcome, of course. The main one is that your subject will not remain the same because the light will change. As the sun moves, the shapes and directions of shadows will alter, and so will all of the colors. The scene you responded to in the morning can look completely different at noon with a high sun bleaching out the colors. On an overcast day, color changes will be fewer, but you may not want to paint in these unappealing conditions.

The best way to deal with changing light is to work in separate sessions of under two hours, always at the same time of day. The alternative is to choose a small scale, so that you can finish the picture in one session.

EQUIPMENT FOR OUTDOOR WORK

In addition to paints, brushes, a palette, and a working surface, there are one or two other items you will need for outdoor painting. If you are working on paper rather than canvas or board, you must have a support. It is not necessary to buy a ready-made drawing board; particle board, plywood, and masonite are all quite satisfactory. Water, and something in which to carry it, is essential, and a supply of rags or paper towels for drying brushes and cleaning up. If you work standing, you need an easel and a small folding table for your equipment. If you prefer to sit, a lightweight chair is ideal. A viewfinder (see p.88) will help you plan the composition.

Place the easel so that you can see the whole of the subject clearly either over the top of the canvas or board or to one side of it. The canvas or board should be held upright; if it is slanted you will be viewing your work at an angle, giving a perspective effect which can lead to distortion in the drawing.
Work with the light behind you so that the subject and your painting share the same lighting conditions.

Place the table so that you can reach it easily, but not so close that you knock into it and spill precious water.

Take a supply of clean water in a plastic bottle so that you can change your painting water when it becomes dirty.

Shop around for a bag that is comfortable to carry and can hold all your painting gear.

CHECKLIST FOR OUTDOOR WORK

Preparing for a painting trip can be stressful, since it is easy to forget some vital piece of equipment, such as water in a bottle. Make a list in advance, and check off each item as you pack it.

✓ *Paints — make sure no tubes are empty*
✓ *Brushes*
✓ *Working surface — take more than one*
✓ *Palette*
✓ *Drawing board — if working on paper*
✓ *Masking tape — if working on paper*
✓ *Water container*
✓ *Water in bottles*
✓ *Rags or paper towels*
✓ *Easel*
✓ *Folding stool or chair*
✓ *Pencil and eraser*
✓ *Protective clothing, depending on weather*
✓ *Viewfinder (see p.88)*

Working from Reference

Because it is not always possible to paint outdoors direct from the subject, many artists work from photographs. Consider, for example, passing through a place when on vacation where you see an attractive subject. Although you do not have time to stop and paint, you can take a photograph for later reference. The camera is also perfect for capturing fleeting effects, such as cloud formations, sunsets, or the light before a storm. There are still purists who insist that good paintings cannot be made from photographs, but there are many fine artists who demonstrate that they can.

There are some words of caution, however. Even an expensive camera will not guarantee that the colors are true to life. We have all seen photographs with near-black shadows, bleached-out highlights, and garishly blue skies. The other difficulty is that you are committed to one viewpoint, and if you took the photo in haste you may find that it does not make a good composition. If possible, take several shots from slightly different viewpoints, to give a wider choice.

SKETCHING

If time permits, make sketches. Even a rapid scribble forces you to analyze the scene, and will commit it to memory in a way that looking through a camera lens does not. A monochrome sketch will not, of course, help you with the color, but you can overcome this by making color notes. Make sure you describe the colors in a meaningful way, either by naming the tube colors or mixtures you think you might use, or by referring to a color you know well. Artists' sketchbooks are sometimes annotated with phrases such as tomato soup or cabbage green.

COMBINED REFERENCE

The photograph below provided a basis for the composition at right, but is inadequate in many respects. The colors are muddy and dark, especially in the foreground, the details are unclear, and there is no strong focal point. Knowing the limitations of the camera, the artist made color notes on his sketch, in which he also worked out an improved composition, with one or two figures omitted and others given increased importance. The color scheme of the painting is based on the yellow-mauve complementary contrast, with the yellow-clad figure in the center of the left-hand group forming a focal point, to which the eye is led by the patch of light and the curving shadows. (Lake Orta, Italy — Alan Oliver)

In the photograph, the foreground shadows are unrealistically dark, making it hard to see the legs of the standing figure.

PANORAMIC PHOTOGRAPHS

There is nothing more frustrating than finding that some promising landscape feature has been cut off, or sliced in half, at one side of the photograph. If you have chosen the viewpoint for your composition but have not decided how much to include, take two or three joiner photos by panning the camera around while keeping it at the same level. Stick the prints together with transparent adhesive tape and then decide on the best section of the view.

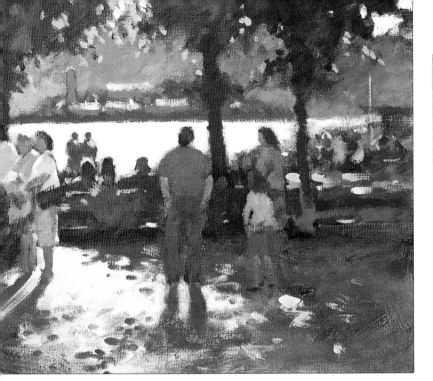

Tonal structure and arrangement of figures worked out fully in pencil sketch. Color notes serve as reminders.

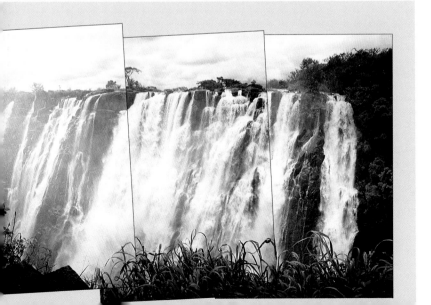

When you are dealing with a complex subject, such as buildings, it is wise to begin with an underdrawing. If you are working from a photograph, this involves enlarging; your painting is likely to be at least four times as big as a standard-sized color print. Make the enlarged drawing by the method known as squaring up, which is slow, but does ensure accuracy. First draw a grid of equal-sized squares over the photograph (use a tracing-paper overlay to avoid spoiling it). Figure out the degree of enlargement you want, and draw another grid of suitably sized squares on the working surface. Number each square in the same way on both, with letters across the top and numerals down the sides, and then transfer the information from the photograph to the surface.

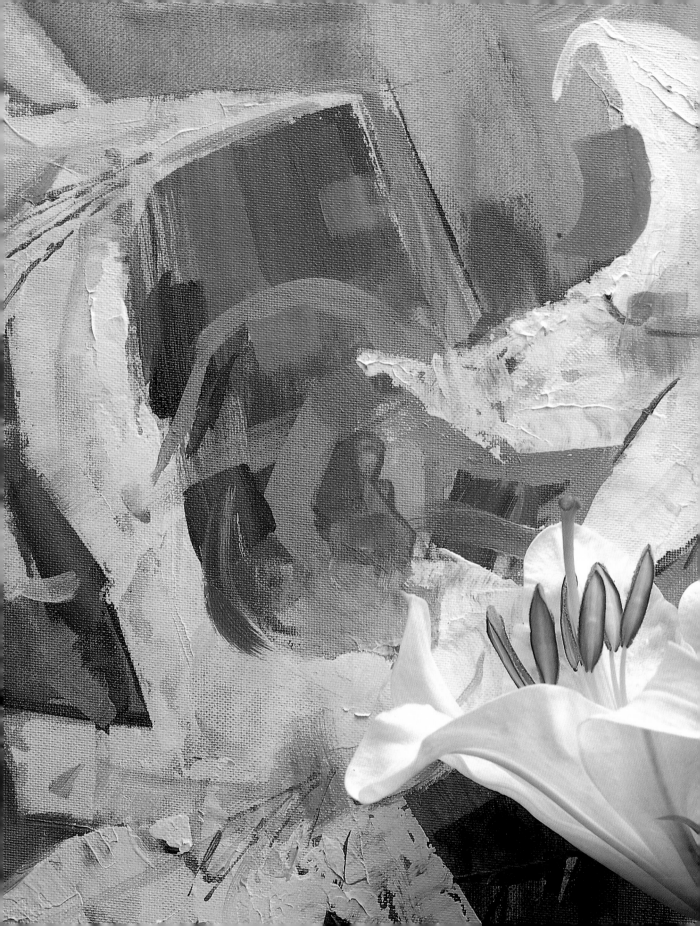

6

Subjects

Landscape

The outdoor world offers an infinite number of enticing scenes for the artist, from dramatic mountainscapes, seascapes, and wide panoramas to intimate corners of a park or yard. It is not surprising that landscape is the most popular of all painting subjects. There is also the pleasure of sitting outdoors at your easel, painting a favorite spot, or sharpening memories of a vacation by recreating scenes from photographs or sketches.

COMPOSING THE LANDSCAPE

Landscape does not demand the level of accuracy of portraiture or architectural subjects, but that does not make it an easy option. The painting will not succeed unless you think about its composition. You may feel that you do not need to compose a landscape because nature has done this for you, but when you paint from life you arrange what you see in a particular way. A scene presents many aspects, and only you can decide which to focus on. For example, will you place a dominant feature, such as a large tree, on the right, on the left, or in the center? Should it be in the foreground or farther back, in the middleground? A viewfinder like the one described on page 88 will be an invaluable aid when making these choices, so be sure to have one of these on hand.

If you are working from a photograph, do not copy the format and composition automatically. Use strips of paper to mask the photo in different ways. A vertical or square shape might work well, or you could base the painting on a small area of the photograph.

Some specific problems of landscape painting are discussed on the following pages.

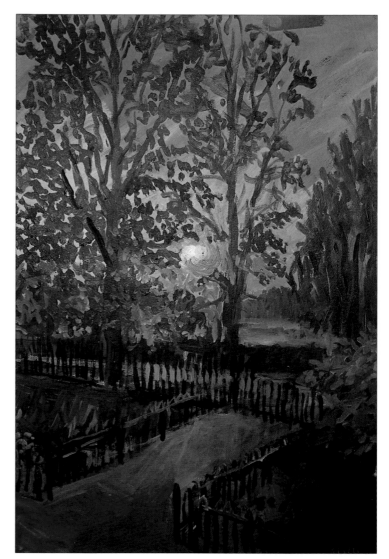

EFFECTS OF LIGHT

In landscape painting, light is inseparable from the subject. An outdoor scene consists of more than its physical components, such as trees, hills, or fields, because all these features are seen under a certain kind of light dictated by the time of day and the weather. This subject might have seemed prosaic at another time of day, but is given drama by the setting sun, which deepens and enriches the colors and casts a blue light on the trees and foreground. (Sunset, Cannon Hill — Daniel Stedman)

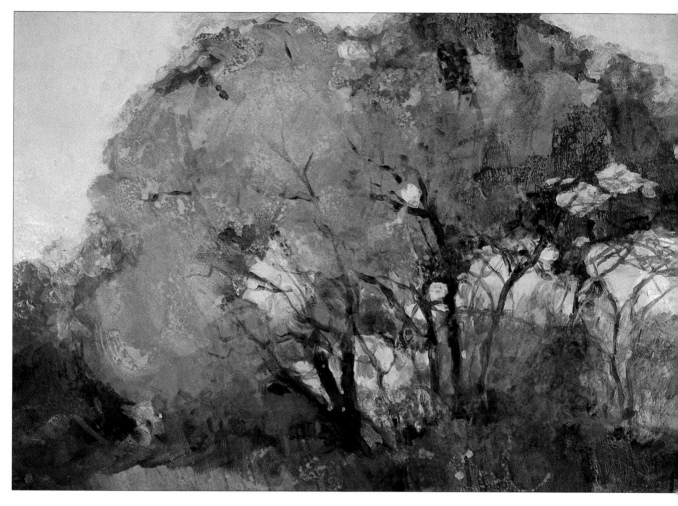

CHOOSING YOUR FOCUS

The word landscape conjures up an image of a wide expanse of country stretching away to a far horizon. But a landscape painting can be simply a study of a single tree, or a group of flowers and foliage by a gate or fence. It is up to you as the artist to decide what interests you most about the scene and what you will choose as your main focus of attention. Here the artist honed in on the group of trees, which she placed boldly in the foreground. Her interest was in the rich colors and the shapes made by the trees, and she avoided any detail that might have reduced the painting's impact. Notice the asymmetrical placing of the trees, and the way in which she brought them forward by cropping them (see p.87). (Beech Trees — Patricia Harrington)

ADDITIONAL COLORS

The dominant colors in the majority of landscapes are blue and green, so you may find it helpful to invest in one or two extras, which will increase the variety of colors available to you for foliage, sky, and water. Further yellows are also helpful additions to your palette. The transparent yellow shown right is particularly useful for glazing, to warm up the greens of trees, for example.

Cobalt blue deep

Indanthrene blue

Olive green

Permanent sap green

Transparent yellow

Naples yellow

The Illusion of Space

There are two main ways of creating the impression of space and depth in landscape. One is by careful observation of the effects of linear perspective, which make things appear smaller the farther away they are, and the other is by control of color and tone in the painting.

When you are working from photographs, which have already reduced the real world to two dimensions, it is relatively easy to see how large a foreground tree is in relation to one in the middle distance. But it is harder to assess relative sizes when you are out in the field. You may know the actual size of a lake or hill because you have walked around or up it, but if it is in the middle or far distance, it will appear tiny as compared to some foreground feature such as a shrub or clump of flowers. One way of checking, used by most artists, is to hold a pencil or paintbrush out in front of you at arm's length and slide your thumb up and down it to find the height or width of a distant feature, then repeat the process for something nearer and compare the measurements.

COLOR AND TONE

As objects recede in space, they become not only smaller, but also less distinct, with narrower contrasts of tone and paler colors. This effect, caused by dust and moisture in the atmosphere, is called aerial or atmospheric perspective. The colors also become bluer or cooler. You have already learned about warm and cool colors on pages 48-49; now is the time to put the idea into practice. Create the illusion of space and depth by using progressively cooler colors for the middle and far distance, reserving the warm colors and strong tonal contrasts for the foreground.

The placing of the horizon also has a bearing on creating space. For example, you can often give a better impression of a panoramic landscape, or an expanse of sea stretching away as far as you can see, if you place the horizon low, letting the sky occupy about two-thirds of the picture space. For a hilly or mountainous landscape, on the other hand, you could cut the sky down to a small sliver at the top, but emphasize space by arranging lead-in lines (see p.90) that draw the eye in from foreground to background.

LOW HORIZON

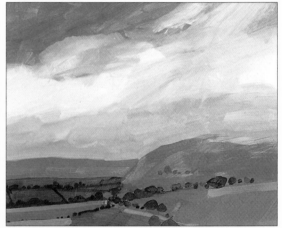

A low horizon gives an open, airy feel to a landscape and is especially suitable when there are dramatic cloud formations.

HIGH HORIZON

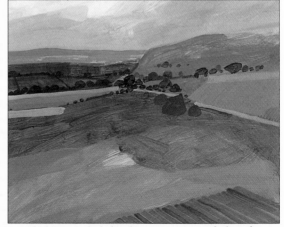

Here, the horizon is high, but there is a convincing feeling of space, with the diagonal lines of the foreground field propelling us into the picture and toward the distant hills.

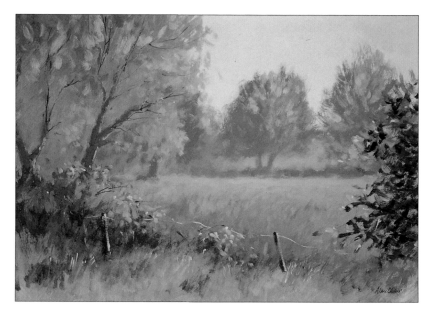

The strongest tonal contrasts and warmest colors are used here and also in the grass and fence, pushing the immediate foreground to the front of the picture.

COOLING THE COLORS

*Here you can see the use of both kinds of perspective, linear and aerial. The tree on the left dwarfs and overlaps those in the middle distance, but it also stands forward because it is warmer in color, with yellows among the greens. The more distant trees are distinctly blue, although this is seen as green. (*Frosty Morning *— Alan Oliver)*

Because of the effects of aerial perspective, little detail can be perceived in this more distant area. Although there are variations in the colors, they are close in tone.

USING PERSPECTIVE

*There is no sky in this painting to create the natural horizon line that suggests space, and there is little or no graying of the color in the distance. Instead, the impression of the receding landscape is conveyed through accurate observation of linear perspective. The houses and trees become smaller, and the boundaries of the fields move closer together as the land recedes. (*Blue Landscape *— Paul Powis)*

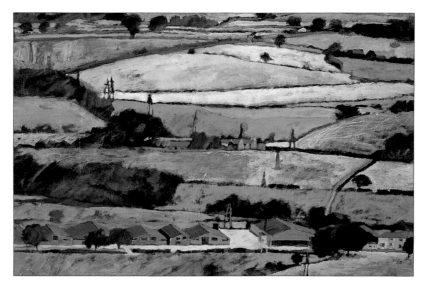

Trees are seldom of equal size, so the linear perspective effects are less easy to assess than with objects of the same size. These two trees, however, are similar enough to those in the immediate foreground to allow a size comparison.

The perspective of the foreground buildings also explains the lay of the land. The artist is looking down on them, but a rise in the land beyond brings the middleground houses nearer eye level.

Painting the Foreground

The foreground is an introduction to a landscape painting. It should encourage the viewer to look around the picture, just as one might when walking into a real landscape. Yet it must be fully integrated into the composition, so that the picture can be read as a whole rather than a series of separate parts. To achieve this you may have to edit reality. Because you can see the most detail, the sharpest contrasts of tone, and the clearest edges in the area of landscape nearest to you, there is a natural tendency to dwell on detail, but this is not always the best course. An over-detailed foreground may dominate the painting and act as a block, preventing the viewer from looking at anything else.

UNITY OF TECHNIQUE

How you treat the foreground depends on your overall approach. If you use broad effects elsewhere, perhaps suggesting middleground trees or fields with one or two brushstrokes, do the same in the foreground. Often just a touch of bright color, a strong light or dark tone, or a thicker application of paint will bring the area forward in space.

If, on the other hand, you enjoy painting detail, this interest must be reflected in every area of the painting. A detailed rendering of middleground features paired with a broad, generalized foreground would make the painting look disjointed and unfinished.

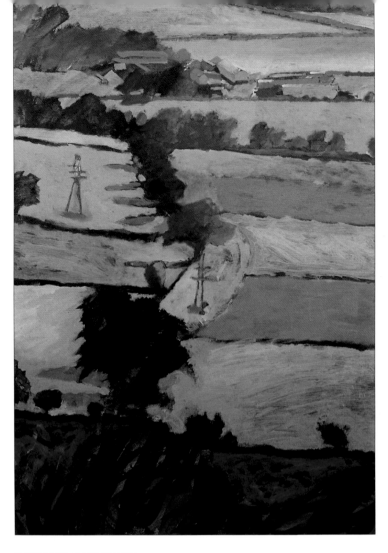

GENERALIZED FOREGROUND

A detailed foreground would have detracted from the overall effect. With the bold use of red over blue, the artist makes no attempt at literal description. Rather, the brushmarks suggest trees, making pictorial links between foreground and middle distance.
(Dry Summer — *Paul Powis)*

The strokes of red used here are repeated on the more distant trees, leading the eye into the picture. The color effect is achieved by laying thin red paint over an earlier layer of blue.

The method of overlaying colors is utilized throughout the painting, and the brushwork is also consistent from one area to another. Here you can see light paint applied over dark.

If you have used the paint thinly and find that a foreground feature requires more emphasis to make it advance to the front of the picture, try applying thick paint in that area alone.

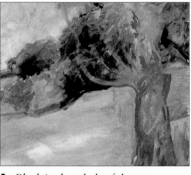

1 *Block in the whole of the composition using slightly thinned paint. Take dark blue-green paint around the edges of the tree.*

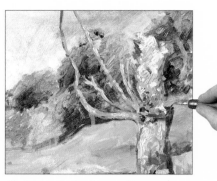

2 *When the background is complete, mix some thick undiluted paint on your palette and flick it on over the thinner paint. Use a painting knife, as shown here, or a brush.*

DEGREES OF DETAIL

The boat is painted in minute detail, so a similarly detailed feature was necessary in the foreground. Because the artist did not want to draw too much attention to the sand in the immediate foreground, he lightly suggested the texture in order to focus attention on the plank of wood. (Self-portrait with Gull — Brian Yale)

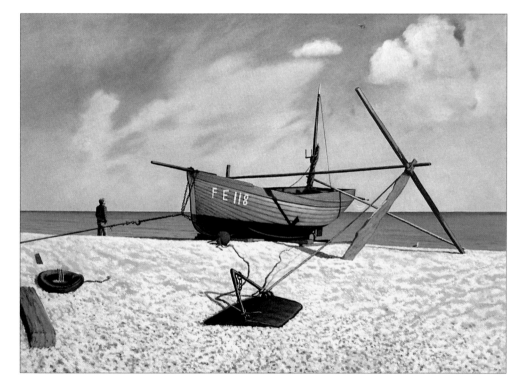

These foreground objects are also important, because the painting needed some dark shapes to provide a balance for those in the center.

The painting is cleverly composed to lead the eye in from the foreground plank to the boat via the diagonal line of the rope linking the two.

Skies

SUBJECTS

The sky is the light source for the land, and therefore plays a central role in landscape painting. Even a composition that shows little or no sky will suggest the weather conditions and time of day, because sky and land are interdependent. A late evening sky produces completely different landscape colors from those seen under an intense midafternoon light. Bright sunshine gives strong light–dark contrasts, but under a clouded sky there are no cast shadows to provide these, and everything therefore looks flatter.

UNIFYING THE COMPOSITION

The sky is also important in compositional terms. The shapes of clouds can balance or echo shapes in the landscape, such as clumps of trees. This will link the separate areas of the picture. The colors of clouds can serve a similar function. As you saw on page 96, repeating colors from one part of the picture to another helps to unify the composition. You will often see blue-grays, browns, and yellows in clouds, and you can bring touches of these colors into the landscape features.

CLOUD COLORS

When you are working from life, the main problem with clouds is that they move so fast, so it is useful to know a few basic rules. A high sun gives a harsh white light, and at this time you will see clouds with pure white tops, gray undersides, and little variation of color. A low evening sun casts a yellowish light, producing vivid yellows on the illuminated areas, brownish yellows in the middle, and blues or violets below, where the clouds are in shadow. If the sun is below the clouds, disappearing beneath the horizon, the bottoms will be illuminated and the tops will be in shadow.

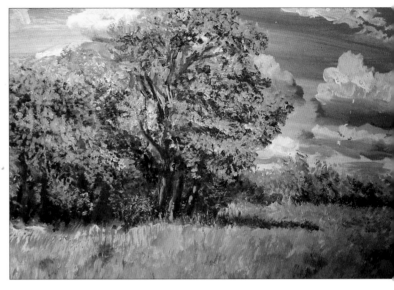

ECHOING SHAPES

The trees form the focal point of this painting, while the sky is important to both the color scheme and the composition. The deep, rich blue sets off the gray-greens of the trees and foreground grass, and the shapes of the clouds echo those of the clumps of foliage to create a link between the two areas of the painting. There are also subtle color echoes, with touches of blue and mauve-gray appearing on the tree trunk and among the foliage greens.
(Lyndon Woods — Daniel Stedman)

To avoid the clouds looking too heavy, slightly thinned white paint was laid over the blue.

The foliage is built up with blue, yellow-green, and very dark green.

The clouds are simplified into areas of light, middle, and dark tone, with swirling brushmarks giving a feeling of movement.

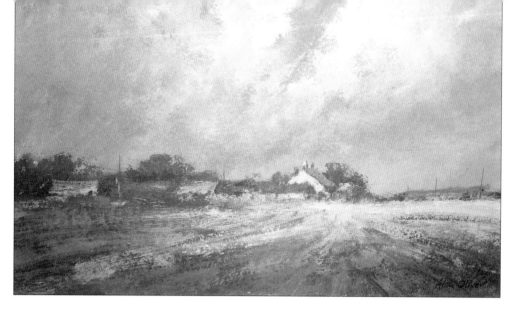

CLOUD AND SUNLIGHT

*One of the most exciting effects of all is that of intermittent sunlight, with clouds casting shadows on the land below, or the sun suddenly emerging from a bank of clouds to spotlight some landscape feature. Here a beam of sunlight created a natural focal point, illuminating the house and far end of the field. (*Norfolk Landscape — *Alan Oliver)*

The patch of blue and the creamy white sides of the clouds, lit by the emerging sun, form a center of interest in the sky area.

The lines and curves that radiate out from the patch of bright sunlight draw the eye in from the foreground to the buildings.

SKY PERSPECTIVE

We tend to think of the sky as a backdrop to the landscape, a vertical plane like the background wall in a still life. But it is not vertical; it resembles a huge bowl inverted over the landscape, and it is subject to the laws of linear and aerial perspective (see pp.126 and 112). As illustrated in the photograph (right), the clouds directly above your head — in the center of the bowl — appear much larger than they do above the horizon, which is the rim of the bowl and the most distant point. As clouds recede, they appear progressively smaller, more closely bunched, and with reduced tone and color contrasts. Even in a clear sky there is a change of tone and color toward the horizon; deep blue gently fades to a paler, greener hue.

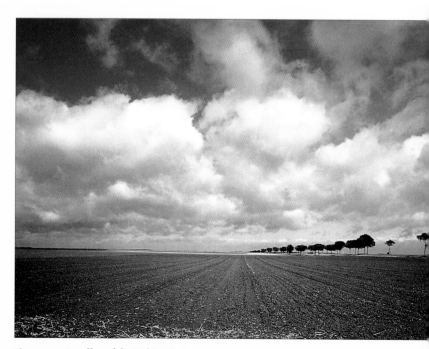

The perspective effect of diminishing size is most obvious when the clouds are all of the same type and formation. These cumulus clouds show it clearly.

Water

There are two important points to remember when painting water. The first is that, even when broken by waves, it is basically a receding flat plane. This sounds obvious, but unless you observe the effects of linear and aerial perspective (see pages 126 and 110), you can make a lake or sea look like a vertical plane, or an inclined one, with the water seeming to run uphill. Waves or ripples toward the back of an expanse of water will be smaller than those in the foreground, and the contrasts of color and tone will be slighter.

The second point is that water is both transparent and reflective. You will always see some of the sky color reflected in water, and anything beneath the water can also influence its color. A shallow river running over peat may have a predominant brown hue, with touches of blue seen only on the tops of ripples. The sea may be greener or browner than a blue sky above, because there is seaweed beneath the surface.

REFLECTED OBJECTS

Still water presents a perfect mirror image of what is above. This is an attractive feature, but it can cause problems. Unless you introduce some visual clues to explain the water surface, the reflections will make no sense — they will simply look like an upside-down version of the landscape. You can blur the reflections slightly in places, or introduce small ripples or some floating leaves.

Disturbed water plays tricks with reflections, scattering them so that they are no longer the same height and width as the objects. Tone and color vary more too, because each ripple consists of two roughly diagonal planes, one of which may reflect the sky and the other some landscape feature.

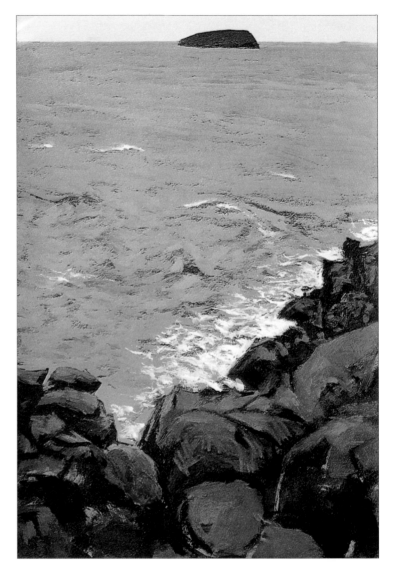

MOVEMENT AND STABILITY

The main theme of this painting is contrast. The shifting quality of the water, which occupies the greater part of the picture space, is emphasized by the solidity of the foreground rocks. These play an additional role in providing a color contrast; the warm browns, yellows, and greenish browns set off the steely gray of the sea. (Steep Holm — David Cuthbert)

The small dark island anchors the expanse of water and provides a tonal balance for the foreground rocks.

Broken-color techniques and brushstrokes following different directions express the movement of the water.

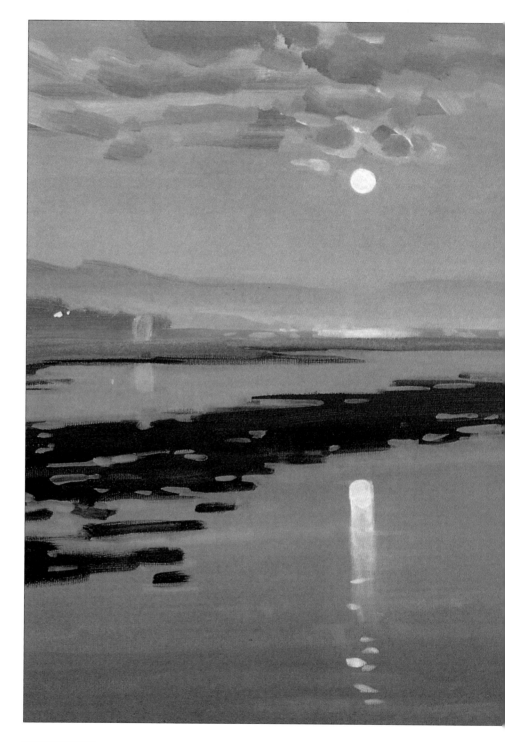

The building and reflection are described with two broad brushmarks. This area of light tone makes a balance for the moon and its reflection.

The reflection is treated economically, with a rounded blob of white applied at the top and dragged lightly down the surface. Small brushmarks below suggest the light bouncing off ripples.

SIMPLIFICATION

Part of the impact of this painting stems from the omission of unnecessary detail. Broad horizontal brushmarks of darker blue suggest ripples that pull the moon's reflection downward, but the contrasts of tone were kept to a minimum in order to give prominence to the reflection itself. (Blue Moon — Marcia Burtt)

Water in Motion

SUBJECTS

Seascape is an enticing subject, but water is not always easy to paint, especially if you are working from a photograph. The advantage of the camera is that it can capture transient effects of light, but it freezes movement, making waves and ripples appear solid and static. If you copy this effect slavishly, your painting will fail to convey the essence of the subject. So use a photograph only as a starting point, as the artist has done here. By the use of lively brushwork, heightened colors, and increased tonal contrasts, an exciting and vibrant picture was produced.

Building up colors in layers 🖌

Using descriptive brushwork 🖌

Translating a photographic image 🖌

Although small, this rock is an important feature in the composition, anchoring and stabilizing the overall movement.

The straight dark band of cloud, which echoes the tones and colors of the foreground, provides balance in the painting.

The reflection of light on the water's surface contrasts with the dull colors of the sea to provide a sense of movement that was emphasized in the painting.

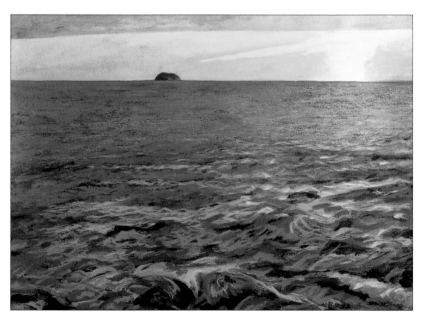

A comparison of the finished painting (right) with the photograph (above right) shows what can be done with a potentially dull subject. The artist used a layering technique, with one color showing through another to create a scintillating surface. In the sky, versions of each of the three primary colors (blue, pink-red, yellow) were laid one over another. The paint was thinned with water in the early stages, and used more thickly as the work progressed. The working surface is heavy watercolor paper. (Seascape — David Cuthbert)

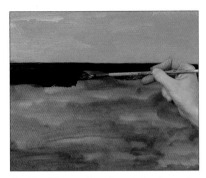

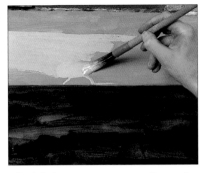

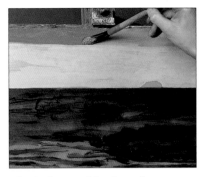

1　*The blue undercolor of the sky and deep purple-red of the sea were laid on with lightly watered paint. The artist darkens the color on the horizon with a mixture of raw umber and ultramarine.*

2　*A light magenta is painted over the blue in the central area of the sky, allowing the blue to show through slightly. The hump of rock and the dark band of cloud at the top of the sky are both left as blue.*

3　*At the top of the sky, yellow is painted over the blue. The two colors mix optically (see p.62), creating a greenish hue.*

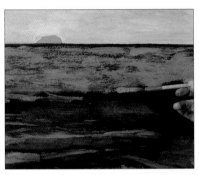

4　*A blue similar to the first sky color is brought in for the sea. The broken-color effect, where the dark color shows through the scumbled blue (see p.63), gives an excellent impression of light and movement.*

5　*Moving from one area to another so that all areas are at the same stage of completion, the stronger colors of the foreground sea are built up with decisive brushstrokes of blue over orange.*

6　*Next the final sky color — yellow — is painted over the mauve created by the pink-blue mixture. The greenish-yellow cloud band is left as it is, because a darker color is to be used for this.*

7　*The band of cloud is deepened and enriched with a strong orange applied over the yellow-green. Again, you can see how one color shows through another to create a subtle mixture.*

8　*The effect of moving water is perfectly conveyed through varied brushmarks, with one color laid over another. Toward the back of the sea, yellow was scumbled (see p.63) over blue to create a green glow.*

9　*Touches of rich deep mauve are introduced over the earlier blues. The yellow-orange brushmarks were made with the hairs of the brush slightly splayed in order to create a series of small fine lines.*

Painting Trees

SUBJECTS

Trees are an appealing subject, but it can be hard to decide how much of them to include. If they are distant, you will be able to see their outline and overall shape. But foreground trees, with every leaf and twig in focus, present a lot of often confusing detail, and you will need to sift out the essential visual information. Here the artist radically simplified the trees, and used a bold, non-naturalistic color scheme. The painting has a semi-abstract quality — the arrangement of shapes and colors is more important than literal description — yet the trees are clearly recognizable as organic forms, contrasting effectively with the humanmade appearance of the buildings.

Simplifying shapes

Abstracting from reality

Working from sketches

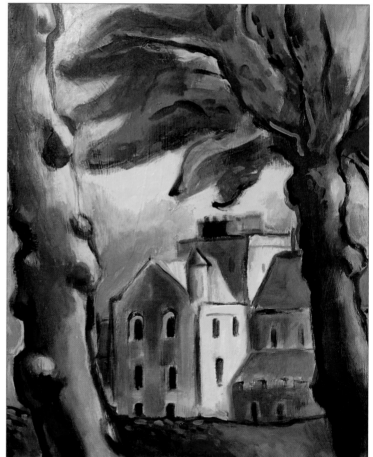

This colorless sky was replaced by vivid yellows and greens, which tie the composition together by linking the buildings and trees.

The yellow-brown of the trunk provided a natural contrast with the purple shadows. This effect was heightened in the painting.

The knobby tree trunk suggested a bold treatment in which each clump of foliage in the finished painting became a stylized leaf form.

As the photograph (left) shows, the scene was dull in terms of color, but the way the two trees frame the building provided the basis for an exciting composition. The artist made several on-the-spot sketches to try out various options, but the painting was done in the studio. When departing from reality, or abstracting, it is helpful to disassociate yourself from the subject. This gives you greater freedom to explore purely pictorial ideas. (Evening Light on Romsey Abbey — Gerry Baptist)

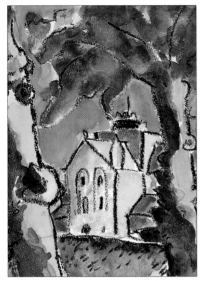

1 This rapid sketch, made on paper with transparent acrylic and black chalk, provided the basis for the composition. Major changes to the colors and shapes were made.

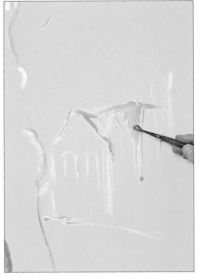

2 The painting is done on canvas, primed with gesso and then given an even allover coat of cadmium yellow. The color scheme is based on the purple/yellow complementary contrast, which were the first colors used. A light purple is used to sketch in the buildings.

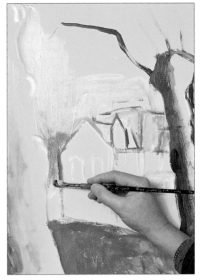

3 By using a layering method with the paint at medium consistency and no added white, one color shows through another color to create rich effects. Here you can see how the pale turquoise does not completely cover the yellow of the ground color.

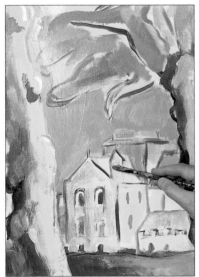

4 The same color is scumbled lightly over the darker side of the building. The light-struck side of the tree on the left is still the original ground color, but the shadowed side was first painted red, then overlaid with purples, mauves, and touches of the turquoise sky color.

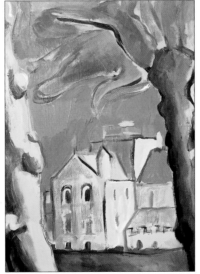

5 Additional layers of color enrich the immediate foreground. Both tree trunks were built up more strongly, with increased tonal contrasts that help them to stand out in front of the buildings.

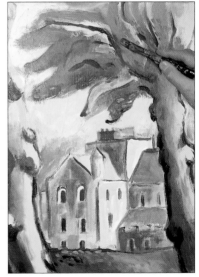

6 Much of the sky was overpainted in yellow to provide a tone contrast with the darker area of the foliage. The front of the building then received a third layer of color, this time purple. Some of the turquoise sky color was brought into the foliage.

Individual approaches

These two landscape paintings illustrate very different pictorial approaches and methods of handling paint. Both works are on canvas, but there the resemblance between the two ends. Where one artist deliberately heightened all the colors and reduced detail, the other produced an almost photographic effect, with naturalistic colors and a wealth of accurate detail.

Sky painted completely flat, as it would appear in a photograph. Fine fitch brushes used for the delicate tracery of the branches.

Background trees provide a middle tone, which helps the tree trunk to stand out. The sunlit side is much lighter; the shadowed side slightly darker.

Roots form foreground interest, leading the eye into the picture and along the twisting and curving forms.

REALISTIC COLOR

This painting demonstrates how successfully acrylic can be used to achieve complete realism and minute detail. It is the medium favored by many photorealists, as well as by numerous illustrators. In spite of its almost photographic quality, the painting has considerable power, which derives partly from the inherent drama of the subject and partly from the strength and simplicity of the composition, the strong contrasts of tone, and the richness of color overall. In contrast to the painting on p.123, where brushwork plays a major role, no brushmarks can be discerned here. (Guardian of the Mill — Brian Yale)

Analysis

122

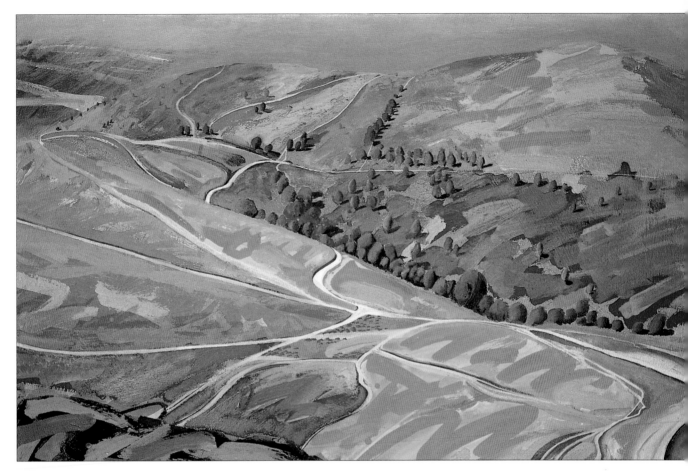

HEIGHTENED COLOR

The interplay of vivid colors is among the artist's main interests, and in this painting he began with a multicolored underpainting. This was applied thickly so that both the colors and the textures would show through the later paint applications. He built up the painting in a series of layers, using the paint liquid but not transparent. To give the painting vitality, large, bold brushmarks were exploited, using a variety of brushes including square ones, with smaller ones for details such as the trees and paths. Notice how the perspective of the receding paths and the diminishing sizes of the trees were used to lead the eye. (View of North Hill — *Paul Powis*)

In order to create pictorial links that tie all the areas of the composition together, the foreground reds are repeated in this area.

This area shows the effect of overlaying brushmarks of thin but opaque paint. One shows through the other, creating a subtle passage of color.

Explicit foreground detail would weaken the impression of space. These brushstrokes of strong red and yellow are all the foreground interest needed.

The trees are treated more precisely than other areas of the painting in order to make the scene explicit and to anchor it in the real world.

Buildings

SUBJECTS

Still life and portraiture subjects can be organized in advance of painting. Landscapes and architectural subjects cannot. When you paint a building or a street scene, you must take what you see; you cannot move the elements around or change the lighting conditions

You may also have a more limited choice of viewpoint. This is seldom a problem if your subject is set in a landscape, but in a busy town it may be difficult to find a spot that provides an interesting composition as well as allowing you to paint in peace. In such cases, working at home from photographs (see p.104) can be the best course. This will also enable you to incorporate moving elements, such as people, which can be caught in seconds on film but take far longer to paint.

LIGHTING

Although you cannot manipulate the lighting, you can choose the time of day that shows the buildings to best advantage. This is important, because the direction and intensity of the light affects the colors, forms, and textures. When the sun is high in the sky, there will be fewest cast shadows, and these play a vital role in highlighting interesting details and textures, as well as providing an interplay of lights and darks. A low evening sun, on the other hand, casts long slanting shadows, picking out features you might not otherwise notice. It also enriches the colors, turning drab brick walls into molten gold.

So take a look at your subject at various times of day, and also in different weather conditions. If you want a brooding atmospheric effect — say, for an industrial townscape — an overcast day could be most suitable.

CITYSCAPE

An attractive painting subject can sometimes be marred by the presence of cars and people, but they are an integral part of a daytime cityscape. Including vehicles, pedestrians, and other city features can also help the composition. Here the yellow cabs are important to the color scheme, balancing the yellows of the buildings and central patch of sunlight. (Powell Street — Benjamin Eisenstat)

Folkes. ©

FOCUSING IN

*You need not paint all of a building: separate details, such as windows and doors, often provide exciting possibilities. The artist contrasted the curves of the window with horizontals and verticals to make a balanced and satisfying composition in which lighting also plays a major role. The evening light cast a golden glow over the stonework to contrast with the blues of sea and sky. (*The Venetian Window, Chania *— Peter Folkes)*

ADDITIONAL COLORS

Buildings are typically less vivid in color than subjects such as flowers, so in many cases you will need to call on your color-mixing skills. However, brick and stonework can be richly colored in certain lighting conditions, so you may find some additional orange-browns, purple-browns, and yellows helpful, along with a gray that can be used in mixtures.

Mars violet Mars violet deep

Burnt sienna Buff titanium

Naples yellow Graphite gray

Perspective

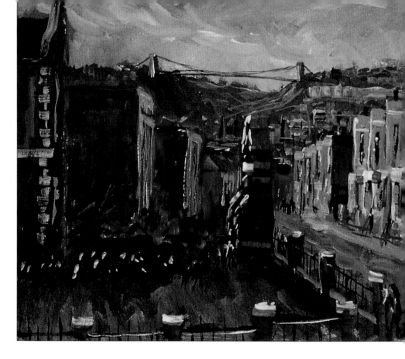

To paint buildings and urban scenes successfully, you need to understand the basics of linear perspective — our main means of creating the illusion of three dimensions on a two-dimensional surface. Linear perspective is based on the observation that parallel lines on a receding plane, such as the tops and bottoms of windows, appear to converge.

If the parallel lines were to be extended they would meet at a point known as the vanishing point (VP). The location of this point is dictated by your viewpoint, because it lies on a notional line called the horizon, which is your own eye level. Thus if you are looking down at a town, perhaps from a hill, the horizon will be higher than the buildings, and the parallels will slope upward. If you are looking up at a tall building, the horizon will be low, and the lines will slope down.

Your angle of viewing does not alter the horizon, but it does affect the position of the vanishing point on the horizon. If you are directly in the middle of a street, the vanishing point will also be in the middle, opposite you, and the angle of the receding lines will be the same on both sides. But if you move to the right, the vanishing point will move with you, so the lines on the left will have farther to travel to the vanishing point than those on the right. You can see how this works in the drawings opposite.

Each separate plane has its own vanishing point, so if you are looking straight at the corner of a house, there will be two, and if a number of houses are set at different angles to one another, there will be several vanishing points.

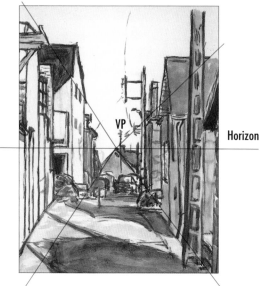

VP Horizon

CENTRAL VANISHING POINT
The artist worked from a standing position, giving a horizon line roughly in the center of the picture. Because he is viewing from the middle of the street, the vanishing point is centrally placed.

SEPARATE VANISHING POINTS
This corner-on view of a house reveals two separate planes, each with its own vanishing point outside the picture area.

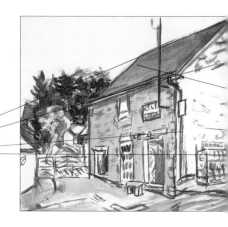

VP

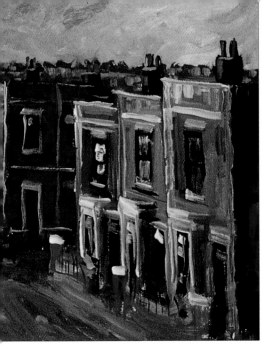

PERSPECTIVE AND STRUCTURE

You need not be too precise about linear perspective, but unless you get the key perspective lines and angles right, the buildings will look structurally unsound. Although treated impressionistically, the structures in this picture are completely convincing, because the perspective effects are well observed. (South Street — Gerald Cains)

Because the tops of the roofs slope slightly upward we can tell that the town is hilly, with the artist's eye-level above the rooftops.

These buildings run downhill. A line if drawn through the center would meet at a vanishing point below the horizon (see Inclined Planes below).

CHANGING THE ANGLE

The perspective alters when you move. The artist's eye level is the same in this view, so the horizon does not change, but he has moved to the right, and so has the vanishing point.

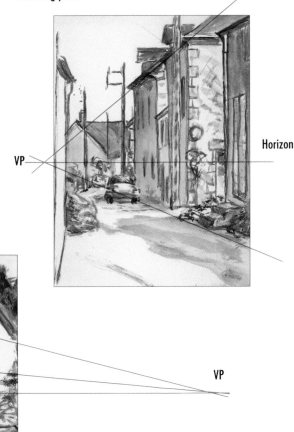

VP

Horizon

VP

INCLINED PLANES

The rule that the vanishing point is located on the horizon only applies to vertical or horizontal planes. Sloping planes, such as pitched roofs, have a vanishing point above the horizon. Houses set on a hill can be particularly confusing. The road going up or down hill is an inclined or declined plane, and the vanishing point for the two sides is above or below the horizon. The houses themselves are built on level foundations, stepped up to accommodate the slope, and follow the normal rules.

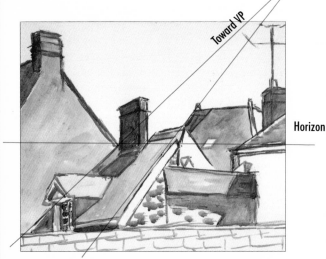

Toward VP

Horizon

The parallel lines formed by the edges of the roof converge only slightly. If they were extended, these lines would meet at a vanishing point well above the horizon.

Proportion and Character

A knowledge of perspective will help you to make buildings look convincingly solid, but it will not enable you to express their particular character. For that, you need to train your own powers of observation. If you want to achieve a recognizable likeness, an attention to proportion and detail are crucial.

Before thinking about perspective, analyze your subject and decide what its special features are. Is the building unusually tall or wide? Are the windows large or small, close together or widely spaced, or deeply recessed in thick walls? Are there any wrought-iron balconies or carved lintels, that will help you construct a portrait?

STYLES AND MATERIALS

Whether you are painting an urban or village scene, or an old barn set in landscape, you will want to give the impression of a specific place. Building styles often vary distinctly from one country and region to another, and so do the materials used. The skyscrapers of Manhattan and the flat-roofed houses of Greek villages are two obvious examples, but there are numerous others, such as the dark red brick of Victorian London, clapboard houses in parts of the United States, gray or sand-colored stone cottages in Britain and Ireland, and tall glass and concrete structures in many modern cities.

Old buildings, in particular, can provide intriguing textures to exploit in your painting. Do not overlook the possibilities of old wood, crumbling brickwork, and peeling whitewash, because the texture of a building is an integral part of its character.

ATTENTION TO SHAPES

The small white or pastel-colored buildings set at seemingly random angles on a hillside are so typical of the Greek islands that little detail is needed, so long as the general shapes, proportions, and colors are correct. The artist paid careful attention to the shape of each house and the placing of the windows, and on the foreground wall gave a hint of the crumbly texture that is another feature of the whitewashed buildings. (Across the Town, Kea — Jill Mirza)

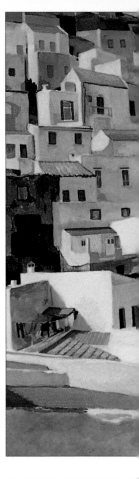

The shape of this central building, with its upward-sloping wall, is clearly defined.

Thick walls are another characteristic of these houses, indicated here by the deep shadows.

ATTENTION TO TEXTURE

Failing to exploit the rich textures of the wood and the rusted metal roof would have been a lost opportunity. They form an integral part of the subject, as exciting in their way as the dramatic shapes made by the broken roof outlined against the sky. The muted color scheme creates a somber atmosphere in keeping with the subject. (Derelict Barn — Gerald Cains)

Fine linear brushstrokes of light color were laid over brown to create the texture of the rusted corrugated iron.

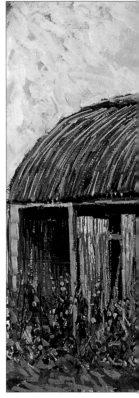

The barn is the focal point of the painting, so the foreground is treated in less detail, with brushstrokes suggesting grasses.

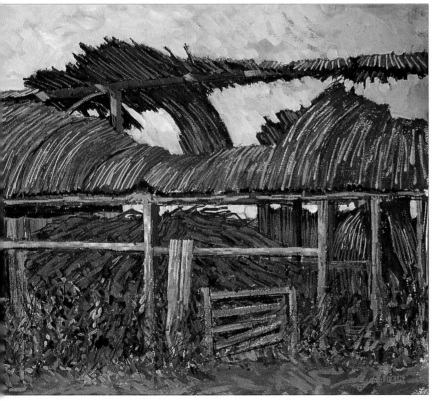

There are various ways of suggesting the texture of brick or stonework. You can use broken-color methods (see p.62), apply thick paint with a knife (see p.66), or you can mix paint with another substance (see p.69) that imitates the texture. Special mediums are sold for texturing, but sand, chosen here, is equally effective.

1 *Begin with a base color in thinned paint. Then mix the color you want, add about half the quantity of sand, and apply it with a bristle brush.*

2 *Use a little less sand for the lines of mortar between the bricks, since this has a smoother texture. Apply the paint with short downward strokes.*

Urban Landscape

SUBJECTS

Painting urban scenes is a branch of landscape art —the only difference lies in emphasis. Many landscapes include human-made elements, such as walls, fences, barns, or farmhouses, but these will usually play a secondary role, whereas in townscapes architectural features dominate. As with any outdoor painting, you must plan the composition and your treatment of the subject. In this painting the artist conveyed the atmosphere of the scene by taking a broad, impressionistic approach, suppressing much of the detail and concentrating on the main shapes and colors.

Compare the painting (right) with the photograph (below). The pale shapes of sky and water, cleaving through the middle of the picture, provided the basis for a dramatic composition. The colors of the original scene are dull, and the buildings on the left are not especially attractive. Using a range of subdued but rich colors and lively, varied brushwork, the artist produced an individualist interpretation while preserving the somber atmosphere. The painting is done on watercolor paper that was primed with acrylic gesso. (Dockhead — Debra Manifold)

Excluding unwanted detail ✒

Orchestrating the colors ✒

Varying the brushwork ✒

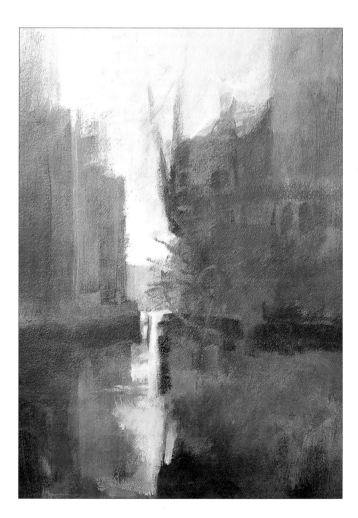

The flat, almost colorless sky was enlivened by broken-color effects and strong brushwork.

The vertical lines of the buildings were conveyed in the painting by vertical brushstrokes. All other detail was excluded.

This light shape could have split the composition in two. In the painting brushstrokes of deep blue unite the two areas of dark reflection.

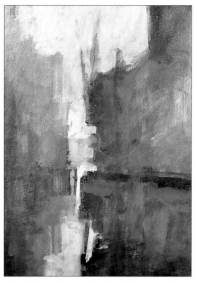

1 *The artist planned a warm color scheme, in which the red of the ironwork plays a vital role. An allover red ground was laid down first. Next, the yellow ocher base color is blocked in for the buildings.*

2 *To establish the tonal structure, the lightest tone of the water is now introduced. Thick white paint is applied over a still-wet blue layer, so that the two mix in streaks.*

3 *A layering method, with one color showing through another, was used to achieve rich effects. A wash of diluted red was laid over and below the left-hand buildings, and deep blues, reds, and greens appear in the reflections. The colors will be modified as the painting progresses.*

4 *Touches of red detail are added to help bring the right-hand building forward in front of the cranes. This will also make a color link with the red of the railings, which are the next area to be painted.*

5 *Having sketched in the ironwork, the artist uses a filbert brush to add the small, square patches of red behind it. Although much of the detail is omitted, these are important in terms of color, since they help to reinforce the focal point of the painting.*

6 *Until the final stages, the paint was thinned slightly with water, but now the red-brown is mixed with acrylic matte medium, which makes the pigment sit on the surface of the paper rather than sinking into it.*

Analysis

Cityscapes

Every large city has its own atmosphere, stemming in part from its historical background, which dictates the style of the buildings, and from climatic conditions. A city such as Venice, with its lavish churches and palaces illuminated by bright or diffused sunlight, has a very different feeling from Manhattan, or from an industrial town typically seen under lowering gray skies. These two paintings convey a strong sense of place, which derives both from the inclusion of typical features — gondolas in one and automobiles in the other — and from the tonal key (see p.100). This is somber in the painting on the right, and delicate in the one opposite.

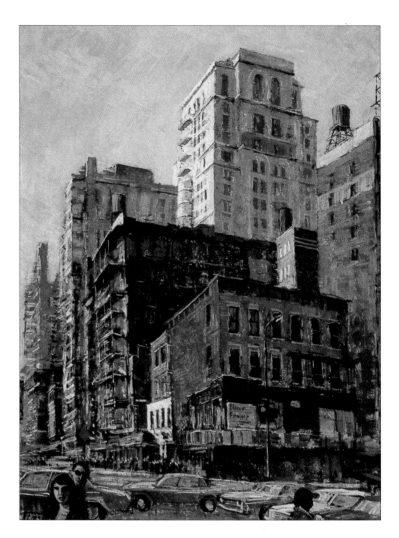

Yellowish and bluish grays in the sky echo the colors of the tall building, forming a visual link between the two areas. Sky is enlivened by crisscrossing brushstrokes.

Yellow is deliberately muted. Some foreground interest is needed, but too much color would distract attention from the buildings, which are the painting's main subject.

DARK TONES

Whether you pitch the overall tones high or low depends on the subject and what you want to say about it. You would probably not choose a low tonal key for a summer landscape, but you might for a portrait of an old person. The low-key approach was well suited to this cityscape, not only because it allowed the artist to express the atmosphere of this area of the city, but also because dark and middle tones give a sense of stability, anchoring the buildings solidly in space. The effect is enhanced by the careful control of color. Avoiding striking contrasts, the artist chose a range of harmonizing colors, giving additional richness and unity by painting on a red-brown ground. He used an oil-painterly technique, working on cardboard with mainly large brushes. (Downtown Manhattan — Gerald Cains)

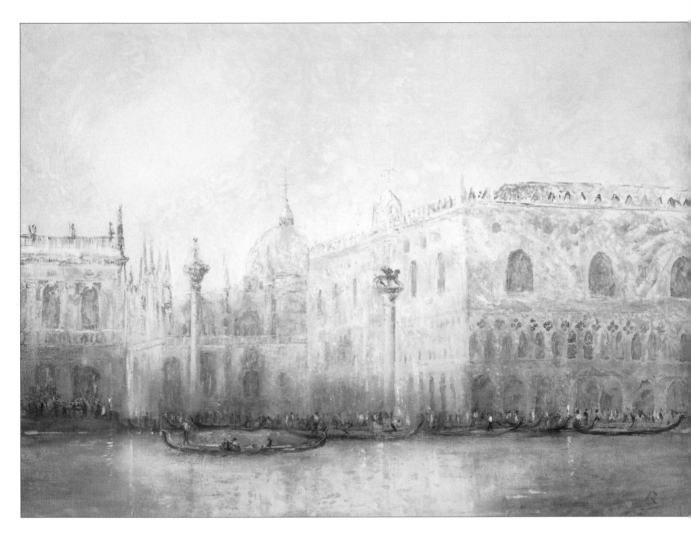

A broken-color effect — with small dabs of pale blue, pink, and ocher laid side by side — breaks up the solid mass of the wall and creates a shimmer of color.

The first layer of paint is thin enough for the canvas grain to show. Brushstrokes of thicker paint give texture.

Pinks and yellows on sunlit side of building link with those on foreground water and make a contrast with the green-blue of sky.

LIGHT TONES

This is a high-key painting, in which the darkest tone would be located around the middle of a gray scale. The artist was especially interested in the effects of light, and captures perfectly the shimmering, misty sunlight often seen in this watery city. In contrast to the view of Manhattan, opposite, the buildings here seem insubstantial, almost as though carved from the air itself. Harmonious colors were used here also, with touches of yellow counterpointing the dominant blues and setting up an understated complementary contrast. Additional contrast was achieved by varying the paint consistency from thin to thick. The painting is on canvas. (The Doge's Palace, Venice — John Rosser)

133

Still Life

When you paint a scene on the spot you must cope with difficulties unrelated to technique. The sky may begin to cloud over, causing you to work too fast. Passers-by may insist on conversation, or sit down in your view. You may be uncomfortably hot or too cold to concentrate fully.

Still life presents none of these problems, and is therefore an excellent means of building up technical and compositional skills. You can work in your own home, at your own pace. You control your subject: you can organize the lighting and arrange the group in any way you choose (see the following pages). Furthermore, you can turn to still life when the weather is not suitable for outdoor work.

THE STILL LIFE GROUP

The term still life defines any inanimate object or group of objects, including organic forms such as fruit, vegetables, or cut flowers. The choice of subject matter is therefore vast: you can paint anything, from one apple on a plate to elaborate arrangements containing many elements, colors, and textures. Your early selections will probably depend upon what you have around the house, but if you find you enjoy this branch of painting, it is a good idea to look out for paintable objects and build up a collection.

The classic still life of the past was an indoor group of objects on a tabletop, but nowadays artists are exploiting the idea of outdoor still life. There may be a wide range of subjects in your own backyard, for example, empty garden chairs, garden tools, or a pair of boots outside a door. Farther afield, you could focus closely on a group of stones on a beach, or on pieces of driftwood.

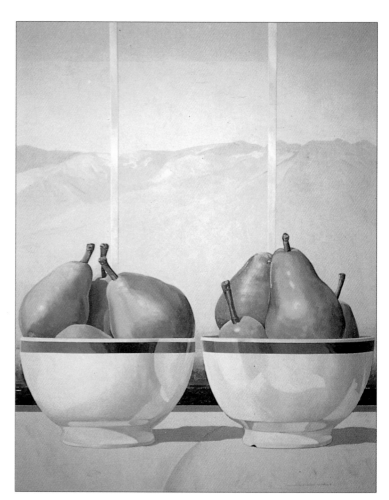

STRUCTURED SIMPLICITY

This group comprises the simplest of ingredients, but instead of aiming for the natural look, which most still-life painters seek, the artist introduced a sense of artificiality through his arrangement. The effect is enhanced by his smooth, yet hard-edged technique, and the controlled use of color and tone. As is often the case in still-life paintings, the spaces between objects — known as negative shapes (see p.137) — play an important part, with the small dark areas between and beside the two bowls balancing the shapes of the pears. (Mist on the Mountains — *William Roberts*)

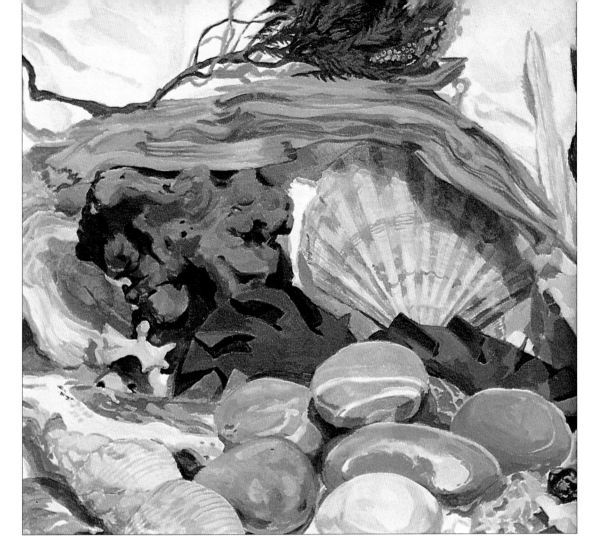

NATURAL FORMS

This painting has a more natural look than the still life opposite, partly because it features objects you would expect to see outdoors on a seashore. But, in fact, it was arranged with equal care to achieve a balance of colors, tones, and shapes, and an interesting composition. Notice how the dark tones of the metal waste in the center are echoed by those of the branch of heather at the top and the narrow dark shape on the right. The color scheme is based on the blue-yellow contrast, with the yellow of the foreground stone repeated on the shell and driftwood. (Driftwood with Heather — Jill Mirza)

ADDITIONAL COLORS

Still life is a varied subject — you may be painting anything from fruit and vegetables to a pile of newspapers on a table — so it is not possible to provide a list of additional colors that would be suitable for all eventualities. However, the first four colors shown here will help you with the vivid hues of fruit, and the others are useful for richer or more subtle color mixes.

Cadmium orange **Bismuth yellow**

Perylene red **Gold ocher**

Payne's gray **Mars violet deep**

Arranging a Still Life

In still life you do a lot of the composition before you begin to paint, so it is wise to take your time choosing and arranging the objects. Paul Cézanne, who painted some of the finest still lifes ever seen, sometimes spent days setting up his groups, which usually consisted of home-grown fruits and vegetables and humble objects from his studio. You need not go to his lengths, but make sure that the group provides an interesting and well-balanced composition before proceeding.

The objects must look as though they belong naturally together, so avoid unlikely contrasts of category. Partnering fruits with a pair of shoes, for example, would create an unsettling effect.

SETTING UP THE GROUP

When you have collected your objects, place them on your chosen surface, and move them around until the group begins to jell. Let some items overlap, because this makes a pictorial link between them, but take care that you can see both objects clearly. Do not crowd all the elements together.

In all paintings, you want to lead the viewer's eyes into and around the picture (see p. 90), so try to set up signposting devices. The folds in a piece of drapery hanging over the table front will guide the gaze to the objects. A small pitcher at the front of the picture could be placed so that the spout points toward objects farther back.

Finally, check the arrangement through a viewfinder (see p.88). This will frame the subject and give you an idea of how it will look as a painting. It will also help you to choose the format: a still life that you have envisaged as a vertical rectangle might work better as a horizontal shape, or a square.

VARYING THE FORMAT

The nature of this subject, with many objects lined together on a long windowsill, called for a horizontal format, but if the artist had used the traditional landscape format proportions he could not have included all of the objects. He therefore extended the rectangle to make a long, narrow shape that echoes that of the windowsill to back up the theme of the painting. (Windowsill — Gerald Cains)

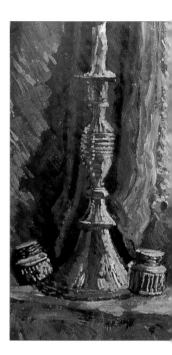

Do not overcrowd your group; simple arrangements often work best. Be prepared to discard some of your initial choices, or to replace them if the shapes and colors do not harmonize.

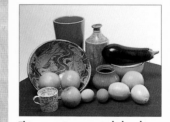

This group is overcrowded and fussy, and the objects do not fit comfortably together.

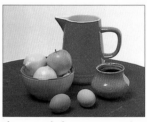

The removal of many items and the introduction of the red pitcher makes a more pleasing arrangement, with a good color balance.

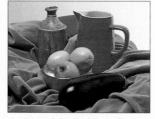

The folds of the cloth provide a sense of movement, and the color sets off those of the objects.

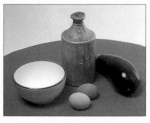

An agreeably simple arrangement, with the curve of the table balancing the circles and ovals of bowls and eggs.

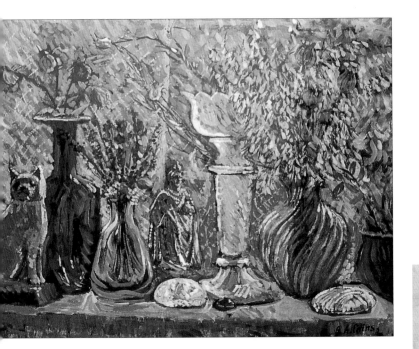

The objects are linked by their setting and by the way some of them overlap.

Placing the small pot at an angle helps to direct the eyes inward toward the tall blue vase in the center.

PLANNING AND SPONTANEITY

The bold, free brushwork and the simplicity of the subject give an immediate impression of spontaneity. But the arrangement and composition were meticulously planned to provide a perfect balance of tones, colors, and shapes. There is also a strong feeling of space. The artist was dealing with a larger area of space than that in the windowsill picture opposite, and ensured that our eyes are led from the front to the back of the painting by the overlapping shapes and the inward-pointing knife. (Still Life with Yellow Table and Knife — Stuart Shills)

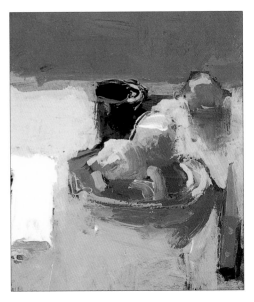

The contrast between the dark rich blue and the vivid yellow makes this the focal point, drawing the eye into the picture.

NEGATIVE SHAPES

The spaces between and behind objects are known as negative shapes. The objects themselves are the positive ones. Because there is often a lot of background in still-life paintings, these shapes play a part in the overall composition; they should not be thought of as blank areas. When you have set up your group, check out these spaces. You may have placed two objects too closely together, so that the negative shapes are thin and cramped-looking.

The fruits were arranged so that the negative shapes balance the positive ones. The reversed image below shows the effective interplay of the shapes.

Interiors

SUBJECTS

Painting domestic interiors is an extension of still life; you are still dealing with inanimate objects, but on a larger scale. Another difference is that you cannot pre-organize the subject to the same extent, though you can, of course, shift tables and chairs, and place objects to provide a focal point or touch of color.

This subject is attractive because it is so readily available, but it is often overlooked by amateur painters. Many artists, past and present, have made lovely paintings of corners of their living rooms, bedrooms, or studios. Look around your home and try to see it with a painter's eye. A chair with scattered cushions by an open window, a mantelpiece cluttered with objects, or morning sunlight streaming onto rumpled sheets may spark your imagination.

LIGHT EFFECTS

Light plays an important part in this branch of painting. A room comes to life on a bright day, with sunlight making patterns on the floor, walls, or windowsills. In the evening, when lamps are on, the colors become richer and the atmosphere cosier. Sunlight effects are, of course, short-lived, so you may need to work in shifts at the same time each day. Artificial light will not change, but may not give you sufficient illumination for your painting. Overcome this by putting a separate light source beside your easel. Or make sketches and color notes (see p.104), and construct the painting in the daytime.

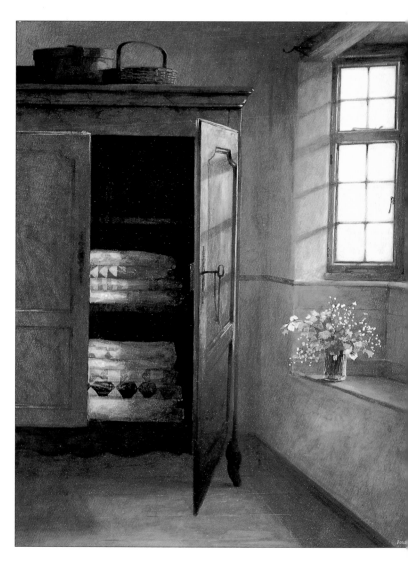

ORGANIZING THE SUBJECT

The artist made an exciting composition by slightly reorganizing his subject: opening the closet door and placing a vase of flowers on the window seat. The door and the left-hand side of the bedding in the closet catch the light from the window, so that the pattern of light and shade is continued into the center of the picture. (Armoire with Quilts — Ron Bone)

The open door makes a center of interest of the bedding, and provides a light tone to balance the flowers and window.

By opening the door, a tall shape was created, with diagonals at top and bottom, which intersect the horizontals of floor and closet.

LIGHT AND COLOR

This painting is also concerned with the effects of light, but the theme was addressed less specifically than in the painting opposite. Here, the quality of light is expressed through a high tonal key (p.100). (Interior with Eighteenth-Century Harlequin Suit — John Rosser)

The broken-color technique, with many different colors laid over one another, imparts a shimmering quality.

The delicate, sketchy treatment contributes to the light, airy impression.

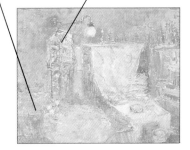

PAINT HANDLING TIP

Paintings of interiors can be spoiled by wobbly lines. For example, it can be tricky to keep paint from spilling over an edge that should be crisp. You may find it helpful to use masking tape whenever you need to create a clean edge. You can use masking tape on paper or canvas,

provided it is not too heavily textured, in which case the tape will only adhere to the raised grain, allowing paint to seep beneath.

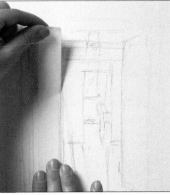

1 *Make a drawing in pencil, checking that the vertical lines are straight. Then stick down the masking tape, rubbing it gently to ensure full adhesion.*

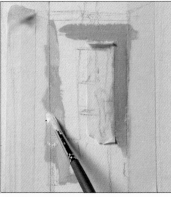

2 *You can now apply the paint as freely as you like, with no worry about keeping the edges clean.*

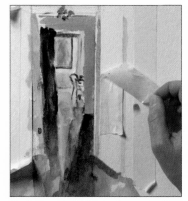

3 *When the paint is dry, peel off the tape to reveal a crisp edge.*

Fruit and Vegetables

Choosing a color theme

Building up from thin to thick

Underdrawing and underpainting

SUBJECTS

Fruit and vegetables are the ideal subjects for a first still life. They are relatively inexpensive, readily available, and provide a wide choice of colors, shapes, and textures. Another advantage is that they need not be wasted — you can eat them when you have finished the painting. The composition will usually be more interesting if you include some non-organic objects, such as crockery, for contrast. Avoid too many colors; the painting may look incoherent unless there is a definite color theme. Here the artist made a bold choice by using primary colors — red, blue, and yellow. Another possibility would be complementary colors: for example, a combination of red and green vegetables, or yellow fruit against a mauve background.

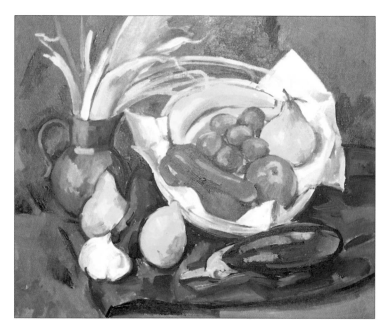

Paintings of arranged objects (see photograph, left) can look dull and static, unless you create a sense of movement in the composition. The eye must travel around the painting rather than focusing first on one thing and then another. There is a strong sense of rhythm here, with the curve of the leek top, which echoes that of the banana, guiding the eye around from the left to the right of the picture. It then travels down, via the edge of the drapery, to the eggplant, and upward again with the lemons and pitcher. The painting is on primed canvas. The artist works in both oils and acrylics, applying similar methods to both media, but for acrylic he uses synthetic brushes instead of oil-painter's bristle ones. (Still Life in Primary Colors — Ted Gould)

The gentle curve of the leek tops is exaggerated in the painting in the interests of the composition. Some detail is suppressed.

The heavy red of the background drapery is lightened in the painting to prevent it from becoming over-dominant.

The blackish purple of the eggplant is conveyed in a wider variety of colors in the painting, and the overall tone is lifted for a delicate effect.

1 To plan the composition and relationships of the objects, a light, sketchy charcoal drawing was made first. The excess charcoal was then flicked off with a rag so that it would not mix with the paint and muddy it.

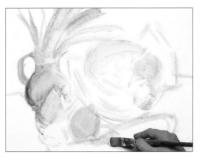

2 The charcoal drawing was reinforced by a brush drawing in heavily thinned blue paint, before establishing areas of color — beginning with the blue pitcher, and yellow fruit and eggplant stalk.

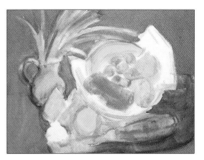

3 The transparent underpainting is complete. The advantage of working in this way is that it allows you to establish the color scheme and composition of the painting at an early stage.

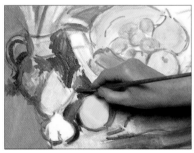

4 The colors are reinforced with thicker, opaque paint. Repeating the same or similar colors in different areas of the painting ensures compositional unity. Here the blue of the pitcher is used again for the drapery.

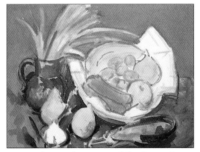

5 As the applications of thicker color progress, areas of light and shade begin to be defined.

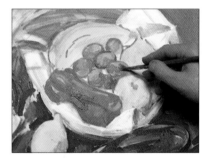

6 The artist continues the process of building up with juicy opaque paint, laying on patches of color all over the picture surface. Varying the brushstrokes helps to impart a lively feeling to the painting.

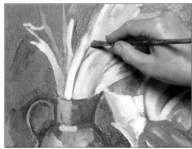

7 After applying opaque paint to the background, and taking it around the edges of the leeks, a touch of detail is added to define the individual leaves. The side of a square-ended brush is used to make a broad line of yellow.

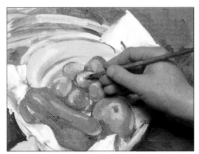

8 Highlights are usually left until last in opaque methods, because it is easier to judge how light they need to be when all of the other colors are in place. Here, a near-white highlight is modified with a touch of pale pink.

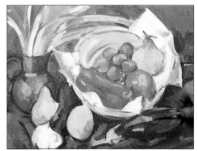

9 The dark shape of the eggplant could have been too dominant in the immediate foreground. Blues and reds were brought in before adding this gray-blue highlight to create a color relationship with the background and with the drapery.

Windowsill Still Life

SUBJECTS

There are several advantages in setting up a group on a windowsill. It gives you a good light; it provides a natural-looking setting; and it allows you to extend the composition beyond the boundaries of the objects. If there is a landscape view outside the window you can exploit the contrast between the enclosed space of the interior and the wider space beyond. Avoid putting too much detail into a landscape background: the objects should be the main focus of attention. Here the artist has edited the outside view to a single tree, but there is still a feeling of exterior space.

Setting up a still life

Working in layers

Framing a composition

The trunk of the tree interferes with the clean lines of the window bars, and is omitted in the painting. The tree is treated as an area of pattern and light.

To give a stronger impression of light, the tonal contrasts are heightened in the painting, with the use of more white.

Backlighting can subdue colors and make forms hard to read. In the painting the blue is intensified, and the shadow on the white pitcher is given a more definite shape.

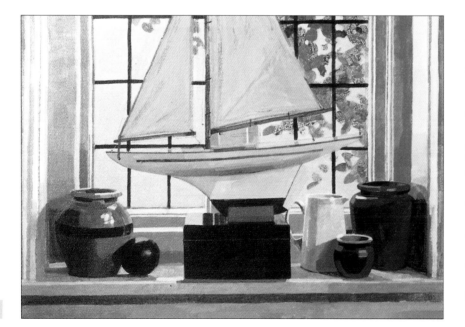

This setup (see photograph, above) gives an impression of formality and organization. This is due in part to the geometric structure of the arrangement, with the central triangle of the boat intersecting the square of the window, and the windowsill and sides acting as a frame within a frame for the objects. In the painting the effect is enhanced by the controlled handling of paint and the precise definition of shapes. The artist worked on primed canvas, using soft synthetic brushes, and built up the picture gradually with pale colors and thin paint, working up to richer colors and fuller-bodied paint. (Yacht — Ian Sidaway)

1 A detailed pencil drawing was made first, and a pale blue wash laid over the window area. A gray window border is added by pulling the brush firmly downward to make a clean straight line.

2 The artist's method is to lay a base color for each object and area of the picture, and build up in successive layers over this. Having painted the sail and hull an allover yellow-brown, a line of darker shadow is added.

3 The composition has a strong tonal structure (see pp.100-101), and the balance of light, dark, and middle tones is established early, with the foreground objects painted next. These are the darkest tones in the picture, and will be intensified as work progresses.

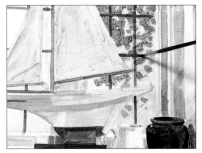

4 The tree was painted with a middle-toned green to help the light-colored sails to stand out. The dark gray now used for the window bars brings them forward in space as well as providing a tonal balance for the foreground objects.

5 Additional layers of semi-transparent color are applied to the vase to build up the form. The highlight was reserved as white canvas to provide a key for judging the middle tones, but this will be reinforced with opaque white paint later.

6 The front edge of the windowsill requires strong definition. A brush well loaded with thicker gray paint is drawn along it, straightening up the edge and increasing the tonal contrast. A short-handled brush is used, held near the ferrule for maximum control.

7 Here, thick, cream-colored paint is laid over the darker underpainting, leaving a little of it showing to suggest the folds of the fabric.

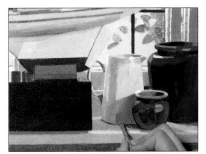

8 The shadow thrown on the white pitcher is important because it helps to make the blue pot stand out and it creates an interesting shape. Thick, yellowish gray paint is applied over the first thinner application of blue-gray.

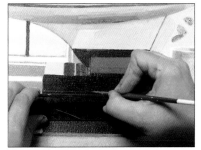

9 This fine line running across the pedestal of the boat requires careful treatment; any unevenness would jar the eye. A fine pointed brush held against a ruler is used to ensure a straight line.

Shape and color

Many still lifes have a theme running through them. Sometimes artists paint objects that have personal significance, such as favorite books, or souvenirs of an exotic vacation, to express an aspect of themselves. But the theme can be a purely pictorial one of color or shape. These two paintings have a theme based on two main color contrasts: yellow and blue in one; and red and blue in the other. Both have a shape theme also, but a dissimilar one. The composition of the fruit still life (far right) is based on a repetition of similar shapes — circles and ovals — while in the teapot and box painting (near right), the artist explores the interplay of different shapes.

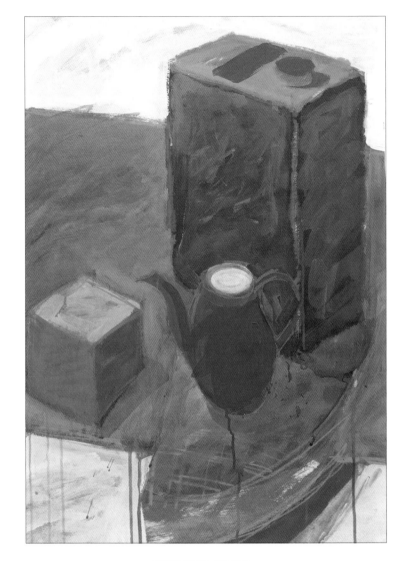

A number of different colors show through one another to give a luminous glow.

Brushstrokes of thin, semitransparent pink are scumbled over thicker applications of red and blue. The patches of still-visible blue make a color link with the pitcher.

Thinned paint was allowed to dribble down the paper, contributing to the free, spontaneous feeling of the composition.

OVERLAYING COLORS

A simple grouping like this, featuring mundane objects with little intrinsic beauty, could look dull, but this painting certainly does not. The contrast of shapes catches the eye, and so do the wonderfully rich color effects. The small area of green provides a near-complementary contrast that enriches the reds, but what makes each individual area of color so vibrant is the way the paint is used. One color is allowed to show through another to build up a scintillating glow. You can see this effect especially clearly on the tall box. The artist worked on paper, using both medium-consistency paint and thin, transparent washes and glazes. (Still Life with Blue Coffee Pot — Paul Powis)

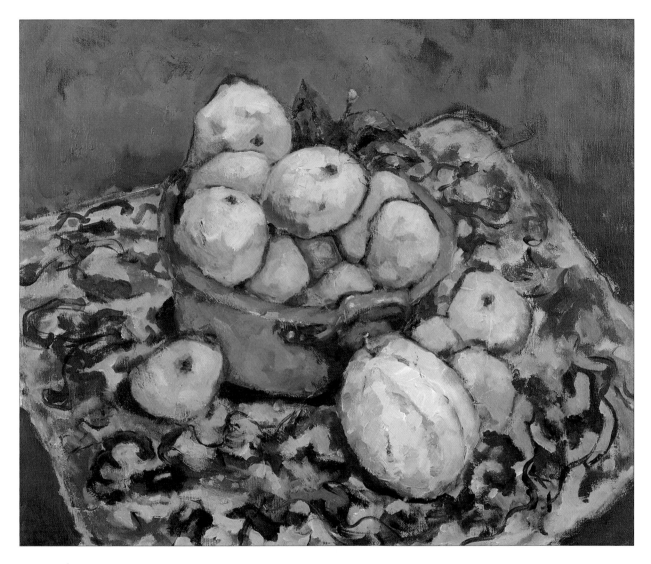

This group of leaves, the same tone as the dark patches in the background blue, forms a visual bridge, uniting the two areas of the picture.

Brushstrokes of thick impasto help to bring the melon forward in the picture space. Touches of blue in the shadows link it with the bowl.

The forms of the fruit are built up with broad strokes of a square-ended brush. A variety of different yellows, oranges, and yellow-greens are used, but kept close in tone, so that they read as one color.

COLOR AND COMPOSITION

Much of the impact of this painting stems from the contrasts of color and tone, with the deep, rich blue making the yellows call out. The color scheme is deliberately restricted, with similar blues used for both the bowl and the background, and the neutral colors of the cloth providing the perfect foil for the lime green of the melon. The painting conveys a feeling of strength and solidity, partly because the forms are so convincingly modeled, but also because of the well-balanced geometric structure of the composition. The group of fruit forms a rhomboid shape sloping to the left, counterpointed by the roughly rectangular shape of the patterned cloth sloping in the opposite direction. The painting is on canvas, and the artist uses the paint thickly throughout. (Tangerines — W. Joe Innis)

145

Flowers

SUBJECTS

One of the great advantages of flower painting is that you need never be at a loss for a subject. Whether or not you grow your own flowers, freshly cut blooms and foliage can be obtained even in winter. Or you could paint dried flowers. These can make colorful groups, and will remain unchanged, unlike fresh flowers, which begin to decay even before you have the chance to put them into a vase.

Cut flowers may last for a week, but you cannot take a leisurely approach to your painting, because your arrangement will alter in the course of a day. Even if blooms and leaves do not wither, other changes will occur; buds that were tightly curled when you put them into the vase will gradually unfurl.

For this reason it is wise to begin with a simple group, or to simplify by the way you paint. Flowers are complex in shape, and an elaborate arrangement of different species could take a long time to complete if each bloom is painted in detail. You can treat flowers broadly and still give the impression of a particular type as long as you get the shapes, colors, and proportions right — and your painting will have more life than if you labor over every petal and stamen. Once you have chosen and set up your subject, analyze it in terms of shape and color. Look first for the shape made by the group as a whole, and then at the individual shapes of the flowers and leaves. It can concentrate the mind to make one or two quick pencil sketches before you paint. This will also help you to select what is most important. You may find that you can create a more exciting painting if you omit some of the smaller flowerheads, and perhaps treat leaves as a broad area of tone and color rather than portraying each one.

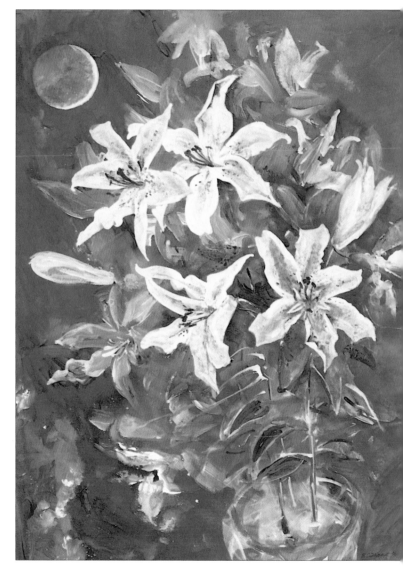

SELECTIVE DETAIL

The four central blooms are treated more precisely than those behind, where white brushstrokes were painted over the background blue in order to merge with it. The shapes of the flowers and petals are accurately observed, but the artist was less concerned with strict realism than with creating a sense of atmosphere; this is achieved by linking the flowers with the moon and night sky. (Stargazer Lilies — Ros Cuthbert)

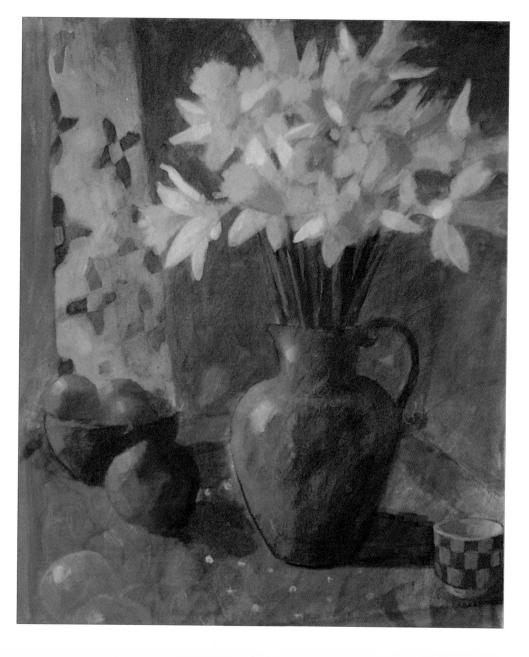

WORKING BROADLY

There are many different elements in this painting, and it would have taken a long time to complete if each had been treated in detail. Instead, the artist simplified, using broad brushstrokes for the flowers, but bringing the nearer ones into sharp focus with stronger contrasts of tone and carefully shaped marks of pale yellow where certain petals catch the light. (Daffodils and Blue Pot — Anne-Marie Butlin)

ADDITIONAL COLORS

The vivid colors of flowers are hard to imitate successfully in paint, especially if you are relying on mixtures, so it is a good idea to invest in one or two extra reds, yellows, and purples, and an orange. The tube versions of the two secondary colors — purple and orange — are purer and brighter than those made by mixing the primary colors given in the starter palette (p.28).

Permanent rose

Quinacridone red

Azo yellow

Cadmium orange

Quinacridone violet

Quinacridone magenta

Composing a Floral Group

SUBJECTS

In a still life or landscape there are usually several components to arrange into a composition, but a floral group contains only one key element — the flowers in their container. The simplicity of the subject often distracts attention from composition. Because the flowers are what you are painting, it seems natural to place the group in the middle of the picture. But as we have seen (see p.86), a painting will nearly always be more interesting if you avoid symmetry. When you have arranged the group, look at it through a viewfinder (see p.89). If you want the vase in or near the center, break the symmetry by letting the flowers themselves form an irregular shape — perhaps taller at one side. If the arrangement does not seem to fit comfortably within the rectangle of the picture, there may be too much space around it, so do not forget the option of cropping (p.87) at the top or sides.

BACKGROUNDS

It is important to remember that backgrounds are not just blank areas; they are part of the picture and require as much attention as any other. In flower paintings, the background is often left vague, as a suggestion of space to provide a context for the flowers, but even so, the tones and colors must play their part in the overall effect. Sometimes the background can exert a more positive role. You might, for example, put your arrangement on a windowsill, with the window bars providing a geometric framework to set off the freer forms of the flowers. You could make pattern the main theme of the picture. Flowers have an inherent pattern, which you could stress by introducing pattern around and behind them, choosing a piece of printed fabric as part of the setup.

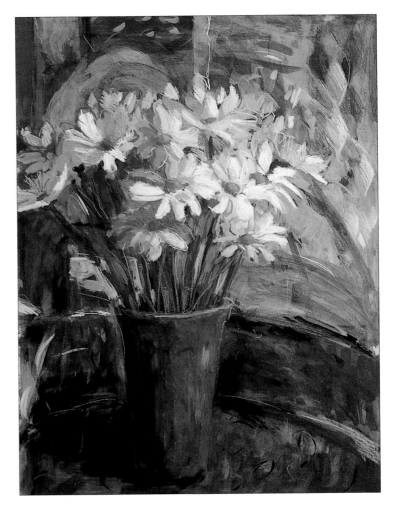

A LIVELY FEELING

Bear in mind that flowers are living organisms, and try to find ways of preventing them from looking too static. This artist conveyed a feeling of vitality through the composition of the group and through her handling of the paint. The curves in the foreground form the perfect counterpoint to the upright shape of the vase and echo the curve of the petals on the right. Loose, sweeping brushstrokes follow the curves, and are repeated on the generalized background. (White Daisies — Anne-Marie Butlin)

The broad brushstrokes of thinned white follow the top curve of the flower group, and the verticals echo the upright of the vase.

COMPOSING WITH SHAPES

The arrangement of shapes and the interplay of dark and light tones is the visual theme of this painting, and the artist avoided adding detail that could have weakened the impact. The groups of flowers are treated as broad areas of dark but subtly varied color, and the brilliant red of the poppies sings out against the dark tones on one side and the grays of the background on the other.
(Flower Study — *Debra Manifold)*

The composition is based on the dark wedge shape that cuts diagonally across the picture.

LIMITING THE COLORS

When choosing flowers for a painting, avoid too many contrasting colors, because these will compete and create a jumpy effect. Many of the best flower paintings use a limited color range, such as yellows and creamy whites, with one or two blue or mauve blooms for contrast. An alternative is to select harmonious colors (see p.94), such as pinks, mauves, and blues, or more strikingly, reds, oranges, and yellows.

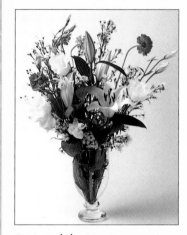

A quiet and pleasing arrangement in which blues contrast with yellows and creamy whites, and are offset by the deep greens of the foliage.

This group is more dramatic, but in spite of the vivid colors it has an inbuilt harmony, because the reds and yellows are closely related colors.

Flowers in Their Habitat

SUBJECTS

The outside world provides a rich and varied source of subjects for the flower painter. Those who have yards are fortunate, because they can combine horticultural and artistic interests. What could be more rewarding than immortalizing a particularly successful flowerbed, or a shrub that you have nurtured from infancy? But non-gardeners need not feel deprived, because equally exciting subjects can be found in public parks and gardens.

If you venture into the countryside, you will have a chance to paint wild flowers. These look best in their natural habitat, and do not take readily to being cut and placed in vases. In fact, picking wild flowers is often actively discouraged in the interests of environmental protection.

PICTORIAL CHOICES

Outdoor flower studies are landscapes in miniature, involving a similar decision-making process. Will you place the flowers in the foreground or in the middle distance? Will you focus on a group of flowers, or even one or two blooms, and treat them in detail, or take a broader approach?

To some extent the subject will dictate the answers. Large, dramatic, or vividly colored flowers, such as sunflowers, roses, or lilies, could benefit from a close-up viewpoint, while small densely growing flowers, such as bluebells or primroses carpeting a wood, could be placed in the middle distance and treated as a broad mass of color. A yard filled with contrasting colors might be dealt with in the same way, with one or two of the nearer flowerheads and leaves picked out in detail.

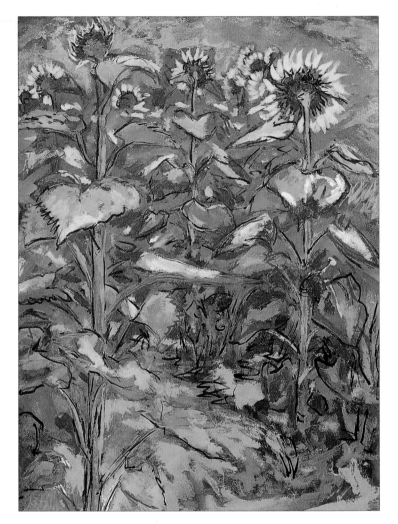

FLOWERS IN CLOSE-UP

Some flowers make their impact en masse, *while other dramatic types demand a more closely focused approach. The artist merely suggested the outdoor setting in order to give the tall sunflowers, with their large flowerheads and well-shaped leaves, pride of place in his painting. He chose to paint them from behind, emphasizing their habit of turning their heads toward the sun.* (Sunflowers From Behind — *David Cuthbert*)

Some of the leaves were outlined with linear brushstrokes of dark red, but here a black-ink pen was used to emphasize the crisp edges.

Each petal was painted with one stroke, the brush flicked outward at the end to taper the shape.

If all of the flowers in your painting are the same kind, for example, poppies or daisies in a field, those in the background will be recognizable simply as blobs of color, provided you treat the foreground flowers in greater detail. To do this, establish the main shapes and colors first, using thin or medium-consistency paint, then add detail in thicker paint when the picture is nearing completion.

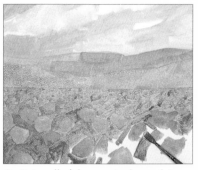

1 Paint all of the poppies by applying separate brushmarks of red, then take green around them. Do not make the flowers all the same shape, and make them smaller in the background.

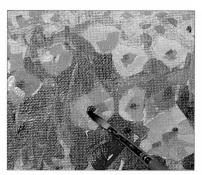

2 Begin to define the foreground flowers, using thicker paint and introducing variations of tone and color suggesting individual petals. Finally, fill in the centers with a pointed brush.

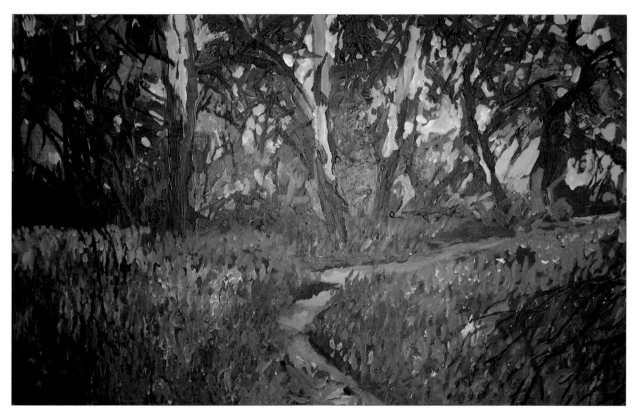

GIVING VISUAL CLUES

To depict a particular type of flower without going into detail, your first consideration must be color, which will give viewers a powerful clue. But color is not enough on its own; you must also convey an impression of how the flowers grow. There is no detail in this painting, but the solid mass of brilliant blue is immediately recognizable to anyone familiar with carpets of bluebells. (Bluebell Woods, Winterbourne — Daniel Stedman)

Each flower is painted with one brushstroke, upright or slightly slanting. The pink-brown of the path, and dark gray-greens in the background, intensify the blues.

151

Flower Shapes

project

6

Exploiting positive and negative shapes

Working wet into wet

Unusual effects with cardboard

SUBJECTS

One of the chief attractions of flower painting is the opportunity the subject provides for studying the interaction of different shapes. Large blooms that do not present too much detail provide a superb basis for bold statements of color and form. These white lilies, with their elegant spiky and curling petals, were an ideal subject. Placing them like this against a dark blue background provided a strong contrast of tone, which can help an artist to exploit the negative shapes (see p.137) as well as the positive ones.

Folds in the drapery weaken the impact of the negative shapes, so are omitted in the painting. Instead, broad, downward-sweeping brushmarks echo the shape of the vase.

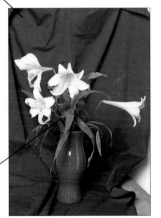

The mass of central leaves is slightly simplified in the painting. Color is lightened and yellowed to provide a better contrast with the background and to echo the yellow of the stamens.

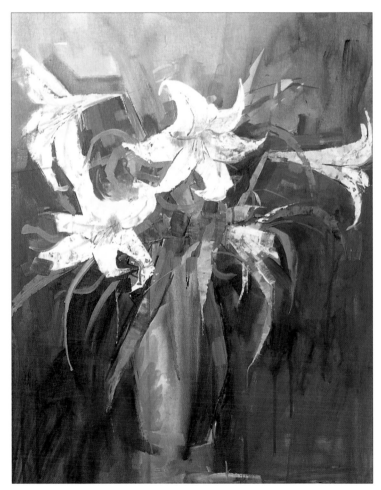

In this painting, above (setup photograph, left) there is enough detail to carry conviction, but the blooms are treated broadly, and the background and vase even more so. The painting is on canvas board with transparent and opaque techniques combined. Thin watercolor-type washes were used for the background and vase, and thicker paint for the flowers, which helps them advance to the front of the picture plane. (Lilies in the Blue — Mike Bernard)

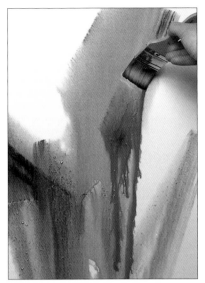

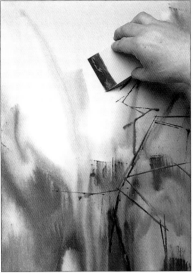

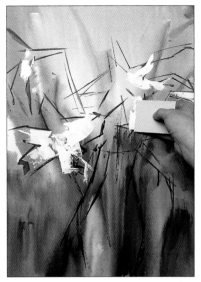

1 *The canvas board was dampened all over to enable the background to be worked wet into wet with transparent, watery paint. A broad, soft brush is used, and the drawing board is held upright on an easel so that the colors flow downward and mix.*

2 *Instead of drawing the flower shapes with a pencil or brush, a piece of cardboard is dipped into paint and the edge is pressed into the paper to give a series of straight lines.*

3 *A clean piece of cardboard is used to apply opaque white paint to the petals. This method is similar to knife painting, but produces a flatter layer of color, which only partially covers the color beneath. On the left-hand bloom there is a broken-color effect, where small patches of blue show through.*

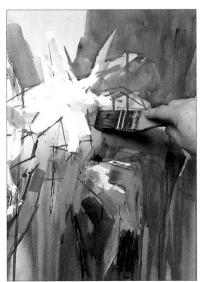

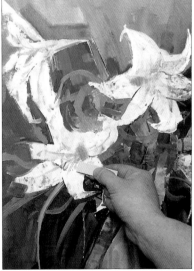

4 *With the flowers and some of the leaves blocked in, the artist can now assess how much to deepen the color of the background. Using the transparent method, a broad brush is employed to apply a rich blue above and around the flowers.*

5 *The leaves and flowers were built up more strongly with opaque paint, and the painting is nearing completion, needing only touches of definition. A small piece of cardboard is used for the stamens, which play an important role in the overall color scheme.*

6 *Finally, a very fine brush is used to draw a precise dark line suggesting the division of the petals. Notice that dabs of yellow were added on the flower to link with the yellow-green of the foreground leaves.*

Floral Still Life

SUBJECTS

Painting flower groups in an indoor setting is a branch of still-life painting, and needs just as much planning as any other form of still life. The more care you give to arranging the group and choosing the color scheme, the better your chances of success. Here, a muted blue and yellow color theme is employed. The panels of stained glass not only provide color accents in the background but they also emphasize the upward thrust of the flowers and provide a shape balance for the tall vases.

Controlling the colors and tones

Using an imaginative approach

Making a monochrome underpainting

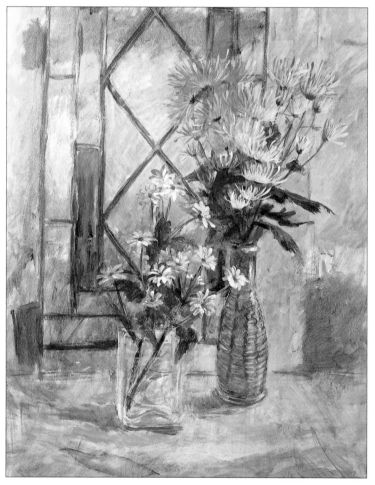

The sharp tonal contrasts between the flowers and leaves are much reduced in the painting, and the flowers simplified.

The strong tonal contrasts in this area provide the focal point for the painting. The detail of the leaf shapes needed to be simplified to increase their impact.

This dark area lacks visual interest. In the painting it is "lifted" and enlivened by the use of thin scumbled glazes of blue-gray over varied brushmarks of light brown.

Even when you arrange a floral group with care, it can seem to lack an important ingredient. In this case the artist wanted to give an impression of light, which is absent in the setup (see photograph, left). So she incorporated the stained glass into an invented window, with blue sky beyond, which reflects onto the tabletop. Her technique is based on washes and glazes of thin, semitransparent paint over a monochrome underpainting.
(Still Life with Flowers — Ros Cuthbert)

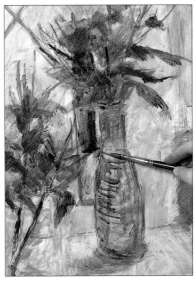

1 *The main shapes were blocked in with diluted paint, in a cool brown that blends with the overall color scheme of blues and browns. The tones were kept light so that transparent colors can be laid over them.*

2 *Still using the paint in the watercolor mode, the artist lays blue lightly over the underpainting with a soft brush, starting the gradual process of building up the colors.*

3 *The blue panel of glass was painted, and the same deep, rich blue is used for the ribs of the vase. Because the paint is still transparent, the underpainting comes through slightly to impart a greenish tinge.*

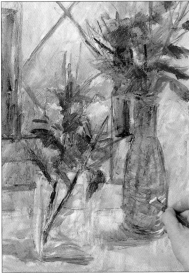

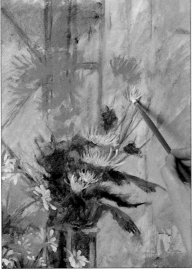

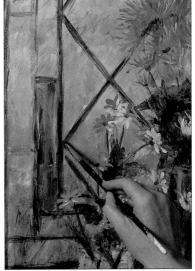

4 *The highlights on the ribs of the vase are important, since they give it solidity, so these are added next, with opaque white. Now that the blue paint is dry you can see the subtle effect of the greenish brown flower stems showing through the blue.*

5 *The flower shapes were blocked in with opaque gray. A single stroke of creamy pale yellow is used to define the petals. On the completed flowers the yellow darkened slightly as it sank into the gray.*

6 *Throughout the working process, one tone and color is assessed against another in order to make adjustments. The window leads need strengthening to provide a balance for the dark green leaves. For this, a stronger version of the brown of the underpainting is used.*

Analysis

Description and suggestion

The amount of detail you include depends both on the subject and on your intentions toward the picture. In the painting on the right the artist was primarily interested in the effects of light streaming through the window to highlight the flowers and creating a rich medley of colors on the tabletop. This pictorial message would have been weakened by detail, and the flowers are suggested rather than literally depicted. It is the color that is important, not the type of flowers. In the painting opposite, the artist focused on the dandelions, treating the feathery heads and long stems in almost botanical detail, but leaving the background as an undefined area of dark tone.

A dry-brush method (p.62) creates the broken-color effect of the light bouncing off the flowers and leaves.

To prevent the vase standing out too strongly, similar colors were used both here and in the foreground, with the pattern only lightly suggested.

The colors used for the tabletop are kept close in tone so that they blend.

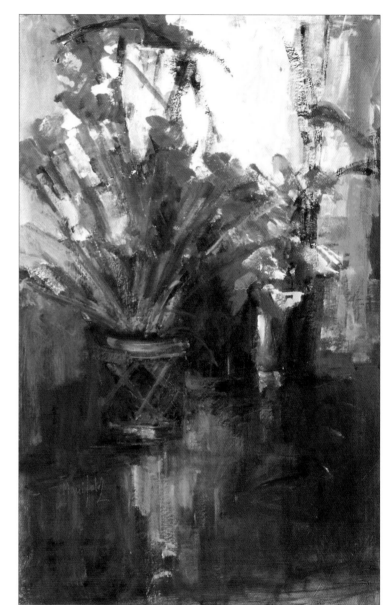

COLOR AND BRUSHWORK

*The painting derives much of its power from a range of rich, warm, harmonizing colors (p.94). The red flowers set the color key. Reds are carried through into the foreground, where they mingle with closely related and pinkish yellows to give the picture a perfect unity of color. An equally important factor is the decisive brushwork, which imparts an energetic feeling as well as contributing to the composition. Notice how the broad, vertical brushstrokes used for the light patch on the table lead the eyes up to the flowers. (*Floral Portrait*— Debra Manifold)*

DEGREES OF REALISM

The background is vital to the composition in providing an area of dark tone against which the flowers and stems stand out. But there is another, more subtle purpose. The contrast between the generalized background and the detail of the plants creates an atmosphere of mystery; they are isolated in space rather than being placed in a naturalistic environment of grass and leaves. Nor are the plants themselves entirely naturalistic. Although obviously living organisms, they are carefully arranged in a way that would seldom be seen in the natural world. This intriguing hint of the unreal gives the painting additional impact. (Five Dandelion Clocks — Ros Cuthbert)

The dandelion "clocks" are treated with a high degree of realism. To describe their light, feathery texture, they were painted over the dark background, with successive layers of thinned white paint.

To give interest to the background, tones and colors are subtly varied, with dark gray scumbled (p.63) unevenly over a yellow ground.

The stems and dead flowerheads are important to the composition, and the curves have been exaggerated in order to lend pattern interest to the lower part of the picture.

Painting People

Many inexperienced artists shy away from living subjects, or try a portrait once or twice, and become discouraged. There is no point in pretending that painting people is easy. Because the human form presents such a complex inter-action of shapes and forms, it represents the ultimate challenge, demanding careful observation and a high standard of drawing.

But try to rise to the challenge. Even if you only want to include figures as incidental features in a landscape, or to give credibility to an urban scene, you must be able to depict them accurately. They best way to teach yourself is to draw as often as possible. We live in a much-peopled world, and you will never run out of subjects. If you cannot join a life drawing or portrait class, draw your family and friends; take a sketchbook with you when you go out, and make studies of people on trains or buses, or sitting in cafés.

DRAW BEFORE YOU PAINT

Most painting subjects require some planning in the form of an underdrawing, and for figure work it is essential unless you are very prac-ticed. Although you can make corrections as you paint, you want to avoid making too many, because this can detract from the pleasure of applying the color. Begin with a light pencil drawing, erasing if necessary, and do not paint until you are sure the drawing is correct. When painting, stand back fre-quently from your work to see whether amendments are needed. If you are not sure, hold the picture up to a mirror. This makes it easier to pinpoint problems, because it pre-sents you with a reversed, and therefore less familiar image. The reflection also helps you to see whether or not the composition is satis-factorily balanced.

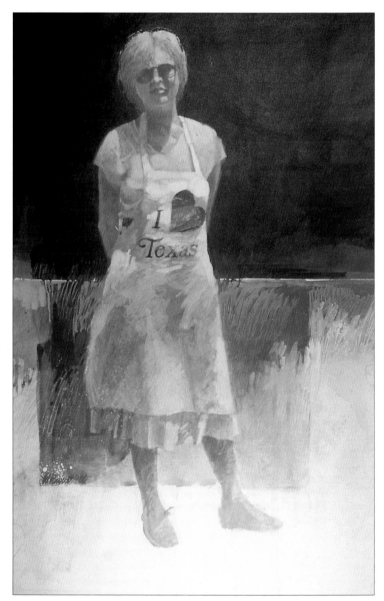

BALANCING THE FIGURE

When painting a standing figure, look for the way the weight is distributed, because this affects the whole body. Here the model stands with most of her weight on one foot, so the hip that carries the weight is pushed upward. (The Yellow Rose of Texas — Al Brouillette)

Unlike the model in this photograph, few people conform exactly to a standard type, but it is useful to know the basic proportions of the body. Common mistakes are to make the head, feet, and hands too small, and the legs too long. The average body is seven and a half heads high, with the halfway point at the crotch. The outstretched hand will cover the face from chin to forehead, and the length of the foot is equal to the height of the head.

FIGURES IN A SETTING

A painting like this, where the figures are only one element among others, is more demanding in terms of composition than the portrait opposite, but does not require such a high standard of figure drawing. For the picture to work, however, the figures must look realistic. Although there is little detail, and the treatment is sketchy, the shapes and postures are convincingly depicted. (Lunchtime at Café Rouge — Debra Manifold)

Painting skin requires more careful observation and practice in mixing colors than any other subject. There is no one color that will guarantee success. You can mix most flesh tints from the starter palette (p.29), but the colors shown right could be helpful additions, and can be used either in mixtures or for glazes.

Naples yellow

Burnt sienna

Raw sienna

Quinacridone burnt orange

Transparent yellow

Permanent rose

Portraiture

SUBJECTS

Achieving a recognizable likeness of a person is very satisfying, but this aspect of portraiture can equally well be carried out by the camera. For the artist, the likeness, although important, is only one concern. If the portrait is to succeed, you must give the same amount of attention to composition and color as you would for any other subject. Some hints on composition are given on the following pages.

Try to express something about the character and interests — and perhaps the occupation — of your sitter. Consider the question of clothes when you ask someone to pose for you. People look more like themselves in their habitual attire, and someone you often see in casual clothes can appear unfamiliar when dressed up. If you are asked to paint someone, they will probably have their own ideas about clothing, however, and the apparel might derive from the occasion such as a graduation or a wedding.

THE SETTING

The setting depends upon the kind of portrait you intend to paint. There are three main types: a head and shoulders; a half-length, which includes the body down to the hands; and a full-length, showing the whole body, either seated or standing. The setting is unimportant for the first sort, because all you will see is an area of space around the sitter's head. You can adopt the same approach for half- or full-length portraits, leaving the background vaguely suggested, but you could use the opportunity to add some information by painting the sitter at home or at work, surrounded by personal objects.

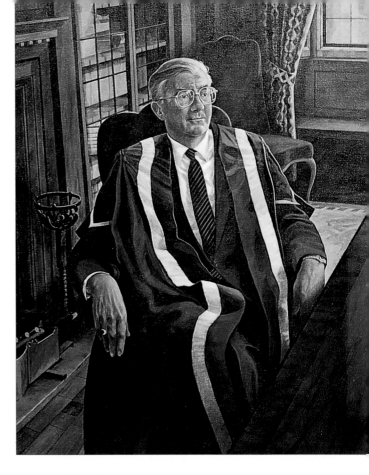

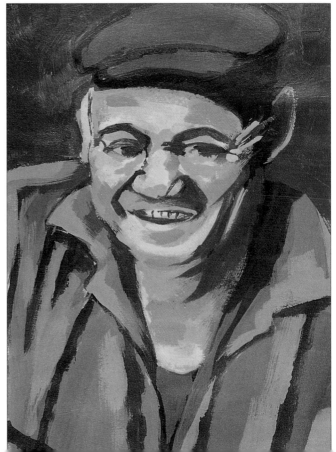

SETTING AND COMPOSITION

When you paint friends or family, you can select the setting and the sitter's clothes, but for formal commissioned portraits the patron will usually do this. The artist's choices are thus more limited, but he or she still has control over the composition. This portrait is artfully planned, with the stark black and white of the figure framed by the middle tones of the room. (Professor Eric Sunderland — David Carpanini)

The perspective is slightly distorted, as it might be in a photograph, so that the side of the fireplace echoes the diagonal slope of the figure.

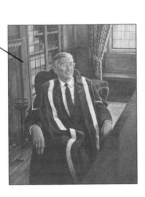

FACIAL EXPRESSION

This artist enjoys making quick portrait studies of working people dressed in their everyday clothes, and the painting is one of a series. The features are broadly treated, but the artist has expressed the jovial nature of the sitter by capturing what is obviously a characteristic facial expression. (French Worker — Sara Hayward)

The broad brushstrokes and lack of detail testify to the rapidity of execution.

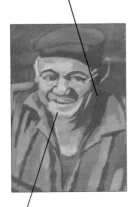

The smile affects the entire face, not just the mouth.

PROPORTIONS OF THE HEAD

Head and face shapes vary widely, which is what makes portraiture so fascinating, but there are some basic rules about proportion that will help you to pinpoint individual differences. It is not always realized how much of the total head area is made up by the forehead and crown: the head's halfway point is the middle of the eyes. Ears are often made too small; in fact they line up with the brow and the bottom of the nose. There is approximately one eye's width between each eye and, taking a line downward, the inner edge of the eye's pupil aligns with the corner of the mouth.

PAINT HANDLING TIP

Hair is seldom a solid mass of the same color: there will be variations of hue and tone caused by the effects of light and shadow. But the secret of painting hair is to avoid too much detail. Block in the main shape and then use directional brushstrokes to suggest the flow of the hair, or individual curls and waves.

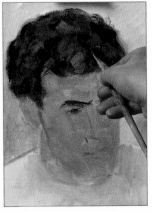

1 *Always look for the main shape first, to ensure that the hair is related to the shape of the head. Use the paint thinly at this stage, with a scrubbing action of the brush to give the impression of texture.*

2 *Now use thicker paint, and apply it with a square-ended brush, with brushstrokes following different directions to build up the impression of curls and waves. Use a variety of colors, but keep them close in tone.*

Composing a Portrait

The two main technical tasks of the portrait painter are to achieve a likeness and to make the forms appear solid and three-dimensional. Neither of these is easy, which often causes beginners to forget that a portrait also requires a structured composition. If you are painting a head-and-shoulders portrait, you may think it does not need to be composed because there is only one element to deal with — but it does. You must decide upon your angle of viewing, how you will place the head, how much space you will leave around it, and at what point you will cut off the body.

VIEWPOINT AND COMPOSITION

The golden rule of avoiding symmetry (see p.86) applies as much to portraiture as to any other branch of painting, though it can be broken on occasion: a symmetrically placed head seen from directly in front can give a powerful feeling of confrontation. A profile does the opposite. It can present an excellent likeness, but it will not engage the viewer, because the subject is looking out of the picture. Many portraits show a three-quarter view, with the eyes looking out. This angle has the advantage of breaking the symmetry, because the shoulders are seen at a slant, with one higher than the other.

Where you cut off the body in a head-and-shoulders portrait depends to some extent upon the sitter's clothing. The traditional cutoff point is just below the neck. But if the sitter is wearing an open-necked shirt, or a low-cut V neckline, the best cutoff point would be immediately below the opening, not in the middle of it, which could give the impression of the head and neck being arbitrarily chopped off. Half-length portraits usually show the body down to the hands.

PLACING THE FIGURE

This shows a conventional and always pleasing compositional structure for a half-length portrait, with the body placed to one side and viewed from a three-quarter angle. The chair was cropped on the left, and the body framed just below the hand. (Model at Alston Hall College — Nolan Abbott)

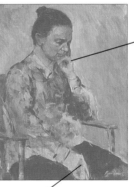

The pose, with head resting on hand, combines with the quiet color scheme to give a pensive atmosphere to the painting.

The hand was only lightly suggested, because a detail here would steal attention from the face.

When you are setting the pose for a head-and-shoulders portrait, consider the direction and intensity of the light, both of which play an important role. Soft, side, or three-quarter lighting are favored choices, because they create areas of highlight and shadow that model the forms well. Direct front lighting is usually less satisfactory. You can use natural or artificial light, but take care that the latter is not too harsh. Strong light creates dramatic effects, but these would be unsuitable for portraits of young people or children. If side lighting makes the shadows too dark, prop up a piece of white cardboard on the dark side to reflect some of the light.

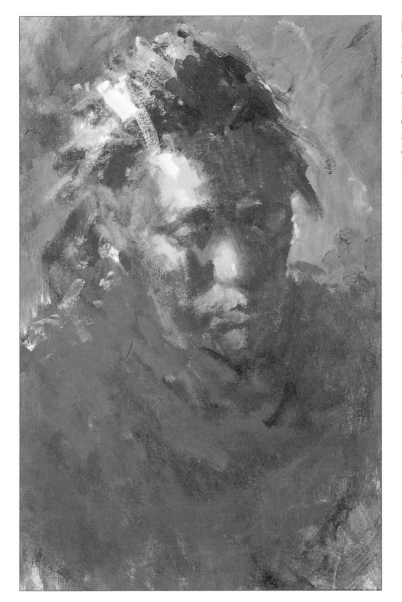

PLACING THE HEAD

Following the usual practice for a head-and-shoulders portrait, the head is seen from an angle and placed slightly asymmetrically. But the sitter's downward gaze hides the eyes and gives the painting a brooding quality. Before embarking on a painting, the artist spends time studying his sitters, looking for the most expressive pose rather than the one that shows the features most clearly. ('Bess' — Ken Paine)

These broad strokes, dry-brushed over darker color, emphasize the downward diagonal thrust of the head.

Strong side lighting gives the composition drama, and creates rich golden highlight areas.

Lighting from the front.

Strong side light.

Light from above and to one side.

Outdoor Figure Groups

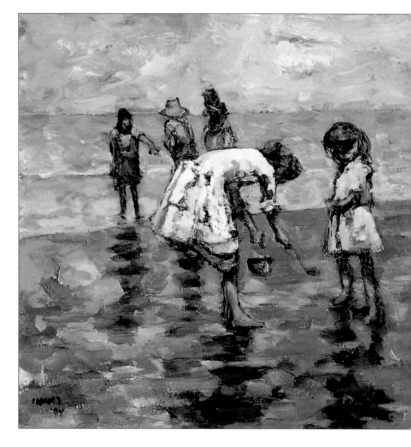

SUBJECTS

When you paint outdoors, you are bound to come across promising subjects that include people, and that would not be meaningful without them. You could not capture the busy atmosphere of a city if you excluded its complement of humanity; a popular summertime beach would not be convincing without children at play and the swimsuit-clad people lying on vividly patterned towels.

Painting figure groups presents different problems from portrait painting. You are not concerned with strict likenesses, but you do want to distinguish the people from one another. Rather than analyzing facial features, look for overall shapes, postures, and ways of moving. You must also arrange the figures to form a well-balanced design and express the interactions between them.

GROUP DYNAMICS

Any group of figures will have something in common. Several people walking down a street, strangers to one another, will share the same setting and the same weather conditions. A group of children building sandcastles, or a family enjoying a picnic, will be linked by a communal activity. These are narrative links: to achieve a coherent composition, pictorial ones are needed also. To avoid isolating a figure, you can let another one overlap it. Spatial relationships can be suggested by allowing the arm or leg of a foreground figure to cut across the body of another one behind. If figures are separated by space, link them by repeating colors. The red of a garment, say, could be introduced in small quantities in the clothes of other figures. Shadows can form a bridge between figures, leading the eye from one to another.

PICTORIAL LINKS

This composition is artfully planned so that the figures are linked both to each other and to the surroundings by repeated colors and overlapping shapes. Notice also how well the shapes and tones are balanced, with the bending figure forming a horizontal light-toned shape that cuts across the darker verticals of those behind. (The Sand Players — W. Joe Innis)

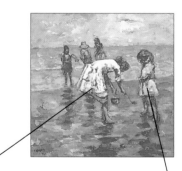

Touches of the deep mauve-blue used for the dress of the background girl are repeated here.

The blues in this dress form a color link with the sea and the puddles of water in the sand.

NARRATIVE ELEMENTS

*These figures are linked through their shared conversation and environment (see the storytelling aspect of painting on page 170). But there are pictorial connections also, with the device of overlapping used to bond the group and explain both spatial relationships and the relative sizes of the figures. (*And Far Away the Silence Was Mine *— David Carpanini)*

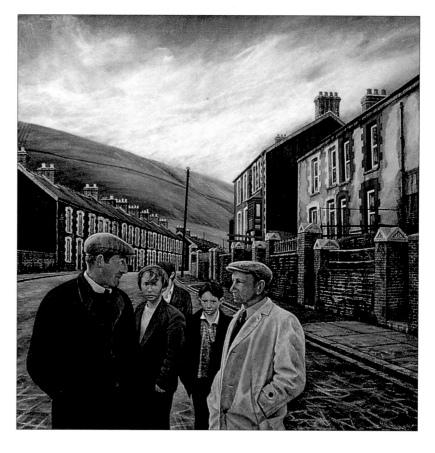

The figures occupy a fairly small area of the picture space, because the setting plays an important role in the narrative.

The head jutting halfway up the background houses emphasizes their smallness.

SKETCHING FOR FIGURE GROUPS

Paintings of figure groups are often done from sketches, partly because people seldom stay still for long enough to be painted on the spot, and partly because the composition requires careful planning. You can compose groups from sketches of individual people provided your drawings convey enough visual information; you need to relate the figures to each other and to the setting. Give an indication of scale by sketching in a little of the background and surroundings — a café table, a beach umbrella, a building. Indicate any shadows, so that you know the direction of the light, and make notes about colors.

In this composite pencil and watercolor sketch, with superimposed figures, the artist focused on expressive gesture.

The table and shopping bags give context to the rapidly sketched figures. Light watercolor washes provide the color information.

Portrait Modeling

SUBJECTS

Aportrait that focuses on the head is easier to compose than a full-length or half-length view because there is only one main element to consider. You must think about the placing of the head, the angle of viewing, and the lighting, which plays a vital role in modeling the forms. The term modeling refers to the process of recreating three-dimensional form — the painter's equivalent of what the sculptor does with solid materials. For this picture the artist chose a way of lighting often used in portraiture, coming from one side and slightly in front of the sitter, throwing a quarter of the face into shadow and creating strong gradations of tone and color. The rough execution of the finished painting, with its expressive brushwork, contributes to the vigorous character of the portrait.

Modeling form

Creating drama

Suppressing unwanted detail

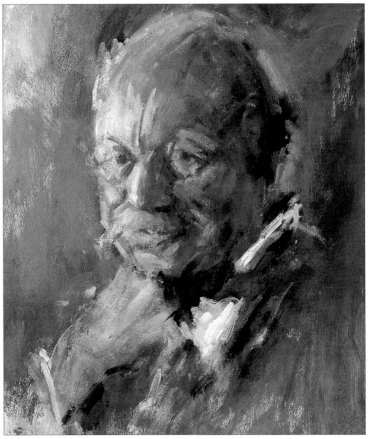

The head is broadly treated, but with attention to important facial features such as the eyes.

This preliminary pastel sketch indicates the direction of the light and the main tonal structure for the painting.

Downward-sweeping diagonals balance the light shape of the hand and the tilt of the head.

For the portrait of a child you would not normally want hard shadows and obvious gradations of tone, but strong light gives dramatic emphasis, and can be a good choice for a painting of an older person. Here the chiaroscuro *(light/dark) effect focuses attention on the face. The white collar and the hand both play a significant part in the composition: the white of the collar provides a tonal balance for the gray-white mustache and hair, while the hand leads the viewer's eye up to the face. (Man with Moustache — Ken Paine)*

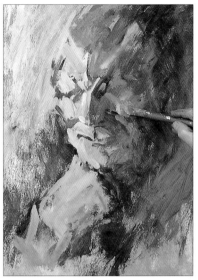

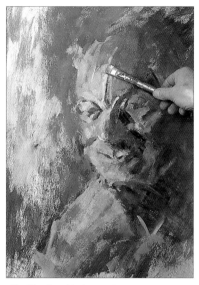

1 *The tonal structure is established before building up the colors by beginning with a middle-toned ground of greenish gray, then blocking in the head and right-hand side of the background in brown.*

2 *Color is introduced by applying patches of the gray-green ground color over the brown underpainting. Details of the facial features will be added when the structure of the head is fully established through tone and color.*

3 *The head is beginning to acquire solidity, with rich blue-browns and red-browns laid over and around the greens on the shadowed side of the face. A variety of lighter-toned colors are now used on the forehead.*

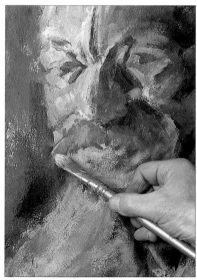

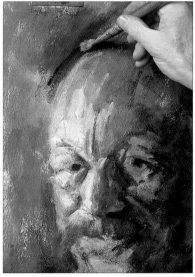

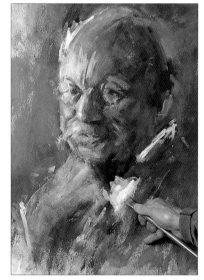

4 *After applying an area of greenish-brown for the mustache, a lighter color is painted over it, using a bristle brush to suggest the texture of the hairs. A dry-brushing method (p.63) is used to create a broken-color effect that can be seen clearly on the chin and eyelid.*

5 *The tone of the background is varied so that the head stands out light against dark on one side and dark against light on the other. Using a tone that balances the shadowed side of the face, the artist outlines the outer curve of the forehead.*

6 *The mustache was further lightened and given greater texture by dry-brushing in white, and a suggestion of white hair was applied above the forehead. Finally, the white shirt and collar, which complete the painting's careful tonal structure, are added.*

Figures in Landscape

SUBJECTS

There are two good reasons for including figures in a landscape painting. First, it helps to give a sense of scale; because we know the average size of a person, the figure gives us a yardstick for judging the sizes of landscape features, such as trees. Second, it encourages the viewer's eye to enter the picture by arousing the natural curiosity that we all feel about our fellow human beings. But there is a potential danger. Because people are more difficult to draw and paint than hills or trees, there is a tendency to treat them in greater detail than the rest of the picture, which creates a jarring effect. If you use a broad, impressionistic approach for the landscape, do the same with the figures, as this artist did. There is little detail, but the figures are completely convincing because the shapes and postures are well observed.

Making a preliminary sketch

Involving the viewer

Working broadly

The curve on the right, which leads the eye from foreground to middle distance, was widened in the painting.

The path is too central, and was changed in the painting, with the area of foreground on the left reduced.

The foreground figures looking toward us play an important part in involving us in the scene. They feature more prominently in the finished painting.

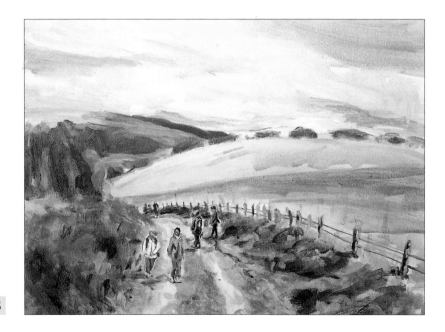

The appeal of some landscapes, such as mountains, deserts, and wild winter seascapes, is their very emptiness. But this is a quiet, everyday landscape, of the sort that attracts families out for a stroll, and the presence of people seems natural. The painting was based on a photograph showing one far-off solitary person, but this did not provide enough human interest, so the artist drew on her store of photographic reference for the other figures, planning their positions in a sketch (above) before beginning painting. The two people in the foreground play an especially important part in involving us in the scene. They could be looking back to call a dog, but we have the feeling of being invited to join the walk.
(Ramblers — Rima Bray)

168

1 *Working on primed canvas, the colors and tones are built up with successive layers of thin to medium-thick paint over a light underpainting applied with a large household brush. The yellow chosen for this will influence the later colors, imparting a warm glow to the painting.*

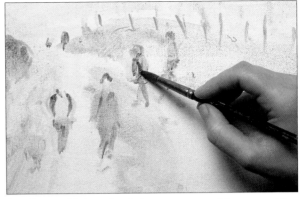

2 *After establishing the skeleton structure of the composition, the figures are started. Even at this early stage, only an indication of their individual shapes, their clothes, and the way they are moving is given.*

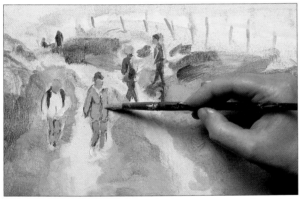

3 *The foreground greens were built up more strongly, and the figures are now given greater solidity with a denser application of paint. The brush is large in relation to the figures, which forces the artist to work broadly, omitting unnecessary detail.*

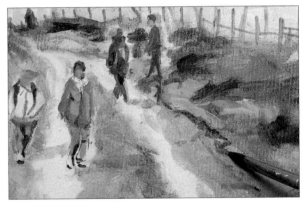

4 *The outer curve of the path, bordered by the triangular shape of dark grass, serves an important role in leading the eye into the picture, so it is given additional emphasis. The tonal contrasts in this area also provide a balance for the figures.*

5 *A touch of highlight is added to the shoulder of the background figure to bring it to the same stage of completion as those in the foreground.*

6 *The final stage is to add touches of highlight to the fenceposts to give them the same solidity as the figures. The thick paint helps them to stand out against the watery, transparent color used for the field behind.*

Telling a story

These two paintings are dissimilar in most respects, but they have one thing in common: both tell a story. Paintings of individuals or groups often have an unintentional narrative element, simply because we identify with our fellow humans, and tend to make up our own stories about them, but in these paintings the artists are the narrators. The stories are very different. While the picture of the chessplayers (far right) is easy to read, the portrayal of the woman drinking tea (near right) keeps us guessing. There are three cups of tea on the table and two empty chairs — where have the other people gone? To whom does the hat belong? Why is there a stuffed animal on the floor behind the woman?

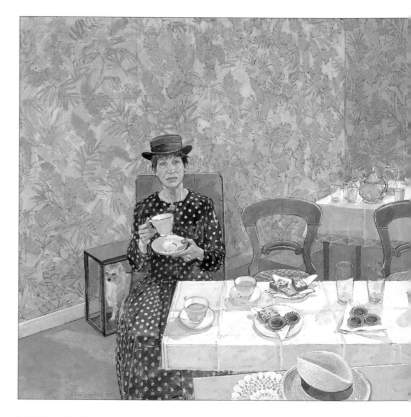

The paint is built up thickly on the face to give it volume. The eyes are unfocused, looking not at the viewer but inward, as though the woman is dreaming.

This area is enlivened by a broken-color effect, resembling hatching and crosshatching in drawing, with lines of gray-blue laid over yellow-brown with a very fine brush.

Dark paint is applied thinly and unevenly, allowing some of the undercolor to show through to give a luminous effect.

A SENSE OF MYSTERY

This painting has a dreamlike quality, which stems partly from the mysteriously empty chairs and uneaten cakes, and partly from the overall stillness of the composition. The woman seems frozen in midmovement, scarcely more animate than the stuffed creature behind her, and the chairs were not disturbed by their former occupants. The artist regards the picture surface as an important element; the controlled use of paint and the quiet colors play a major role in the overall effect. He likes to work on primed, fine-grain canvas or masonite, building up gradually in a continual layering process. (Afternoon Tea — John Sprakes)

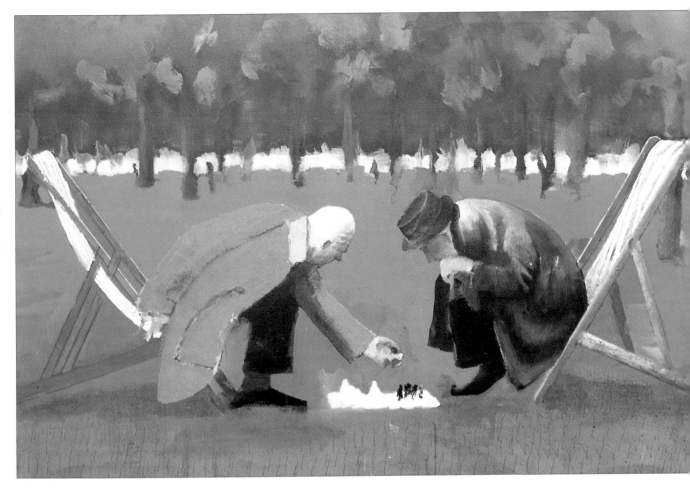

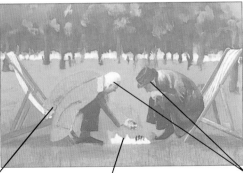

The coat is painted as an almost flat shape, and the hand gripping the side of the chair is only lightly suggested.

Treating the chessboard in more detail would have given it too much importance: the story is about the people, not the state of play on the board.

Detail elsewhere is suppressed, but care is given to the profiles and shapes of the heads to convey their individual character.

A HUMOROUS APPROACH

This delightful glimpse into the lives of two ordinary people is full of affectionate humor. There is a slight caricature quality in the simplification of the figures. Their postures, as they bend a little uncomfortably over the board, are central to the storyline, but details of their clothing are not, and were left vague.
(Polish Chess Players in Kensington Gardens — Paul Powis)

Manufacturers' Equivalent Chart

The colors suggested on page 29 as a starter palette are from a new range of artist's acrylics called Finity, produced by Winsor and Newton. If you have difficulty in obtaining these paints, or simply prefer a different brand, you can choose the equivalent colors from another range. Most of the pigments used will be the same, and in many cases so will the names, but there may be variations. Some manufacturers give their own name to one or two of their colors, while others change the spelling, or abbreviate a pigment name. For example, the blue made from phthalocyanine, a widely used pigment, may be named as phthalo or thalo blue. If in any doubt, ask your supplier for advice on colors.

WINSOR AND NEWTON	DALER-ROWNEY	LIQUITEX	GRUMBACHER
Cadmium Lemon	Cadmium Yellow Pale	Cadmium Yellow Light Hue (159)	Thalo Yellow
Cadmium Yellow Deep	Cadmium Yellow Deep	Cadmium Yellow Deep Hue (163)	H034—Cadmium Yellow Medium (+H025 Cadmium Orange)
Yellow Ocher	Yellow Ocher	Yellow Oxide (416)	H244—Yellow Ocher Light
Cadmium Red Medium	Cadmium Red	Cadmium Red Medium Hue (151)	H027—Cadmium Red Medium
Permanent Alizarin Crimson	Crimson Alizarin (Hue)	Permanent Alizarin Crimson Hue (116)	H0211—Thio Violet (+ a touch of H219—Ultramarine Blue)
Dioxazine Purple	Deep Violet	Dioxazine Purple (186)	H094—Grumbacher Purple (Dioxazine Purple)
Ultramarine Blue	Ultramarine	Ultramarine Blue (380)	H219—Ultramarine Blue
Phthalo Blue (Green Shade)	Phthalo Blue (Green Shade)	Phthalocyanine Blue (316)	H203—Thalo Blue
Coeruleum Blue	Coeruleum	Cerulean Blue (164)	H039—Cerulean Blue
Cobalt Green Light	Hooker Green (closest, but different hue)	Cobalt Green (171)	No comparison
Chromium Oxide Green	Opaque Oxide of Chromium	Chromium Oxide Green (166)	H048—Chromium Oxide Green
Raw Umber	Raw Umber	Raw Umber (331)	H172—Raw Umber
Burnt Umber	Burnt Umber	Burnt Umber (128)	H024—Burnt Umber
Titanium White	Titanium White	Titanium White (432)	Titanium White
Ivory Black	Ivory Black	Ivory Black, Mars Black (244, 276)	Ivory Black
Davy's Gray	Middle Gray	Paynes Gray (310)	No comparison

Index

Credits

Quarto would like to thank all the artists who have kindly allowed us to reproduce their work in this book.

We would like to acknowledge and thank the following artists for their help in the demonstrations of techniques: Gerry Baptist, Mike Bernard, Rima Bray, David Cuthbert, Ros Cuthbert, Brian Dunce, Ted Gould, Debra Manifold, Alan Oliver, Ken Payne, Ian Sidaway, Mark Topham.

We would like to thank Liquitex, Bedford, England for the use of their picture on page 9, and E. Ploton Ltd, Archway Road, London, N6 for the use of their easel in photography.

All other photographs are the copyright of Quarto Publishing plc.